Race and the Modern Exotic

Three 'Australian' Women on Global Display

Angela Woollacott

Manning Clark Professor of History,
The Australian National University

Monash University Publishing
Building 4, Monash University
Clayton, Victoria 3800, Australia
www.publishing.monash.edu

Monash University Publishing brings to the world publications which advance the best traditions of humane and enlightened thought.

Monash University Publishing titles pass through a rigorous process of independent peer review.

National Library of Australia Cataloguing-in-Publication entry:

> Author: Woollacott, Angela, 1955-
>
> Title: Race and the modern exotic : three 'Australian' women on global display / Angela Woollacott.
>
> ISBN: 9781921867125 (pbk.)
>
> ISBN: 9781921867132 (ebook : epub)
>
> Notes: Includes bibliographical references and index.
>
> Subjects: Women in popular culture--Australia; White Australia policy; Women--Australia--Social conditions; Australia--Social conditions--20th century.
>
> Dewey Number: 305.4209421

www.publishing.monash.edu/books/rme.html

Design: Les Thomas

Cover images:
Left: Annette Kellerman in mermaid costume. Papers of Annette Kellerman, MLMSS 6270, with permission of the Mitchell Library, State Library of New South Wales.

Centre: Portrait of Rose Quong. Rose Quong Papers, MSS132, Historical Society of Pennsylvania, with permission of the Historical Society of Pennsylvania.

Right: Merle Oberon as Anne Boleyn. Special Collections, Cleveland State University Library, with permission of ITN Source.

Printed in Australia by Griffin Press an Accredited ISO AS/NZS 14001:2004 Environmental Management System printer.

Race and the Modern Exotic

Contents

Acknowledgements ..ix

List of Illustrations..xi

Introduction..xv

CHAPTER 1
Annette Kellerman: Mermaids and South Sea Islanders............................1

CHAPTER 2
Rose Quong: Appropriating Orientalism ...49

CHAPTER 3
Merle Oberon: Nationalism and Negotiating the Exotic............................93

Conclusion..133

Bibliography..145

Index..151

To Tony, with gratitude for many things.

Acknowledgements

Annette Kellerman, Rose Quong and Merle Oberon each appear very briefly in my 2001 book *To Try Her Fortune in London: Australian Women, Colonialism, and Modernity*. And that would have been it, for my work on them, despite their extraordinary stories, were it not for a chance conversation I had a year or so later. I am truly indebted to Dr. Robert K. Batchelor, currently of Georgia Southern University, for suggesting I look harder to see whether Rose Quong's papers had survived, then himself pointing out to me that they were held at the Historical Society of Pennsylvania. Had it not been for Bob's curiosity about connections between Britain and China, and his spurring me on to pursue Quong's story, this book likely would not have been written. As I immersed myself in the rich collection of Quong's papers fortuitously preserved in Philadelphia, I came to see both the fascination and the significance of such an individual story, and in turn to be increasingly captured by Kellerman and Oberon's stories too, and the connections I perceived among them. The potential significance for Australian and global history of connecting these three stories, and explicating their resonances for the early to mid-twentieth century, took hold in my mind.

My debts extend to several others too. My partner Carroll Pursell enhances all that I do, and I am grateful to him for doubling my research productivity in Philadelphia by transcribing some of the Quong papers, and making the research trips pleasurable by helping me explore that city's considerable culinary resources. Watching some of Kellerman's silent films and Quong and Oberon's movies with me was yet another contribution. I am grateful to Juilee Decker for her cheerfully efficient research assistance when we were both at Case Western Reserve University in Ohio; and to Jane Hunt for her creative and knowledgeable research assistance at Macquarie University in Sydney. Carolyn Skinner provided her typically efficient research assistance in locating images and obtaining permissions. I thankfully acknowledge research funding that helped this project from Case Western Reserve University, Macquarie University and the Australian National University.

Barbara Firth permitted my access to the closed boxes of the Annette Kellerman collection at the Mitchell Library, State Library of New South Wales, and Peter Wyllie Johnston helpfully gave me information on Kellerman's education at Simpsons' School, now Mentone Girls' Grammar

School, in Melbourne. Finally, in the many years of this project's life, my work on it has been sustained by the helpful interest of audiences for papers I presented at the Centre for British Studies, the University of Adelaide; Macquarie University; the Centre for Public Culture and Ideas at Griffith University; the Australian Historical Association annual conference; the Vernacular Modernities conference at the University of Queensland; the Sydney Feminist History Group; and at the Australian National University.

List of Illustrations

Page 2. Annette Kellerman diving in sheer swimsuit of silver scales
Source: Annette Kellerman, *How to Swim* (London: William Heinemann, 1918).

Page 5. Annette Kellerman posing at the beach
Source: Papers of Annette Kellerman, MLMSS 6270, with permission of the Mitchell Library, State Library of New South Wales.

Page 8. Annette Kellerman called 'Coo-ee' during performances in an assertion of her Australian identity
Source: Papers of Annette Kellerman, MLMSS 6270, with permission of the Mitchell Library, State Library of New South Wales.

Page 11. Annette Kellerman performing in an on-stage tank
Source: Papers of Annette Kellerman, MLMSS 6270, with permission of the Mitchell Library, State Library of New South Wales.

Page 18. Annette Kellerman, 'The Perfect Woman'
Source: NLA.PIC- AN22948275, David Elliott Postcard Collection, with permission of the National Library of Australia.

Pages 20–21. Frontispiece from *Physical Beauty and How to Keep It*
Source: Annette Kellerman, *Physical Beauty and How to Keep It* (London: William Heinemann, 1919).

Page 26. Annette Kellerman in mermaid costume
Source: Papers of Annette Kellerman, MLMSS 6270, with permission of the Mitchell Library, State Library of New South Wales

Page 28. Annette Kellerman dives from a tower in *A Daughter of the Gods* (1916)
Source: Annette Kellerman, *How to Swim* (London: William Heinemann, 1918).

Page 30. Annette Kellerman in *A Daughter of the Gods* (1916)
Source: Annette Kellerman, *Physical Beauty and How to Keep It* (London: William Heinemann, 1919).

Page 32. Annette Kellerman and other actresses in mermaid costume
From Annette Kellerman, *How to Swim* (London: William Heinemann, 1918).

Page 36. Annette Kellerman being officially welcomed in Atlantic City, New Jersey
Source: Papers of Annette Kellerman, MLMSS 6270, with permission of the Mitchell Library, State Library of New South Wales.

Page 39. Annette Kellerman cross-dressing as 'the English Johnny' in a vaudeville routine
Source: Papers of Annette Kellerman, MLMSS 6270, with permission of the Mitchell Library, State Library of New South Wales.

Page 50. Portrait of Rose Quong taken in Melbourne
Source: Rose Quong Papers, MSS132, Historical Society of Pennsylvania, with permission of the Historical Society of Pennsylvania.

Page 54. Portrait of Rose Quong, presumably in Australia
Source: Papers of Rose Quong, NLA MS 9796, with permission of the National Library of Australia.

Page 60. Rose Quong in medieval costume
Source: Papers of Rose Quong, NLA MS 9796, with permission of the National Library of Australia.

Page 70. Rose Quong (front left), with legendary actress Ellen Terry (front centre) and Laurence Olivier (standing behind Quong)
Source: Papers of Rose Quong, NLA MS 9796, with permission of the National Library of Australia.

Page 72. Rose Quong in one of her early Chinese costumes
Rose Quong Papers, MSS 132, Historical Society of Pennsylvania, with permission of the Historical Society of Pennsylvania.

Page 75. Rose Quong on stage in Chinese drama
Rose Quong Papers, MSS 132, Historical Society of Pennsylvania, with permission of the Historical Society of Pennsylvania.

Page 78. Advertisement for Rose Quong's 'Circle'
Source: Papers of Rose Quong, NLA MS 9796, with permission of the National Library of Australia.

Page 82. Advertising flier used by Quong's New York agent
Source: Papers of Rose Quong, NLA MS 9796, with permission of the National Library of Australia.

Page 85. Portrait of Rose Quong, presumably during her New York years
Source: Rose Quong Papers, MSS132, Historical Society of Pennsylvania, with permission of the Historical Society of Pennsylvania.

Page 88. Rose Quong at an opening night at the White Barn Theatre in Westport, Connecticut
Source: Rose Quong Papers, MSS 132, Historical Society of Pennsylvania, with permission of the Historical Society of Pennsylvania.

Page 98. Merle Oberon as Anne Boleyn
Source: Special Collections, Cleveland State University Library, with permission of ITN Source.

Page 99. Merle Oberon seated between Fredric March and Charlie Chaplin
Source: Charles Higham and Roy Moseley, *Princess Merle: The Romantic Life of Merle Oberon* (New York: Coward-McCann Inc., 1983), with permission of Culver Pictures, Inc.

Page 107. Merle Oberon in an advertisement for Max Factor cosmetics
Source: *The Australian Women's Weekly*, 10 July 1937, p. 66.

Page 110. The Australian press instantly accepted Oberon as a 'Tasmanian girl'
Source: *The Sydney Morning Herald*, Women's Supplement, 21 June 1934, p. 8.

Page 114. Merle Oberon, featured in *The Australian Women's Weekly* article, 'A Specialist Rarely Escapes'
Source: *The Australian Women's Weekly*, 30 January 1937, p. 4.

Page 117. Merle Oberon in *The Dark Angel* (1935)
Source: *Everyone's*, 8 June 1936, p. 12.

Page 121. Merle Oberon as the subject of a cartoon, 'Screen Oddities'
Source: *The Australian Women's Weekly*, 29 February 1936, p. 40.

Page 125. Merle Oberon on the cover of *The Australian Woman's Mirror*
Source: *The Australian Woman's Mirror*, 14 May 1940.

Introduction

This book tells the stories of three internationally successful 'Australian' performers of the first half of the twentieth century, in order to raise questions about femininity, transnational celebrity, race and Australianness. Annette Kellerman was an early twentieth-century swimmer, diver, lecturer, and silent-film star. Kellerman turned herself into a star through a modern, performative career centred on her own body – a very fit body that she used in spectacular ways to challenge older notions of weak, modest femininity. Through her international vaudeville performances and film roles, Kellerman played with gender boundaries, and the quasi-racial identity of South Sea Islander. Rose Quong was an actor, lecturer and writer who was born and brought up in Melbourne, but left Australia in 1924 and forged a career in London and New York. Quong also built a career based on her own body, through a careful appropriation of Orientalism. In Quong's case, her body was the signifier of her Chinese authenticity, the essentialist foundation for her constructed, diasporic Chinese identity. While both Kellerman and Quong deployed their bodies strategically, and both were performers, Quong was modern in ways distinctive from Kellerman.

Merle Oberon was one of the most celebrated film stars of the 1930s and 1940s, first in London and then Hollywood. The official story of her origins was that she was Tasmanian; Oberon kept up the pretence of her Australian birth until her death. However, this was a publicity story concocted at the beginning of her film career to mask her illegitimate, lower-class, Anglo-Indian birth. A Tasmanian version of Oberon's birth contends that her mother was an unmarried Chinese hotel worker in a small town in the island's northeast. Denying her Anglo-Indian birth, the Tasmanian believers insist that Oberon's exotic beauty was because she was part-Chinese. This local myth of Oberon's origins thus posits a Chinese-Australian celebrity who made it by suppressing her Chineseness, just shortly after Rose Quong made it (to a lesser extent) by foregrounding hers. This myth, disproven by Oberon's birth certificate and family testimony, is a relatively recent construction. At the time of Oberon's rise to fame Australian audiences, like those elsewhere, believed that she was an Australian of British colonial descent. Despite anxious undercurrents about her exoticism, Australians were thrilled to claim a true Hollywood star as one of their own.

White Australia existed as a legislative entity from 1901, when the Commonwealth Immigration Restriction Act was passed, until the 1960s when restrictions were gradually eased and Australia moved towards embracing multiculturalism. Most Australians knew of this immigration restriction and its legislative basis, but did not spend much time thinking about it. Rather, for them White Australia was the cultural reality of a society dominated by Anglo-Saxons and Celts, descendants of and migrants from the British Isles with an admixture of others from Europe. Racial thinking was at the core of White Australian culture: far from being oblivious to racial hierarchies and constructions, Australians engaged with them on an everyday basis. White Australia was in part an imaginative construct, a sense of a nation born only at the beginning of the century, a product of the British Empire flourishing in the Asia-Pacific region. The whiteness of White Australia was maintained, beside immigration restriction, through the pervasive repression and subordination of Indigenous people. But it was also a racial identity that was continually produced and negotiated, in a process that can be explored through the imagery, the cracks and the fissures of the period's popular culture.

This book looks at the careers of three celebrated 'Australian' women performers of the first half of the twentieth century, a period nearly coterminous with full-blown White Australia. Revealing the racial ambiguities related to each of these three women's projected images, *Race and the Modern Exotic* suggests that White Australia played out as an imaginative construct replete with complex cultural tensions. Glad to see their own celebrities on the international stage, Australians were willing to negotiate imaginary connections with South Sea Islanders that played on actual historical links, the compound cultural identity of a Chinese-Australian who performed traditional English drama, and a mysteriously exotic film star's utterly false claim to be Tasmanian.

Looking in detail at Annette Kellerman, Rose Quong and Merle Oberon's careers, their merging of Australianness with other racial and ethnic identities, and Australians' views of them, provides us with insight into the deep tensions within White Australia as a cultural identity in its prime decades. Ghassan Hage contends that White Australian culture was not as confident as its American counterpart, that Australians were made nervous by their uncontrollable natural environment, and the continuing presence of cultural otherness within the new nation's shores. It was this nervousness that provided emotional depth to what was more than simply

an immigration policy. What Hage terms 'White paranoia' was based on a logic that British civilisation was the highest form, that it was defined by racial whiteness, that non-whites were unable to uphold the values of British civilisation, and if admitted they would undermine the values and standard of living for everyone. It was this logic that provided broad cultural support for the White Australia policy for most of its duration.[1] Hage's notions of cultural lack of confidence and nervousness help to explain tensions and ambiguity within Australian popular culture in these decades.

Popular culture has been at the heart of the modern, perhaps never more so than in the first decades of the twentieth century. In the era when new technologies such as the car, and social iconoclasts such as the flapper, remade the world, the modern entertainment vehicles of live theatre, magazines and film carried dramatic images of them to towns and cities around the globe. As audiences everywhere used cinematic and other forms of popular culture to help them negotiate the modern in their daily lives, the cult of the star produced individual figures who represented specific, gendered and racialised forms of modernity. For Australians, the emergence of 'Australian' celebrities meant that they could recognise themselves as part of global modernity. Yet analysis of successful actors and entertainers reveals the Australianness represented in transnational cultural forms as open to negotiation in ways not usually associated with the entrenched era of White Australia.

Moreover, it becomes difficult to disentangle the national from the transnational. The most revered 'Australian' performers were those who made it internationally – a global success of which Australians could be proud. Australian actors and filmmakers were a recognised presence in Hollywood in its formative years, and the healthy Australian film industry of the 1910s–20s throve in part because of this connection, and the constant traffic across the Pacific. New York was a magnet for Australians in theatre: of the many ambitious Australians who first headed to London, the British imperial metropole, a substantial proportion moved from there to New York; some went to New York first. It is possible to see the transatlantic axis not only as the cultural highway of the Anglophone world in this period, but as part of a wider triangulation for Australians, as it was in different directions for those from other English-speaking smaller nations.

These three women's careers, and the images of modern femininity they projected, jointly pose questions about the transnational construction

1 Ghassan Hage, *Against Paranoid Nationalism: Searching for Hope in a Shrinking Society* (Annandale, NSW: Pluto Press, 2003), pp. 51–54.

of Australianness. They suggest an entanglement of Australianness, in popular culture, with other racial categories and 'the exotic'. Performative careers that made 'Australian' women's bodies visible and internationally recognisable helped to shape Australian modernities. In making themselves recognisable, these three women performers created newly modern, racially ambiguous Australian femininities. Their stories speak as well to the tensions between the national and the transnational in the popular cultural forms of high modernity. Vaudeville, fiction and film in its first decades were all global industries, with participants moving according to their ambitions and careers, working in both national and international companies and entertainment circuits. The backstage areas of circuses, vaudeville and other popular theatres, like the production sets of early film companies, were remarkably polyglot spaces. In nineteenth-century Australia, for example, Aboriginal people were recruited for circus and sideshow work, travelling both here and overseas; some were given Spanish names to explain their dark looks.[2] From the mid-nineteenth century the steamship and the railroad, before the rise of the motor car, facilitated the rise of national and international theatrical circuits, and the geopolitical and economic ties forged by Western imperialism provided the itineraries.[3] The national and the transnational were interwoven in that success in one country enhanced the prospects of a production's international tour. The geographical circuits established for live theatre in the nineteenth century became the basis for film distribution in the twentieth, as films were first shown as part of mixed programs in theatres.

Increasingly popular daily newspapers promoted the vaudeville and film industries, and the stars that were their emblems. Magazines too proliferated in this period, including specialist theatre and film periodicals, women's magazines and those celebrating modern culture. Women increasingly constituted theatre audiences. Veronica Kelly has pointed to the connections between increasing numbers of young women workers 'with just enough discretionary income to wield their consumer power in the expanding marketplace of cultural choice', feminine passion for theatrical glamour,

2 On this, see Wendy Holland, 'Reimagining Aboriginality in the Circus Space', *Journal of Popular Culture* Vol. 33, No. 1 (Summer 1999), 91–104; Mark St. Leon, *Wizard of the Wire: The Story of Con Colleano* (Canberra: Aboriginal Studies Press, 1993); Roslyn Poignant, *Professional Savages: Captive Lives and Western Spectacle* (Sydney: University of New South Wales Press, 2004).
3 On the significance of these international circuits for Australian theatre, see Veronica Kelly, 'A Complementary Economy? National Markets and International Product in Early Australian Theatre Managements', *New Theatre Quarterly* Vol. 21 Pt. 1 (Feb. 2005), 77–95.

and the 'deliriums of star worship'.[4] In the same decades, the prodigious and transnational growth of clubs, not least women's clubs, created lecture circuits for women speakers. Looking for the 'Australianness' in the performances and personas of entertainers in such transnational industries and networks is thus, to some extent, a chimerical endeavour. Yet national as well as racial typing was a staple of the mass entertainment industries and popular culture alike.

This book contributes at once to the fields of Australian history, transnational history, gender history and the history of popular culture. Its central focus on global circulation and interconnectedness reflects the concerns of transnational history, while its interest in the construction of 'Australianness' reveals the symbiotic relationship between transnational culture and national identities. Like much current transnational history, my analysis is informed by the insights of postcolonial studies, such as the interconnections between imperial ties, racial hierarchies and cultural production. I also bring to bear a feminist analysis that insists on the connections between cultural understandings of the body and sexuality, gender categories, and the public importance of the supposedly private. As much work in feminist cultural history has evocatively demonstrated, the female body's role as visual spectacle in the modern period has been at once the product of women's subordination and sexualisation, and central to women's exercise of their own social and economic agency.

I hope that showing the interconnection between idealised representations of femininity, and racial ambiguity, will provide insight into the profundity of transnational racial awareness during a period replete with legally entrenched forms of discrimination based on race – from White Australia, to the segregated American South, and the late stages of European colonialism across the globe from Africa, to South Asia, the Pacific and elsewhere. Racism flourished not because people, even in cities or metropoles, were unaware of racial categories and their effects; on the contrary, they were exposed to and grappled with them constantly. Like other consumers and audiences, Australians made sense of the world and their place in it from myriad sources of information, not least those they found in popular culture.

The majority of Australians, European-descended, constructed their sense of themselves as 'white' people from their privileges as citizens in a settler nation founded on the suppression of its Indigenous inhabitants. As Hage

4 Veronica Kelly, 'An Australian Idol of Modernist Consumerism: Minnie Tittell Brune and the Gallery Girls', *Theatre Research International* Vol. 31, No. 1 (March 2006), p. 19.

has pointed out, the 'Blackness' associated with Aboriginality has functioned in Australian culture as a marker against which others – those who need to promote their claims to national belonging – can distinguish themselves and thereby have 'access to Whiteness'.[5] Australians also absorbed racial lessons about Australia's place and regional hierarchies from representations of the South Sea Islands (their immediate vicinity including Australia's colonial dependencies), China and its diasporic peoples (whose perceived threats to Australia's racial purity and economic standing had been the impetus for the White Australia policy), and other parts of the British Empire, not least the South Asian colonies at which most Australian passengers en route to England necessarily sojourned. Like 'Australianness' and other national identities, racial understandings were shaped transnationally. The complex meanings attached to three successful 'Australian' performers in this period of highly articulated racism thus become a popular cultural archive we can investigate to learn more about contemporary connections between race, exoticism and gender on the global stage.

Modern women, visual spectacle and White Australia

Kellerman, Quong and Oberon exemplify the significance of femininity and celebrity to vernacular culture in the period of high modernity. Between them, these three ostensibly 'Australian' stars encompassed the performance genres of vaudeville and live spectacle; the club and community lecture circuit; and the legitimate stage; they wrote books and articles; and appeared on radio, television and film, from the 1900s to the 1970s. Making careers from this range of forms of the modern entertainment industry, Kellerman, Quong and Oberon deployed their own bodies and meanings attached to them to create and sell modern images of femininity. While their degrees of fame varied, with Kellerman and Oberon outshining Quong, their times in the spotlight were both sequential and overlapping – reinforcing, I would like to suggest, the ambiguity of each other's careers.

Using Australianness in various ways, they linked it to a range of other national and ethnic forms, from the South Sea Islander, to the Chinese or 'Oriental', and the 'English girl'. Playing with racial ambiguity, they invited audiences to embrace, consume and enjoy racial and ethnic slippage, as well as instances of gender transgression. If the modern has consisted of local and specific engagements with global culture, these putatively Australian

5 Ghassan Hage, *White Nation: Fantasies of White Supremacy in a Multicultural Society* (Annandale, NSW: Pluto Press, 1998), p. 57.

celebrities with overseas careers show gender instability and racial ambiguity to have been as central to Australian modernity as any elsewhere. The Australian public's support for and fascination with their careers (especially Kellerman and Oberon) reveal the thrills of skirting the edges of whiteness, the precarious balance between shoring up its boundaries and admitting the exotic. Identifying the racial dynamics at work in these instances of popular culture helps us to understand the racial thinking of the period, the constant racial awareness that underlay immigration restrictions and the very idea of 'White Australia'.

Racialised and eroticised images were at the core of modernist culture, and thus particularly powerful vehicles for manipulation and appropriation. The extraordinarily successful career of Josephine Baker in 1920s–30s Europe shows the centrality of conceptions of the primitive and the exotic to live performance. Baker was perhaps the most successful performer of the 1920s, and even later, to use her own body to create an iconic stage presence. An African-American born into poverty in St. Louis, Missouri, Baker toured America in popular theatre before she moved to Paris in 1925. There, and to a lesser extent in Berlin, she became a hugely successful dancer and performer, earning considerable wealth in the process. She appropriated and satirised contemporary racist stereotypes, depicting them with her own beautiful body and modernist irony. For the most iconic of her dances, she wore her trademark 'banana skirt' and virtually nothing else, at once playing on racist stereotypes and mocking them in highly erotic fashion. Baker, who apparently had astonishing rhythm and energy, performed what was known as her 'danse sauvage', and played on images of the Black Venus, specific characters from French colonial culture, and motifs of African art currently much in vogue through cubism. Baker consciously played on the primitivism so pervasively represented in European modernism.[6]

Yet, as Nancy Nenno argues, her appeal to Europeans lay partly in her fusing of the primitive and the modern. Audiences knew she was American, and thus linked to jazz and the urban modernity they themselves sought, for all of her jungle allusions. She allowed them at once to take pleasure in near-nudity and the erotic, and to indulge racist stereotypes and apparently laugh at them. Baker is a useful example of the extent to which racial thinking suffused popular culture in these decades, even as it worked through overt mimicry, and was closely linked to spectacular display of the female body.

6 Bennetta Jules-Rosette, *Josephine Baker in Art and Life: The Icon and the Image* (Urbana: University of Illinois Press, 2007), esp. pp. 2–4.

She also exemplifies the commercial appeal of such spectacle, in the way she commodified herself through, for example, cosmetic products and dolls.[7] Wendy Martin contends that, while Baker transcended her racial status as a black person through her parodies of racial and colonial stereotypes, her representation of uninhibited sexuality rendered her still dependent on erotic imagery and the male gaze.[8]

Josephine Baker's astonishing success and much-publicised career is instrumental to understanding Kellerman, Quong and Oberon's careers. Spanning the 1920s and '30s, the decades of Baker's greatest success, Kellerman, Quong and Oberon also depended on the seemingly insatiable public appetite for displays of the female body – though Kellerman was the only one of the three who rivalled Baker's near-nudity. Similarly, they each relied on modernist culture's fascination with ethnic and racial stereotypes. They were different from Baker in that none of them used parody as she did, though again Kellerman came closest with her playful presentation of mermaids. Baker's success depended on audiences' willingness to laugh at parody (even as they indulged in racist caricatures) and to engage with irony. None of Kellerman, Quong or Oberon employed irony. Rather, they each sought to impress as well as to entertain audiences: Kellerman with her daring and feats, Quong with her acting, voice and literacy in traditional Chinese culture, and Oberon with her acting and her beauty. Nevertheless, their careers all also involved audiences' willingness to engage with racial and ethnic stereotypes, or to either engage or suppress their fascination with the exotic.

The period spanning the late nineteenth century and the early twentieth century comprised high modernity in the introduction of new technologies, the acceleration of global movement, and the rapidity of urbanisation and industrialisation. It was also the age of aggressive imperialism when the European, American, Japanese and other empires asserted control over massively expanded amounts of territory – from Africa to the Pacific and elsewhere. With the extensive 'exploration' of parts of the globe previously known well to their inhabitants but not to the West, geography, cartography, and anthropology all caught the Western imagination. Ethnographic study combined with large-scale looting of artifacts around the world, and both

7 Nancy Nenno, 'Femininity, the Primitive, and Modern Urban Space: Josephine Baker in Berlin', in Katharina von Ankum (ed.), *Women in the Metropolis: Gender and Modernity in Weimar Culture* (Berkeley: University of California Press, 1997), esp. pp. 156–57.
8 Wendy Martin, '"Remembering the Jungle": Josephine Baker and Modernist Parody', in Elazar Barkan and Ronald Bush (eds.), *Prehistories of the Future: The Primitivist Project and the Culture of Modernism* (Stanford, CA: Stanford University Press, 1995), pp. 310–325.

stocked the expanding natural history and art museums of the Western capitals. Interest in the art of so-called 'primitive' cultures sparked the appropriation of primitive motifs in modernist art, including cubism and other forms. And in the second half of the nineteenth century, the enormous appetite for imperial and colonial exhibitions that was sparked by the London Great Exhibition of 1851 created a mass entertainment industry of temporary displays of non-Western cultures, such as the villages constructed at exhibitions in Paris and elsewhere. As Elazar Barkan and Ronald Bush have suggested, the result was 'the kind of ambiguous appropriation associated with modernism: a mixture of violence and aestheticism; the difficulties of placing and displacing the modern and the primordial; the conflation of the past and the future'.[9] These dimensions of modernism infused popular culture, and had much to do with the early twentieth century fascination with racial and ethnic stereotypes. The huge worldwide popularity of jazz music, which arrived in Australia in 1918, represented a fusion of modernity, excitement and otherness.[10] It was these broad and globally pervasive cultural currents that Kellerman and Quong tapped into with their marketing of ethnic and exotic stereotypes that seemed timeless, and that at once fuelled public interest in Oberon's mysterious exoticism.

It was equally significant that all three careers depended on the display of female bodies, tapping into both eroticism and the commodification of changing gender ideas. Femininities had become unsettled and exciting, through women's dramatic encroachment on the public sphere, gaining of voting rights gradually around the world and particularly early in Australia, and their incursion into arenas from which they had been excluded. It was only in the late nineteenth century that Western culture reluctantly began to concede that women's presence on stage could be respectable. Renee Sentilles locates the birth of modern celebrity culture in the United States during the Civil War period, the 1850s and 1860s, an era of tremendous social upheaval for that divided then unified nation. In her study of the sensational theatrical performer and poet Adah Isaacs Menken, Sentilles argues that it was the emergence of a media-driven national culture as well as contemporary awareness of the uncertainty of social categories (including

9 Barkan and Bush (eds.), *Prehistories of the Future*, pp. 1–2.
10 Bruce Johnson, *The Inaudible Music: Jazz, Gender and Australian Modernity* (Sydney: Currency Press, 2000), p. 8.

race and gender) that enabled Menken, who played with such categories, to spark a cult of celebrity.[11]

Other women celebrities would soon follow. Actress Sarah Bernhardt, of course, transfixed audiences in Europe, America and around the world in the late nineteenth and early twentieth centuries. Susan Glenn has suggested that, from the 1880s, celebrity women performers such as Bernhardt linked the spectacular and the New Woman, throwing femininity open to public renegotiation through the modern.[12] Then there was Loie Fuller, the American vaudeville dancer who built a significant European career from her modernist dancing and performances that incorporated phosphorescence and elaborate coloured lighting.[13] Such women provided a powerful cultural counterpoint to the first-wave women's movement, placing images of transgressive and dramatically sexualised femininity at the heart of popular culture. They added an extra provocation to the already explosive debates surrounding gender roles and women's place. Femininity, the erotic, and women's bodily display became intertwined in vaudeville and other forms of theatre, even before the rise of film.

Scholars in feminist history have understood for decades that cinema, femininity and modernity were interconnected. Mary Ryan's 1970s article on 'The Movie Moderns in the 1920s' argued that 'screen femininity' shaped American conceptions of the 'flapper', sexual permissiveness, the display of the female body, and a renewed emphasis on heterosexual relations and marriage, even or perhaps especially for the flapper.[14] The rapid rise of the film industry and the cinema in the early twentieth century meant that screen representations of modern femininities reached massive audiences around the world. By the 1920s four times as many Australians patronised the cinema as live theatre and horse racing together: by 1928 the nation boasted 1250 cinemas with an annual attendance of around 110 million, many times the actual population.[15] It was the mass scale of cinema globally that made Kellerman's career so successful, and, coming two decades later when the

11 Renee M. Sentilles, *Performing Menken: Adah Isaacs Menken and the Birth of American Celebrity* (Cambridge: Cambridge University Press, 2003).

12 Susan A. Glenn, *Female Spectacle: The Theatrical Roots of Modern Feminism* (Cambridge, MA: Harvard University Press, 2000).

13 Rhonda K. Garelick, *Electric Salome: Loie Fuller's Performance of Modernism* (Princeton: Princeton University Press, 2007).

14 Mary P. Ryan, 'The Projection of a New Womanhood: The Movie Moderns of the 1920s', in Jean E. Friedman and William G. Shade (eds.), *Our American Sisters: Women in American Life and Thought* (Boston: Allyn and Bacon, 1976), pp. 366–85.

15 Richard Waterhouse, *Private Pleasures, Public Leisure: A History of Australian Popular Culture Since 1788* (South Melbourne: Longman Australia, 1995), p. 176.

talkies had made films even more popular, Oberon's even more so. As Jill Matthews has put it so well: 'In the early years of the twentieth century, moving pictures blazed like a comet in the night-life sky with the other practices and entertainments streaming away in brilliant tails, scattering the sparks of modernity into everyday life'.[16] Women's changing behaviour and new definitions of femininity were at the heart of cultural modernity, and not only on the cinematic screen. Liz Conor's study of *The Spectacular Modern Woman* analyzes the manifold ways in which visual spectacle and appearance came to define femininity in the 1920s, in media from film and magazines, to cartoons, advertisements, postcards, posters, sheet music, billboards and mannequins. Conor draws most of her examples from Australia, yet at once shows the transnational context of these developments, while analyzing the operation of both racism and colonialism in equating modernity with white women and excluding colonised and non-white women.[17]

The 'Modern Girl Around the World' research project, based at the University of Washington, was an interdisciplinary study of the connected global emergence of the 'Modern Girl' in the first half of the twentieth century. The study's authors point out that: 'In cities from Beijing to Bombay, Tokyo to Berlin, Johannesburg to New York, the Modern Girl made her sometimes flashy, always fashionable appearance.... Modern Girls were known by a variety of names including flappers, *garçonnes*, *moga*, *modeng xiaojie*, schoolgirls, *kallege ladki*, vamps, and *neue Frauen*.'[18] Importantly, the researchers on this project have pointed to the roles of nationalism, colonialism, race and the international in this gendered form 'produced through twentieth-century multinational corporations, imperial relations, the mass media and modernist literary, aesthetic and political discourses'.[19] They identify the 'imbrication of the local and the global in these web-like circuits' particularly 'the Modern Girl's repeated role in processes of racialisation and articulations of nationalism'.[20] A quintessentially transnational product of the cinema and commodity culture, the 'Modern

16 Jill Julius Matthews, *Dance Hall & Picture Palace: Sydney's Romance with Modernity* (Sydney: Currency Press, 2005), p. 15.
17 Liz Conor, *The Spectacular Modern Woman: Feminine Visibility in the 1920s* (Bloomington: Indiana University Press, 2004).
18 The Modern Girl Around the World Research Group: Alys Eve Weinbaum, Lynn M. Thomas, Priti Ramamurthy, Uta G. Poiger, Madeleine Yue Dong, and Tani E. Barlow (eds.), *The Modern Girl Around the World: Consumption, Modernity, and Globalization* (Durham: Duke University Press, 2008), p. 1
19 Modern Girl Around the World Research Group (Tani E. Barlow, Madeleine Y. Dong, Uta G. Poiger, Priti Ramamurthy, Lynn M. Thomas, and Alys Eve Weinbaum), 'The Modern Girl around the World', *Gender and History* Vol. 17, No. 2 (2005), p. 246.
20 'The Modern Girl around the World', p. 247.

Girl' represented the seeming paradox of national types constructed through globally circulating cultural forms.

The 'Modern Girl' provided the transnational cultural canvas against which Kellerman, Quong and Oberon's careers were staged. Each represented different aspects of feminine modernity. Kellerman exemplified physical fitness and transgression, bodily display, endurance and daring, as well as both live theatre and film. Quong stood for cross-cultural exchange, Orientalism, serious theatre, and modern women's intellectual and literary capabilities. Oberon personified the glamour that film stars had accrued by the 1930s and 1940s, herself one of the most famous visual spectacles of modern femininity, not least because of her exoticism. Off-stage as well as on they each represented feminine sophistication, though at different levels of wealth. Between them they connected Australianness to the South Sea Islands, China and the Orient, and the mysteriously exotic, representing the ways in which Australian modernity participated in the global. As success stories of White Australia, they show its racial hierarchies to have been continually produced through imagined and feared connections with diverse parts of its Asia-Pacific regional location.

Chapter 1

Annette Kellerman

Mermaids and South Sea Islanders

Annette Kellerman was a swimmer, diver, vaudeville performer, lecturer, writer and a silent-film star.[1] The central motif of Kellerman's performances was a blend of the mermaid, the water nymph and the South Sea Islander, a modernist pastiche of the primitive and the exotic. Kellerman's significance now includes the ways she reflects both the modernity of the early twentieth century and contemporary understanding of Australia's geopolitical identity – its location in 'the South Seas'. She provides us with insight into cultural conceptions that underpinned Australia's emergence as a regional imperial power, not least Australians' stereotyping of Pacific Islanders as unsophisticated creatures of nature available for colonial purposes. From the turn of the twentieth century until the 1920s and later, Annette Kellerman's glamorous and much-publicised career placed Australian culture in the international spotlight, through an amalgam of the fit modern female body, her stamina and daring, and a shrewd use of the possibilities of the mass entertainment industry. Kellerman realised the potential of her swimming and diving performances as spectacle, and adapted them to the media of vaudeville and film, which complemented each other in these decades, even as film superseded vaudeville. Her career exemplified the transnationalism of vaudeville and film: an Australian performer whose success depended upon the national and international entertainment circuits, and in particular on London and New York as global capitals.

1 Annette Kellerman's surname was often spelled Kellermann during her career, even in one of her own publications. Yet by far the dominant spelling was Kellerman, so that is what I use here.

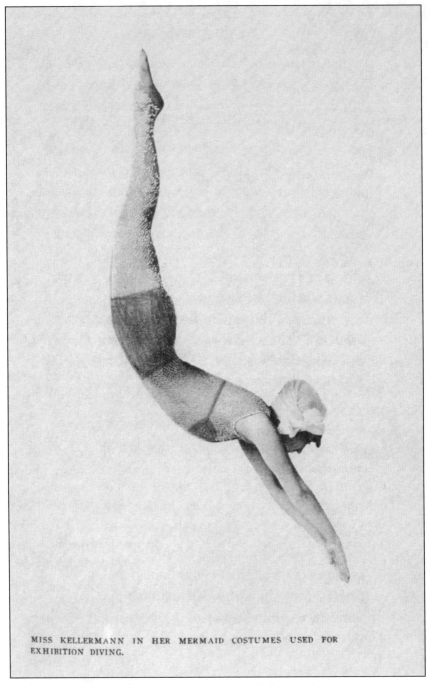

MISS KELLERMANN IN HER MERMAID COSTUMES USED FOR
EXHIBITION DIVING.

Annette Kellerman diving in a sheer swimsuit of silver scales

Source: Annette Kellerman, *How to Swim* (London: William Heinemann, 1918).

Kellerman's global celebrity (extending to American and Japanese literature) fused Australianness with a feminine modernity that had a bold edge, even as it was exoticised in a quasi-racial way. Her story gives us insight into the profound ways in which cultural understanding of the modern centred on the dramatic and embodied changes in women's behaviour – women's physical strengthening through sport and exercise, and their gradual discarding of restrictive and voluminous clothing, as well as their sexualisation and bodily display. But it also shows how cultural modernity was at once steeped in racialised imagery and thinking. This chapter traces Kellerman's life and career, before interpreting her contemporary significance and that of her iconic mermaids and exotic ingénues.

Annette Kellerman was born in Sydney on 6 July 1886, to parents who were both musicians: her mother Alice Charbonnet Kellerman was a pianist and ran a music school, and her father Frederick Kellerman taught harmony and played the violin. As an infant, Kellerman was crippled, probably due to rickets, a deficiency of calcium in the bones which can be caused by lack of dietary calcium or vitamin D, or lack of sunshine to produce vitamin D. Kellerman herself in later life blamed her parents: 'when I was a girl I was a cripple from calcium deficiency. So little was known about diet that my parents didn't think it was important to make me drink milk'.[2] Braces helped to straighten her bent legs, and based on that improvement, her doctor recommended swimming to develop further strength.[3] It was this recommendation that would lead to one of the most dramatic aquatic careers of the twentieth century. 'When I was a little Tot about six years old', she later wrote, 'Dad took me to Cavill's Baths, in Sydney, Australia, to learn to swim. Each day we walked with my brother and sister through the beautiful Botanical Gardens, with its wondrous view of the most famous harbour in the world, to our swimming lesson. I was awfully scared and did not learn quickly, but Mr. Percy Cavill, who was my teacher, never frightened me, so I soon lost all fear... Before I was

2 Lydia Lane, '"Ageless" Swimmer Gives Health Rules', *The Los Angeles Times* 9 April 1950, p. B9.
3 For brief biographical information on Kellerman, see G. P. Walsh, 'Kellermann, Annette Marie Sarah (1886 – 1975)', *Australian Dictionary of Biography*, Volume 9 (Melbourne: Melbourne University Press, 1983), pp. 548–9; Philip Parsons (ed.), *Companion to Theatre in Australia* (Sydney: Currency Press, 1995), p. 312; and Anthony Slide, *The Encyclopedia of Vaudeville* (Westport: Greenwood Press, 1994), pp. 285–287. Biographical sketches of Kellerman abound, though many are inaccurate. Kellerman herself commented: 'I have seen several biographies that are so far from the truth as to make them farcical'. 'My Story', Annette Kellerman Papers, ML MSS 6270 Box 1, Folder 3, State Library of NSW.

thirteen years old I was like a fish in the water... Later, in Melbourne, I was the first girl to swim – two, five and ten miles'.[4] By age fifteen, she would report, she had 'caught the mermaid fever'.[5]

Her first swimming training at Cavill's baths at Farm Cove in Sydney was indirectly connected to the Islander themes she would employ. Frederick Cavill was an English long-distance swimmer in the 1860s and 1870s who migrated to Australia in 1879, and pioneered the teaching of swimming with 'natatoriums' in several parts of Sydney Harbour. Frederick's six sons all participated in competitive swimming, variously in the United States and England as well as Australia, and it was they who introduced the 'Australian crawl' internationally.[6] Bathing in the harbour was integral to Sydney's cultural practices both before and after the arrival of the First Fleet. By the early 1830s, a particular spot in the harbour at the Domain was a favoured public swimming place with some special amenities, while soldiers had their own bathing-house in Darling Harbour.[7] Evidence shows that Anglo-Australian swimming strokes themselves were not purely imported from England but made critical advances through lessons from Indigenous swimmers. In 1854 an Aboriginal swimmer taught George Wallis the sidestroke, and the following year Wallis performed it in England. The 'trudgeon' stroke, which overtook the sidestroke in local popularity and was a forerunner of the butterfly, reputedly drew from 'the swimming style of the East Indies natives'. In the 1890s the trudgeon was superseded by what became known as 'the crawl', which some accounts claim was introduced to Sydney by brothers Harry and Alick Wickham, who were of mixed-race parentage from the Solomon Islands and presumably learnt it there. Sydney, Arthur and Dick Cavill all played a role in developing the crawl and introducing it to the United States. Syd Cavill recalled that his observations of a woman swimmer in Samoa, on his way to America in 1898, were crucial to his version of the stroke.[8]

4 Annette Kellerman, *Fairy Tales of the South Seas and Other Stories* (London: Sampson Low, Marston & Co., n.d. [1926]), pp. 11–12.

5 Annette Kellermann, *How to Swim* (London: William Heinemann, 1919), p. 16.

6 'Cavill, Frederick (1839–1927), *Australian Dictionary of Biography* Vol. 7 (Melbourne: Melbourne University Press, 1979), pp. 593–4.

7 'Bathing Under the Fig-Tree in the Domain', *Sydney Gazette and New South Wales Advertiser* 10 January 1833, p. 3.

8 Alan Clarkson, *Lanes of Gold: 100 Years of the NSW Amateur Swimming Association* (Sydney: Lester-Townsend Publishing Pty. Ltd., 1990), pp. 12–19.

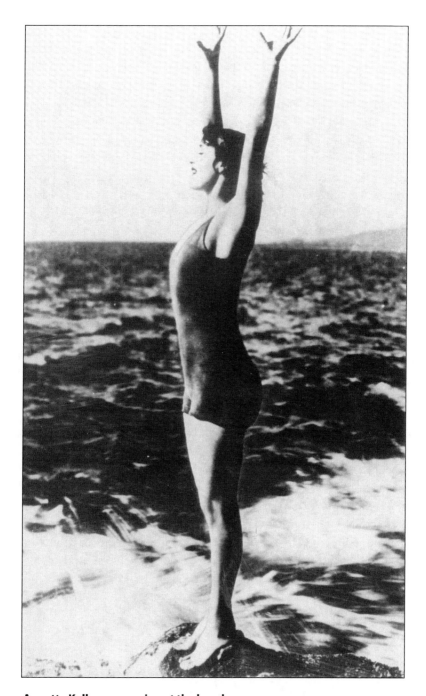

Annette Kellerman posing at the beach

Source: Papers of Annette Kellerman, MLMSS 6270, with permission of the Mitchell Library, State Library of New South Wales.

Accounts vary as to the relative importance of the Cavill brothers and Alick Wickham in 'inventing' the crawl stroke, yet all concur on the participation of both parties in its rise, and on the influence of Pacific Islands swimming practices.[9] It is unclear how much detail of the genesis of Australian swimming strokes Kellerman knew, though she credited the Cavills with starting the crawl.[10] She herself apparently continued to favour the trudgeon in her early years of long-distance swimming; later, she preferred what she called her 'six beat crawl'.[11] But there *is* evidence that she knew Alick Wickham: in February 1905 she swam five miles down the Yarra River, in a successful public event officiated at by swimming authorities from around Australia, including Wickham 'and other champion swimmers'.[12] In one of her books, Kellerman compares other 'savages' who only regard swimming as 'a utility' rather than 'a matter of recreation and pleasure' with 'the more highly developed sea folk of the South Pacific'.[13]

Perhaps even more significant to what would become her mermaid and islander performances was the pervasive turn-of-the-century Australian fascination with Islanders, and assumptions of their aquatic abilities; these assumptions were represented in the myth of the swimming 'nimble savage' which, according to Gary Osmond and Murray G. Phillips, led to the 'exotic island images and stereotypes' that appeared at swimming and surf carnivals.[14] Tellingly, in Kellerman's 1926 children's book *Fairy Tales of the South Seas*, the Scandinavian-born princess who lives on one of the Tongan islands is taught to swim and dive by 'the good native Vanu' who 'had been patient, never frightening her'.[15] This fictional allusion echoes a biographical fragment that *The Los Angeles Times* reported (presumably from her) in 1919: that in her childhood Kellerman had learnt swimming and diving '[u]nder the tuition of a Samoan pearl diver'.[16] Kellerman had a familial connection to the Pacific Islands as well. Her mother spent part of her childhood in New Caledonia, where her father (Annette's grandfather) Amable Charbonnet served as 'French Chief Justice of Overseas Possessions' in a position that took him around French colonies, including Algeria and French Indochina.[17]

9 Gary Osmond and Murray G. Phillips, '"Look at That Kid Crawling": Race, Myth and the "Crawl" Stroke', *Australian Historical Studies* No. 127 (April 2006), pp. 43–62.
10 Kellermann, *How to Swim*, p. 135.
11 Kellerman, 'My Story', Kellerman Papers, Box 1, Folder 3; Annette Kellerman, 'Swim in Your Own Home', *The Los Angeles Times* 22 March 1921.
12 'Miss Annette Kellermann's Latest Feat', *The Sydney Mail* 8 February 1905, p. 350.
13 Kellermann, *How to Swim*, p. 126.
14 Osmond and Phillips, '"Look at That Kid Crawling"', p. 44–45, 55–56.
15 Kellerman, *Fairy Tales of the South Seas*, p. 22.
16 'Stage Mermaid Doing Farewell', *The Los Angeles Times* 25 May 1919, p. III 15.
17 Letter from Amable Charbonnet to his mother 21 April 1867, Box 1, Folder 1; and Marcelle Wooster's biography of her sister Annette Kellerman, Box 1, Folder 4, Annette Kellerman Papers,

Whether or not she developed a liking for the water during her years in New Caledonia, Kellerman's mother claimed to have swum frequently, including the day that Annette was born.[18]

The small musical academy run in Sydney by Alice Charbonnet Kellerman and Frederick Kellerman apparently suffered financial strains due to the economic downturn of the 1890s. In 1901 Alice Charbonnet Kellerman moved to Melbourne, to take up a teaching position at Mentone High School run by the Misses Simpson (now called Mentone Girls' Grammar School). Annette stayed in Sydney with her father, while her younger sister Marcelle moved with her mother. In 1903 Annette and the rest of the family moved to Melbourne, where she began attending the school. Unlike her sister, who was dux of the school in 1903 and 1904, Annette apparently was uninterested in academic subjects, and even skipped examinations – becoming known as the 'rebel' of the school.[19] Instead Annette focused on her swimming, with family support and involvement. If family interest in Annette's swimming was first due to her health, the motivation shifted towards her competitive success, and then to her capacity to augment the family coffers. In her autobiographical account, Kellerman asserts that she had wanted to be an actress and dancer, but her father asked her to take up swimming and diving professionally to support the family – despite her mother's objection that it was not a respectable career.[20] At least one of her performances, in 1903 at the Theatre Royal in Melbourne, was billed as a family event, a 'diving exhibition' by 'the famous Kellerman family' as they had previously performed at Sydney's Coogee Baths.[21] Her father was an organiser of the first New South Wales Ladies' State Championship Swimming Carnival, held in 1901–02 at the St. George Baths in Redfern. This was an inaugural event for women's competitive swimming in Australia. Annette won two of the races, the one-hundred yards and the mile freestyle.[22] Such successes enabled her to build a career of competitive and performative swimming and

ML MSS 6270 State Library of NSW.

18 Kellerman, 'My Story', Kellerman Papers, Box 1, Folder 3.

19 Pauline B. Burren, *Mentone: The Place for a School: A History of Mentone Girls' Grammar School from 1899* (South Yarra: Hyland House Publishing, 1984), p. 20. I am grateful to Dr. Peter Wyllie Johnston for this reference. In the school's official history, Burren comments that Kellerman 'apparently shared her mother's flamboyant character and she was in no way typical of the girls who attended Mentone High School' (p. 21). Nevertheless, in recent years the school has built its Annette Kellerman Swimming Centre.

20 Kellerman, 'My Story', Kellerman Papers, Box 1, Folder 3.

21 Margaret Williams, *Australia on the Popular Stage, 1829–1929* (Oxford: Oxford University Press, 1983), p. 208.

22 'Women in the World', *The Australian Woman's Mirror* 6 December 1927, p. 20; Veronica Raszeja, *A Decent and Proper Exertion: The Rise of Women's Competitive Swimming in Sydney to 1912* (Campbelltown, NSW: Australian Studies in Sports History, No. 9, 1992), pp. 43, 87.

diving in Sydney, Melbourne, Adelaide and elsewhere. In Melbourne, she performed at the Exhibition building Aquarium, giving two shows a day 'in what was then the largest glass tank in the world – sixty feet – with fish swimming all about me'.[23] She also gave diving displays at Prince's Court, near Prince's Bridge on the Yarra River, and in April 1905 undertook a ten-mile swim down the river, a feat only accomplished twenty years previously by a man.[24]

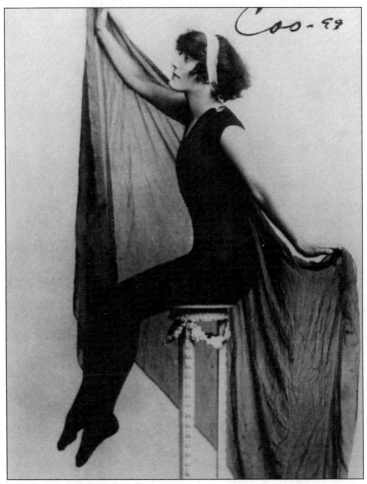

Annette Kellerman called 'Coo-ee' during performances in an assertion of her Australian identity

Source: Papers of Annette Kellerman, MLMSS 6270, with permission of the Mitchell Library, State Library of New South Wales.

23 Kellermann, *How to Swim*, p. 18.
24 Burren, *Mentone: The Place for a School*, pp. 21–22.

Kellerman's career was helped partly by the fact that swimming was just becoming a popular competitive sport, and partly by its underrepresentation of women – though other women swimmers competed against and followed her. Australian women became internationally recognised in the sport, particularly through Fanny Durack and Mina Wylie's medal wins at the 1912 Olympics in Stockholm – the first Olympic games to include women swimmers. Women swimmers, both at the beach and in competition, faced the dilemmas posed by modesty versus practicality in their attire. Kellerman would exploit these tensions, essentially by throwing Victorian notions of feminine modesty to the winds. To some extent, Kellerman's preparedness to appear in brief costumes may have been due to the customs of Australian women's early competitive swimming, where women wore costumes not too dissimilar to men's. Yet even there women were required to wear cloaks over their costumes before and after their races, for reasons of modesty; and from 1906 onwards male spectators were banned from the women's events, due not least to prominent feminist Rose Scott who insisted on segregation.[25] By then, Annette had left Australia, which was perhaps just as well because she did not shy away from male spectators.

In April 1905, with her father as her manager, she left for London, the imperial metropole.[26] At her departure she was considered Australia's 'best lady swimmer', who had won 'world-wide fame' through breaking records in Australia.[27] Kellerman's European career began with long-distance swimming. Her twenty-six mile swim down the Thames from Putney to Blackwall soon after they arrived in 1905 was a stunt her father suggested, as a way to grab publicity – and it worked. She swam for three and a half hours through what she remembered as oily water, amid tugboats and barges, but when she reached the Blackwall docks journalists, alerted ahead of time by her father, were there. Because of that swim, *The Daily Mirror* contracted Kellerman for eight weeks to swim five days a week from one seaside resort to another, between Dover and Margate, a total of about forty-five miles a week, as preparation for an attempt at the Channel – for eight guineas a week. Perhaps not surprisingly with that kind of training, she did well in a twenty-four mile race that summer from Dover to Ramsgate.[28] From England, she made trips to the Continent where she drew attention with long-distance swims, firstly in the Seine, and later the Rhine,

25 Raszeja, *A Decent and Proper Exertion*, pp. 65–66.
26 Kellerman's biographers place her departure in 1904, using her own words, but newspaper reports show it to have been 1905. Emily Gibson with Barbara Firth, *The Original Million Dollar Mermaid: The Annette Kellerman Story* (Crows Nest, NSW: Allen & Unwin, 2005), p. 21.
27 Caption of photo 'Annette Kellermann's Most Graceful Dive', *The Sydney Mail* 26 April 1905, p. 1044.
28 Kellerman, 'My Story', Kellerman Papers, Box 1, Folder 3.

and a 28-mile swim down the Danube. In the race down the Seine, in which she competed against seventeen men, she came third.[29] Kellerman made two attempts to swim the English Channel in July and August 1905.[30] Although she failed both times, due to bad weather and seasickness, she garnered international press attention as the first woman to attempt it.[31] It was not until 1926 that a woman (American Gertrude Ederle) successfully swam the channel.

The publicity from Kellerman's long-distance swims launched her into a vaudeville career, at first based on aquatic feats and acrobatics, later incorporating ballet, acting, lecturing, singing, cross-dressing and even high-wire walking. In London, she drew on performance strategies she had developed in Australia, but she was always refining and changing her routine. She performed at the London Hippodrome in the winter season of 1905–1906, as well as being invited to do special events, such as her performance at the elite Bath Club before the Duke and Duchess of Connaught. It was for this performance, under strictures from the club not to reveal her legs, that she sewed black stockings onto a boy's swimsuit, and first produced what would become her famous one-piece bathing suit. In 2006 the centenary of the one-piece swimsuit was celebrated, based on the story of Kellerman's first having worn it in a performance for King Edward VII in 1906; in fact the king himself was not at the Bath Club, though she was presented to Queen Alexandria at the Hippodrome.[32] Although Kellerman would enjoy huge success in films and would augment her performative career with lecturing, teaching and publishing books, the staple of her career from around 1905 to the 1930s was vaudeville – that vast, democratic circus tent that dominated live theatre in cities and towns from the 1890s. Indeed, in 1910, one American commentator reportedly dubbed her 'The Queen of Modern Vaudeville'.[33] At the end of her life Kellerman herself told a script-writer that 'I always hoped from early years to become a first class Vaudeville entertainer and for upward of 40 yrs [sic] I held my place in Vaudeville as top liner [sic] in all the big cities of the world'.[34] Her success was partly historically contingent: her career took off when vaudeville was at its height, and may have been helped by vaudeville's relative accessibility to women, both performers and audience.[35]

29 Kellerman, *Fairy Tales of the South Seas*, p. 13.
30 'Woman Tries to Swim Channel', *Chicago Daily Tribune* 27 July 1905; 'Fail to Swim the Channel', *Chicago Daily Tribune* 25 August 1905; 'Fails in Attempt to Swim Channel', *The New York Times* 3 September 1920, p. 14.
31 'Men and Women of the Hour', *Life* [Australia], 15 September 1905, p. 891.
32 'Celebrating one-piece of history', *The Sun-Herald* 20 August 2006, p. 27.
33 Slide, *The Encyclopedia of Vaudeville*, p. 285.
34 Undated letter to Colin Thompson, Kellerman Papers, Box 1, Folder 1.
35 Armond Fields, *Women Vaudeville Stars: Eighty Biographical Profiles* (Jefferson, NC: McFarland & Co., 2006), pp. 5–6.

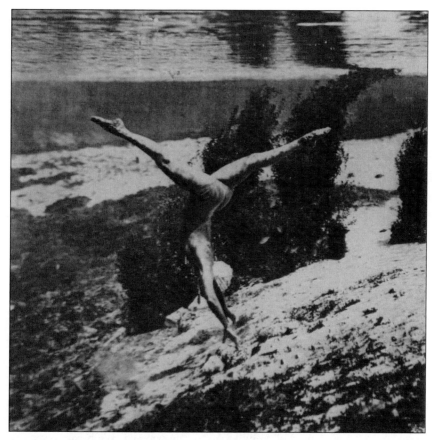

Annette Kellerman performing in an on-stage tank

Source: Papers of Annette Kellerman, MLMSS 6270, with permission of the Mitchell Library, State Library of New South Wales.

In 1906 she sailed from England to the United States to work in amusement parks, first in Chicago at White City Park where she performed multiple swimming and diving shows each day on one of the lots. She later recalled that Buffalo Bill had performed nearby on another lot.[36] From Chicago, she moved on to Wonderland amusement park in Boston at Revere Beach. During these early days while she was single and not yet a celebrity, she remembered, she spent 'many happy hours with friends – in "Back stage life"'.[37] Indeed, in 1909 she was named in a divorce suit. While working at Wonderland, she boarded with another worker there and his mother. Two years later, his wife, suing for divorce, explained that when Kellerman

36 Kellerman, 'My Story', Kellerman Papers, Box 1, Folder 3.
37 Kellerman, 'My Story', Kellerman Papers, Box 1, Folder 3.

boarded with Herbert Pattee and his mother, she and Pattee 'would sit for hours in the kitchen, drinking beer and eating crackers and cheese'. Pattee later asked his wife to allow Kellerman to live with her. It is unclear whether Mrs Pattee was alleging sexual involvement.[38] In 1907, records suggest, she performed in both Boston and Chicago: the *Chicago Daily Tribune* shows her at White City Park in the summer, from June to October.[39] In May 1907 White City's advertisement in the *Tribune* listed 'Annette Kellerman (The Water Nymph)' along with its other acts, including the 'Educated Flea Circus' and 'Mundy's Trained Wild Animal Arena'.[40] In July the paper advised its readers that: 'None should fail to see Miss Kellerman, as she is not only an expert swimmer but a beautiful woman, who is at her best in her bathing suit'.[41] In Boston Kellerman was approached by B.F. Keith, an impresario who ran a vaudeville circuit, and moved from amusement parks to vaudeville theatres: he offered her three hundred dollars a week for two shows a day.[42]

In 1907 she made headlines when she was arrested on Revere Beach itself (not the amusement park) for a swimming costume considered improper, again demonstrating her facility for gaining publicity to promote her career. Kellerman's version of events is that she planned to go for a three-mile swim, and walked down Revere Beach towards the water in her usual one-piece boy's racing suit. Others on the beach gathered around her with mixed reactions, and a policeman soon arrested her for indecent exposure. The following day Kellerman explained to the judge the impossibility of long-distance swimming in the cumbersome customary women's swimwear. The judge was sympathetic, but ruled that she must wear a beach robe over her swimsuit until she reached the water and entered it (not unlike the swimming carnivals in Australia). The story was covered in the press around the United States. Kellerman then designed what would become known in America and later in Britain as the 'Annette Kellerman suit': she wore a tight-fitting knitted stockingette tunic over the top of the boy's racing suit; according to Kellerman, other women immediately wanted the same thing.[43]

Mark Herlihy, in his study of the cultural contests staged over time at Boston's well-known Revere Beach, suggests that the incident occurred partly because Kellerman was already famous. Moreover, Revere Beach was historically a site of official attempts to regulate popular morality and

38 'No Affinity in Her Flat', *The Los Angeles Times* 13 March 1909, p. I 1.
39 *Chicago Daily Tribune* 2 June 1907; 16 June 1907; 28 July 1907; 2 August 1907; 4 August 1907; 17 October 1907.
40 Amusements, *Chicago Daily Tribune* 11 May 1907.
41 'The Biggest Day of the Year at White City Next Friday', *Chicago Daily Tribune* 28 July 1907.
42 Kellermann, *How to Swim*, p. 30.
43 Kellerman, 'My Story', Kellerman Papers, Box 1, Folder 3.

behaviour.[44] It is unclear whether Kellerman knew this when she was arrested there. Kellerman made the most of the swimsuit's sensational and erotic dimensions. Certainly her Boston arrest and the trial that followed attracted national and international publicity that helped to make her a household name. In her own defence, she repeatedly stated in public that it was a purely practical matter of wearing a bathing costume that enabled long-distance swimming; and she viewed Boston morality regarding women's beachwear as more conservative than in England. Over the years of Kellerman's career, women's bathing suits became more streamlined and revealing, a change to which she contributed though there were many other social and cultural factors. Kellerman became a byword for feminine daring and immodesty, in dress and behaviour. For example, in 1915 the *Ohio State Journal* expressed its relieved conviction that Ohio young women were exhibiting a return to relative conservatism in dress, and that they 'aren't going to go on an Annette Kellermann basis for a while yet'.[45]

Kellerman's argument to the judge about the practicality of swimsuits for long-distance swimming was grounded in her career plans; in both Chicago and Boston in these years she staged several such public feats. In Chicago, she 'created a new record from the government pier in Lake Michigan to Hyde Park crib, a distance of six miles', as well as doing a 72-foot dive from the topmast of a steamship. In Boston harbour she swam twelve miles 'from Charlestown bridge to Boston light', breaking 'all records for this course by a good half hour'.[46]

By November 1908, her fame in America was such that *The Boston Post* published a poem comparing her to the turn-of-the-century American icon of New Womanhood, the 'Gibson Girl':

No more the Gibson bathing girl
Shall grace the Newport summer whirl.
Annette declares her garment's wrong,
At both ends too extremely long.

The Gibson girl may be a peach,
As she perambulates the beach,
But now if in the 'swim' she'd be
She must with sweet Annette agree.

44 Mark A. Herlihy, 'Leisure, Space, and Collective Memory in the "Athens of America": A History of Boston's Revere Beach', PhD Thesis, Dept of American Civilization, Brown University, 2000; UMI Films, pp. 137–138.
45 'Returning to Conservatism', *The New York Times* 7 May 1915, p. 6.
46 'Annette Kellerman in a New Role', *Chicago Daily Tribune* 1 August 1909.

Her heavy skirt she must replace
With filmy raiment for the race.
Think you she will consent to dress
In such approach to nothingness?[47]

By 1911, the term 'Annette Kellermann suit' had entered American speech as the name for a style of swimsuit, a relatively form-fitting but kneelength one-piece tunic top worn with tights or shorter leggings.[48] In the 1920s, they were still called 'Kellermann suits' though they had become considerably more abbreviated, due to the iconoclastic ways of the flapper. In 1930, in a crackdown on the moral behaviour of bathers of both sexes, Coney Island barred 'bathing suits of the Annette Kellermann type', meaning those without skirts.[49] A 1934 piece on the history of women's sports attire saw Kellerman's role as pivotal in changing swimsuit fashions. Mildred Adams put it succinctly: 'When, in 1907 [sic], Annette Kellermann came over from Australia and played mermaid in the vaudeville houses from New York to San Francisco they found her free and careless grace exciting, though slightly shocking, and some of them went so far as to adopt her swimming suit… [though] most of her devotees put skirts over the "cheap, ordinary stockinette [sic] suit" until a good deal later'.[50]

Annette Kellerman used the fame she garnered from her swimming feats and swimsuit scandals to promote her vaudeville career of aquatic spectacle. Her recorded achievements as a swimmer and diver enabled marketing herself as a 'mermaid', which had the right kind of fanciful appeal for vaudeville. While others had preceded Kellerman in combining physical culture and vaudeville in a successful international career, such as the German-born strongman Eugen Sandow,51 she was one of the first women to attain such celebrity. Surviving film footage helps explain Kellerman's success: her inventive underwater ballet, the visual appeal of her trim and fit body in minuscule costumes, her extraordinary ability to stay underwater for minutes at a time, her athleticism and daring as a swimmer and diver were a powerful combination.[52]

47 'Bathing Suit Must be Cut', *The Boston Post* 7 November 1908, cited in Herlihy, 'Leisure, Space, and Collective Memory in the "Athens of America"', pp.138–9.
48 For example, 'Gimbels' department store advertisement, *The New York Times* 9 June 1911, p. 7.
49 'Coney Island to Ban "Petting" This Summer', *The New York Times* 13 May 1930, p. 28.
50 Mildred Adams, 'From Bloomers to Shorts: An Epic Journey', *The New York Times* 26 August 1934, pp. SM10, 17.
51 Caroline Daley, *Leisure & Pleasure: Reshaping & Revealing the New Zealand Body 1900–1960* (Auckland: Auckland University Press, 2003).
52 For example, 'Annette Kellerman Performing Water Ballet ca. 1925', Item 554, National Film and Sound Archive (Australia).

From January 1909, advertisements began appearing in the New York daily press for Kellerman's vaudeville performances there, beginning in early January in the Keith and Proctor house on 125th Street near Lexington Avenue. The first such advertisement billed Kellerman as a 'Peerless Performer with Form Divine', a 'Champion Woman Swimmer, in Daring Dives Into a Huge Tank'.[53] By late January, she was engaged at the Colonial Theatre, where she was billed as 'The Diving Venus', an epithet she used throughout her career.[54] It was a demanding and indubitably exhausting line of work; she later commented that many stars of her day had had a '[h]ard vaudeville background'.[55] At first her contracts were short term – just for two or three weeks. By late February, she had moved on to the Alhambra, and by late March, the American Music Hall on West 42nd Street.[56]

Her popularity was quickly apparent, however, evidenced by competing contractual claims on her, and the fact that by March 28th she was getting headline billing, even if in a small display advertisement.[57] The American Music Hall began to describe her as its 'star attraction' 'the Australian mermaid', with a 'lagoon stage setting' specially built for her.[58] By late April, she was back at Keith and Proctor's, this time heading the bill at their Fifth Avenue Theatre, and it was reported in the press in May that they were paying her $1,500 a week.[59] The press also reported some of the drama surrounding the legal proceedings resulting from the conflicting contracts she had signed with different managers, such as the 'exciting automobile chase down Broadway' on May 3[rd] when Kellerman sought to elude a clerk from the US Circuit Court trying to deliver an injunction on her.[60] It is unclear whether Kellerman and her manager James Sullivan (whom she would marry in 1912) were being avaricious or careless in signing conflicting contracts. It

53 In theatre advertisements, *The New York Times* 10 January 1909, p. X9.

54 'Theatrical Notes', *The New York Times* 23 January 1909, p. 5.

55 Kellerman interview with Michael Charlton, Kellerman Papers, Box 1, Folder 2.

56 'Vaudeville', *The New York Times* 28 February 1909, p. X10; Theatre advertisements, *The New York Times* 22 March 1909, p. 16.

57 'The Vaudeville Theatres', *The New York Times* 23 March 1909, p. 9; display advertisements, *The New York Times* 28 March 1909, p. X9.

58 'Vaudeville', *The New York Times* 28 March 1909, p. X8.

59 'The Vaudeville Theatres', *The New York Times* 27 April 1909, p. 11; 'Woman Diver Scored', *The New York Times* 11 May 1909, p. 4.

60 'Actress Leads Auto Chase; Annette Kellermann Barely Beats an Injunction in a Broadway Race', *The New York Times* 4 May 1909, p. 9; 'Woman Diver Scored; Neither She Nor Her Manager Regards a Contract', *The New York Times* 11 May 1909, p. 4; 'Her Dive into Tank was only a Faint: William Morris Blames Vaudeville Trust for the Swooning of Annette Kellerman', *The New York Times* 20 October 1915, p. 9. There is some detail on this episode in Emily Gibson and Barbara Firth, *The Original Million Dollar Mermaid: The Annette Kellerman Story* (Crows Nest, NSW: Allen & Unwin, 2005), pp. 79–84.

seems that her reputation was slightly sullied through this episode, with a judge proclaiming that neither she nor Sullivan 'has the slightest regard for business honor', but it did not hurt her popularity.[61]

Kellerman was a hit with the sizeable New York vaudeville audiences, a fact that was demonstrated in April 1909 when she was voted 'Queen of the Automobile Carnival'. This event, to be held on May Day, was designed as a celebration and promotion of cars, and the King and Queen of the Automobile Carnival were elected by popular vote. The election drew a large crowd of 'motor enthusiasts' to carnival headquarters on Broadway on the day of the final vote but, unlike the more closely contested race for the King, Kellerman was so much the front-runner for Queen – with more than 50,000 votes – that her victory was assured.[62] On the eve of the parade day, she and the King were given box seats at the Majestic Theatre for the special carnival performance of the Imperial Opera Company.[63] The parade itself, delayed a couple of days by the spring weather, included 310 cars, and was watched by around 200,000 people despite being held on a Monday afternoon.

Kellerman rode in a Buick that was built into 'an enormous float, surmounted by the dolphin and a large sea shell, with a playing fountain in the foreground'.[64] Her 'gown of shimmering green silk' and being seated on her sea-shell throne reflect the extent to which Kellerman's image as the mermaid and the diving Venus seems to have shaped her presentation even for the Automobile Carnival.[65] Buick presented Kellerman with 'a beautiful Cream coloured' car, because of which she learned to drive, and to match which she bought herself a white fur coat.[66] Apparently, she took this car with her on her tours: in August 1910 in Long Beach, California, she was reported as driving 'her own car, a dumpy, tan-colored little Buick' to and from her hotel.[67] Whether or not because of its modern symbolism and speed, at this point in her life Kellerman exhibited an affinity for the car. Beside her being Queen of the Automobile Carnival, and being witnessed in a car chase down Broadway to avoid the law once, in July 1909 Sullivan was arrested for speeding down Flatbush Avenue, while Kellerman, his passenger, pleaded that she was late for

61 It was not the last time she had a legal battle with a theatre manager. In 1913, she sued for salary and royalties. 'Splash! Splash! And Splash! Annette Kellerman Sues', *Chicago Daily Tribune* 8 February 1913.

62 'King and Queen of Carnival Elected', *The New York Times* 23 April 1909, p. 7.

63 'Volley of Hail Routs Soldiers', *The New York Times* 30 April 1909, p. 7.

64 'Carnival Parade Off Until Monday', *The New York Times* 1 May 1909, p. 7.

65 'Told Thousands of Auto's Universality', *The Automobile* Vol. XX, No. 18 (6 May 1909), p. 728.

66 Kellerman, 'My Story', Kellerman Papers, Box 1, Folder 3.

67 'No Swimming for Annette', *The Los Angeles Times* 28 August 1910, p. III 1.

work.[68] That her physical prowess was considered akin to modern technology is also suggested by her being likened to the '20th Century Limited', the fast train that ran between New York and Chicago, and the fact that her 1925 flight from Cleveland to New York in a 'Martin bomber' was reported in the press.[69]

In the summer of 1909, Hammerstein's Roof Garden was completely renovated: instead of its previous farm theme, it was transformed into a recreation of 'the bathing beach at Atlantic City' and the 'lake which in former years has been filled with ducks and other water fowl [was] made larger and deeper to represent the Atlantic Ocean'. A wave generator was installed to provide the illusion of surf, and Annette Kellerman was billed as a special attraction each evening.[70] By early 1910 Gertrude Hoffmann, another vaudeville performer who had a successful routine of imitating well-known performers, included an imitation of Kellerman in her act, with the assistance of 'a dozen beautiful girls'. Kellerman herself increasingly relied on a troupe of other women performers to augment her own act; she came to call them 'the Kellerman Girls'.[71] Hoffmann's 'attempt at appearing as Miss Kellermann is made a rough and laughable burlesque, in which some remarkable diving is done with the aid of not at all invisible wires. This particular part of the act ends with a riot of merriment by the girls, who, in black tights, dive from a springboard and slide down an inclined plane into a pool of water.'[72] It is unclear whether Maud and Gladys Finney who performed underwater as diving 'Mermaids' in a Keith's Theatre program in Columbus, Ohio, in February 1910 were members of Kellerman's troupe, inspired by her, or perhaps competitors – but a program for their tour carried an advertisement for Kellerman's correspondence course on women's health.[73] Kellerman later complained that around this time she was 'being copied all over the country'.[74]

68 The speed for which he was arrested was all of thirty miles per hour. 'Miss Kellermann in Speeding Auto', *The New York Times* 29 July 1909, p. 4.
69 'A New "Century" Dictionary' [advertisement], *The New York Times* 19 August 1909, p. 4; 'Miss Kellermann Flies: Makes Trip From Cleveland to Curtis Field in Five Hours', *The New York Times* 14 September 1925, p. 17.
70 'Farewell to "The Old Farm"', *The New York Times* 13 May 1909, p. 7; 'At the Theatres and Roof Gardens', *The New York Times* 25 July 1909, p. X7.
71 Kellerman, 'My Story', Kellerman Papers, Box 1, Folder 3.
72 'Miss Hoffmann's New Act', *The New York Times* 1 February 1910, p. 7.
73 Program for Keith's Theatres, Columbus, Ohio 1909–10, week of 28 February, Ephemera Collection, Petherick Reading Room, National Library of Australia.
74 Kellermann, *How to Swim*, p. 31. She was probably aware in 1909 that 'Little Elsie [who] swims like a mermaid and looks like a peach' was performing at White City Park where she had worked. *Chicago Daily Tribune* 25 July 1909. Her films would be imitated later too. 'The Spice of Life... News and Gossip of the Playhouses', *The Los Angeles Times* 14 May 1919, p. III 4.

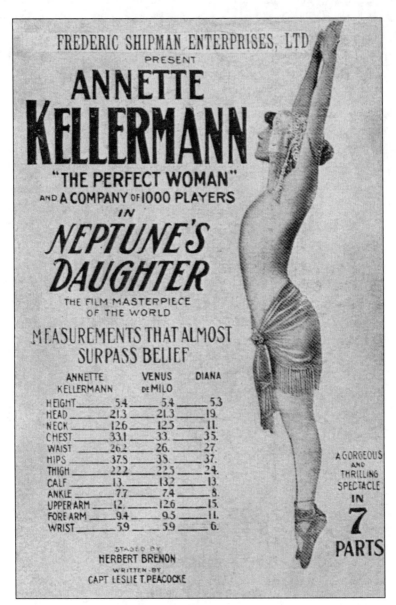

Annette Kellerman, 'The Perfect Woman'

Source: NLA.PIC-AN22948275, David Elliott Postcard Collection, with permission of the National Library of Australia.

In 1910 Kellerman herself toured the United States, performing in places from Chicago to the west coast.[75]

An event in 1910 helped to promote her career, in a way that she would slightly exaggerate for the rest of her life. Dr. Dudley Allen Sargent, the Director of the Harvard University Gymnasium, undertook a study of the figure of the 'modern woman'. He studied the 'physical proportions' of ten thousand women students, in order to address what was perhaps a contemporary anxiety, the question whether women were becoming more masculine. He allayed this concern, concluding that while women's proportions had indeed changed over a period of twenty years or so (presumably as a result of their increased physical exercise), it was a change for the better. Having seen Kellerman perform, he invited her to Harvard in order to measure her in detail, and also to display her to women students as a model of the benefits of exercise.[76] 'The American woman of to-day is becoming more like the Greek ideal of the beautiful', he declared. 'She substitutes harmonious curves and symmetry for exaggeration of the distinctly feminine characteristics'. *The New York Times* reported that, while Dr. Sargent had not found any one man or woman to have what he claimed to have calculated as the perfect proportions and figure, Annette Kellerman was 'nearest to a perfectly proportioned woman'. The paper printed details of his measurements of Kellerman including, for example, her weight of 137 pounds, her standing height of 64.5 inches, and the 'girth' measurements of everything from her head and neck, to her chest, ribs, waist, and even her thighs, knees, calves, ankles and instep.[77]

For Kellerman, this was invaluable advertising material. Her self-promotions for decades to follow would include references to her having been 'scientifically' shown to be 'the perfect woman'. Moreover, the publicity sparked by the Harvard study spurred competitors. In one instance, in 1913, Mrs G. E. Magee, a 'professor of physical culture' at the University of California, Berkeley, proclaimed that Miss Yarlock Lowe, a Chinese-American student and 'the only person of her race in the College of Law', was 'the most perfect specimen of young womanhood that has entered the university for a number of years'.

75 'In the Theaters', *Chicago Daily Tribune* 11 December 1910; *Chicago Daily Tribune* 21 December 1910.
76 Kellerman, 'My Story', Kellerman Papers, Box 1, Folder 3.
77 'Modern Woman Getting Nearer the Perfect Figure', *The New York Times* 4 December 1910, p. SM4.

MISS KELLERMANN IS AN EXAMPLE OF FULL BODILY
DEVELOPMENT APPROXIMATING THE "IDEAL RATIO OF
FEMININITY."

Frontispiece from *Physical Beauty and How to Keep It*

Source: Annette Kellerman, *Physical Beauty and How to Keep It* (London: William Heinemann, 1919).

PHYSICAL BEAUTY

HOW TO KEEP IT

BY

ANNETTE KELLERMANN

Illustrated

LONDON: WILLIAM HEINEMANN

Frontispiece from *Physical Beauty and How to Keep It* (continued)

Source: Annette Kellerman, *Physical Beauty and How to Keep It* (London: William Heinemann, 1919).

Mrs Magee used detailed measurements of Annette Kellerman's body to compare Miss Lowe's, all of which were published in the *Los Angeles Times* report, with the conclusion that Lowe's proportions were 'just as exquisite'.[78]

Kellerman published books on fitness and beauty for women, presenting herself as an expert on as well as exemplar of the healthy, modern female body. Soon after her American vaudeville career was launched, she published an article on 'Swimming as a Sport for Women' in the August 1909 issue of the magazine *Recreation*.[79] Over the years, her instructions to novices on how to swim would appear in various newspapers. In 1910 a book by Edwin Tenney Brewster, published by Houghton, Mifflin, and titled *Swimming*, aimed to be an advanced instruction manual for amateur swimmers. Its frontispiece was a photograph of Kellerman diving. Later, she would publish not only more articles but her own books, such as *The Body Beautiful* in 1912, and *How To Swim* and *Physical Beauty – How to Keep It* both in 1918. Not a feminist in political terms, Kellerman cast her advice as how women could improve their health, become freer and happier, and thus more equal to men.

As early as 1909 if not before, some of Kellerman's public performances included lectures on fitness, health and beauty. In August 1909, at the Brighton Beach Theatre, she lectured on 'How to Swim' and 'How to Keep in Condition'.[80] At least some of these lectures were restricted to women audiences, such as that in San Francisco in mid-1910, because, according to Kellerman, 'I had to rip my gown to pieces to show [the women] that I was not padded'.[81] By early 1910 she was advertising her correspondence course on women's health.[82] Public lectures on health later merged with a part-time career as private instructor. In November 1912, Kellerman began advertising private tuition for anyone seeking to 'Reduce or Increase Your Weight – Improve Your Health – Perfect Your Figure'.[83] Perhaps she hoped that giving private lessons (an early form of what we would call 'personal training') would generate a sufficient income stream to allow her to reduce her vaudeville routine, which must have been taxing. Her advertisement united fitness and beauty, promising:

78 'Chinese Girl Rivals Annette Kellerman', *The Los Angeles Times* 9 September 1913, p. I 4.
79 'Among the Magazines', *The New York Times* 24 July 1909, p. BR456.
80 'Vaudeville', *The New York Times* 15 August 1909, p. X7.
81 'No Swimming for Annette', *The Los Angeles Times* 28 August 1910, p. III 1.
82 Program for Keith's theatres, Columbus, Ohio 1909–10, week of 28 February, Ephemera Collection, Petherick Reading Room, National Library of Australia.
83 Advertisements, *The New York Times* 3 November 1912, p. PS7.

Become my pupil and I will make you my friend. Devote but fifteen minutes daily to my system and you can weigh what Nature intended. You can reduce any part of your figure burdened with superfluous flesh or build up any part that is undeveloped... My system stimulates, reorganises and regenerates your entire body. My latest book, "The Body Beautiful", should be read by every woman, and *I will send it to you free*. It explodes the fallacy that lack of beauty or health cannot be avoided. In it I explain how every woman can be vigorous, healthy and attractive.[84]

Much the same advertisement, always with an image of her svelte form in profile, appeared regularly for at least three years, with an address on West 31st Street.

There is no record of how great a response or how many pupils she received, though she would later boast that 'over forty thousand women have been benefited by her system of exercise and diet'.[85] In her story of her life, she claimed: 'I have lectured to over half million women [sic] in the world (In five different languages)'; apparently fluent in French because of her mother, she learned only enough of the other languages to perform.[86] In 1912 *The New York Times* reported, with a humorous undertone, that a prominent Tammany Hall politician Richard Croker was 'undergoing a course in physical culture' prescribed by Kellerman, a key part of which was vegetarianism.[87] By August 1914, Kellerman had an arrangement with Gimbels department store on Broadway, under which they used her name for a line of sweaters, and a young woman from the 'Annette Kellermann School of Physical Culture' modelled current fashions.[88]

As Kellerman's reputation developed, she sought both more control of her acts and more elaborate vehicles for them. In late 1911 at the Winter Garden on Broadway, she first introduced 'Undine', a one-act pantomime set in twelfth-century England – a medieval setting that reflected Kellerman's ability to use traditional imagery for her modernist turns. As would be true of her films, the plot was selected because it enabled her to perform her feats in the water; this time in 'a fanciful idyll of forest and stream'.[89] In this case, though the sketch

84 Advertisements, *The New York Times* 3 November 1912, p. PS7.
85 'Annette Kellerman's Deauville Season', *New York Herald* n.d, Folder of Photos, Postcards, A. Kellerman papers, MS. 9669, National Library of Australia.
86 Kellerman, 'My Story', Kellerman Papers, Box 1, Folder 3.
87 'Croker in Training, But Breaks Rules', *The New York Times* 4 June 1912, p. 4.
88 Advertisement for Gimbel Brothers, *The New York Times* 23 August 1914, p. 16. Other product endorsements would include bathing suits and caps.
89 'Theatrical News Notes', *Chicago Daily Tribune* 21 February 1912.

was written by someone else, the story had an autobiographical element: it revolved around an aristocratic daughter with an unknown illness, the noble father offering a reward for a cure, and 'Undine' the 'water nymph' effecting it.[90] But there were new dimensions: the act was set to music, and it included ballet, with several dancers. Kellerman herself 'in white fleshings... did a toe dance with considerable skill' prior to her diving act.[91] When the show had been running over two months, Kellerman added a song to her own part of the act.[92] Presumably, her musician parents had nurtured some musical ability, and she had had music, elocution and ballet lessons as a child; to these she added ballet lessons from the ballet master at the Metropolitan Opera House.[93] Critical opinion was that the show had 'caught the popular favor and seem[ed] to be assured of a long run'.[94] Indeed, it ran in New York for at least three months, then she took it on a national tour.

In the summer of 1912 Kellerman took 'Undine' to the Oxford Theatre (and later the Palace Theatre) in London. *The British Australasian* reported that, 'supported by an attractive company of [thirty] girls', Kellerman 'gives a very pretty dancing scene', followed by 'a wonderfully graceful exhibition of fancy diving into a large tank', and a lecture on 'Health, Beauty and Happiness' at the end of the performance.[95] Part of the favourable comment Kellerman drew in London focused on 'the skin-tight bathing suit that clothes her graceful form', a constant element of her act that perhaps seemed less novel by then in New York.[96] In the autumn of 1912 she took 'Undine' back to New York, as part of an agreement between the London Palace and the New York Fifth Avenue Theatre for exclusive exchanges, prior to a tour of American cities.[97] By August 1913, 'Undine' had evolved into 'Annette Kellerman, The Perfect Woman, And her Dancing Girls, in "The Wood Nymph" A Classical Aquatic Entertainment'.[98]

By November 1913 Kellerman announced that she had decided to turn to the more legitimate theatre, and to give up vaudeville – but instead of the theatre, her new medium became film.[99] Kellerman's vaudeville success

90 'Society at Home and Abroad', *The New York Times* 12 November 1911, p. X1.
91 'Lively Operetta at Winter Garden', *The New York Times* 21 November 1911, p. 9.
92 'Theatrical Notes', *The New York Times* 25 January 1912, p. 11.
93 Kellerman, 'My Story', Kellerman Papers, Box 1, Folder 3.
94 'At Other Playhouses', *The New York Times* 26 November 1911, p. X1.
95 *The British Australasian* 23 May 1912, p. 23 and 30 May 1912, p. 23.
96 *The British Australasian* 6 June 1912, p. 23.
97 'Proctor in London Alliance', *The New York Times* 9 September 1912, p. 9; 'Annette Kellermann Back', *The New York Times* 13 September 1912, p. 9.
98 Program for the Southend Hippodrome, week of 25 August 1913, Ephemera Collection, Petherick Reading Room, National Library of Australia.
99 'Annette Kellermann Here With Play', *The New York Times* 13 November 1913, p. 11.

lent her the profile and credibility for a foray into the early film industry. In fact she appeared in at least three minor films as early as 1909.[100] Her first major film was *Neptune's Daughter*, made by the Universal Film Company, with a script based on Kellerman's own idea though written by a seasoned professional. It was filmed in Bermuda in late 1913 and early 1914, and released as soon as May that year. It was reported that 'the Bermuda colony' was excited by the arrival of the film company, because the rumour had spread that when the ship docked Kellerman would 'make an unconventional landing by diving from the stern of the liner', but to their disappointment she simply walked down the gangplank.[101] An early press report said Kellerman would play 'the role of the wife of Neptune, wantoning with a United States naval officer on the hot coast of a South Sea island', though the plot shifted.[102] Kellerman plays a mermaid who becomes a human being to avenge her sister's death, then falls in love with the island's king and becomes embroiled in politics and intrigues. Like all her films, the plot was a secondary consideration. The primary purpose was for her to perform as many stunning feats of diving and underwater swimming as possible. A brief critical comment in the press noted that 'Miss Kellermann [being] hurled from a sixty-five foot cliff into the water bound hand and foot is one of the stirring scenes'.[103]

Neptune's Daughter screened in New York for months, but by December 1914 she was back on the vaudeville stage there, now earning $2,500 per week.[104] The film was shown around the world: by March 1915 it was being screened in Sydney, where it was described as 'A Spectacular Photo Play' and 'A Marvellous Fantasy of the Sea'.[105] In Chicago, when the film opened in May 1914, 'several thousand people congregated in front of that playhouse [the Fine Arts theatre] and tried to get in'; the waiting crowd 'extended in a double row north far past the Chicago club'. Not only did Michigan Avenue have 'a carnival aspect' but police were called in, while some of the crowd waited for hours.[106]

100 These 1909 films were titled 'The Bride of Lammermoor, a Tragedy of Bonnie Scotland', 'Adele's Wash Day' and 'Miss Annette Kellerman' and were made by the Vitagraph Co.; listed in the Catalog of the American Film Institute.

101 'Bermuda Gayeties, Balls and Dinners', *The New York Times* 24 December 1913, p. 11.

102 'Facts and Comments About the Stage and Its People', *Chicago Daily Tribune* 17 August 1913.

103 'In the Busy World of the Movies', *The New York Times* 10 May 1914, p. X5.

104 Advertisement for B.F. Keith's Palace Theatre, *The New York Times* 6 December 1914, p. XX4; and Kellerman, 'My Story', Kellerman Papers, Box 1, Folder 3.

105 Program for Palace Theatre, Sydney, Ephemera Collection, Petherick Reading Room, National Library of Australia.

106 'Annette Kellerman in Pretty Pictures', *Chicago Daily Tribune* 18 May 1914. The film was shown in Chicago until at least the end of the year.

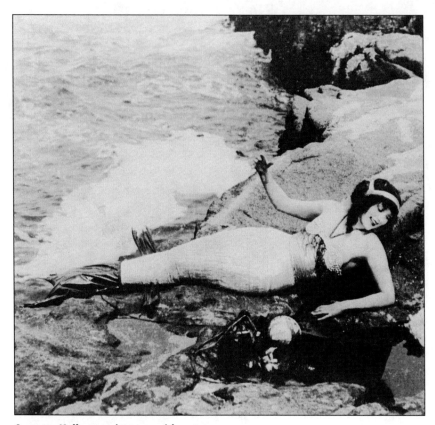

Annette Kellerman in mermaid costume

Source: Papers of Annette Kellerman, MLMSS 6270, with permission of the Mitchell Library, State Library of New South Wales.

Central to *Neptune's Daughter* was Kellerman's blatant bodily display. Apparently at one point, where Kellerman's mermaid character has taken on human shape, she 'is seen in the woods undressing, and later flitting white and nymphlike among the trees en route to the ocean for a swim'.[107] Because of the nudity, failed attempts were made to ban the film in places ranging from Ontario, California (by the Woman's Christian Temperance Union),[108] to the Australian bush. The film's distributor in western New South Wales later recorded an incident in one bush town where he took the film on its travelling roadshow. Although 'the whole township turned out' for the film on its first night, someone in the audience complained

107 'Annette Kellerman in Pretty Pictures', *Chicago Daily Tribune* 18 May 1914.
108 'All Excitement Over Pictures', *The Los Angeles Times* 20 May 1915, p. II 9.

to the police constable. The police sergeant, however, was on duty at a neighbouring town. The constable 'sent a tracker out to tell the sergeant that we were displaying a lady clad only in a fish tail'. The sergeant rode back into town, looked at the posters advertising the film, then took a seat in the front row, but let the film run. The nervous distributor finally approached the sergeant, to ask what he intended to do. The sergeant replied that he intended to come back the next night to watch the film from the beginning. It turned out that his daughter had gone to school with Kellerman in Sydney and even swum with her.[109]

That first silent film was followed by several more, confirming Kellerman's status as an international star, particularly with the box-office success of the 1916 *A Daughter of the Gods*. Produced by the William Fox Company and written and directed by Herbert Brenon (who had directed *Neptune's Daughter*), *A Daughter of the Gods* made news even before it was released, because of its million-dollar costs, a vast budget in 1916. Filmed in Jamaica from August 1915 to April 1916, it incorporated the spectacular on several levels. Reports of it during filming included the note that ten camels had been shipped from Connecticut, where they were in winter rest from the circus, down to Kingston, Jamaica, to be used on the set.[110] It was claimed that 'the largest stage in the world' had been constructed for the set, and that it was 'equipped with dressing rooms for 2,000 players'.[111] A 'gnome village' was built around a waterfall constructed by changing the local topography, and 'native children' were used to play the gnomes.[112] Another report was that twenty thousand people had been used in one scene, and that a Moorish city had been built of steel and concrete for one background, then set on fire as part of the film's drama.[113] Moreover, it was credited with the first nude scene to be made on film, though in at least some scenes Kellerman actually wore a flesh-coloured body-suit designed to look as though nude.[114] Late in life, Kellerman rated *A Daughter of the Gods* as the 'best thing' she ever did, because she 'did many hair raising stunts & was never doubled – including doing a 72 ft dive from a tower – being thrown to the crocodiles'.[115]

109 Munchausen Mullagitawny, 'When the Sergeant Saw Annette!", *The Picture Show* 20 September 1919, pp. 16–17.
110 'Written on the Screen', *The New York Times* 16 January 1916, p. X6.
111 'Written on the Screen', *The New York Times* 19 December 1915, p. X11.
112 'Written on the Screen', *The New York Times* 12 March 1916, p. X10.
113 'Annette Kellermann Returns', *The New York Times* 19 April 1916, p. 11.
114 Kellerman, 'My Story', Kellerman Papers, Box 1, Folder 3.
115 Undated letter [ca. 1974] to Colin Thompson, Kellerman Papers, Box 1, Folder 1.

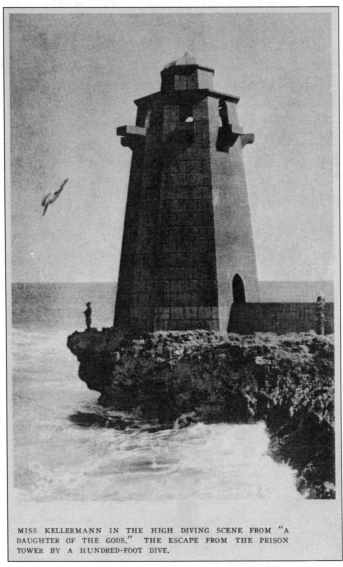

MISS KELLERMANN IN THE HIGH DIVING SCENE FROM "A DAUGHTER OF THE GODS." THE ESCAPE FROM THE PRISON TOWER BY A HUNDRED-FOOT DIVE.

Annette Kellerman dives from a tower in *A Daughter of the Gods* (1916)

Source: Annette Kellerman, *How to Swim* (London: William Heinemann, 1918).

While the film was large on spectacle, its plot reportedly came adrift, and as a result it took extensive editing which delayed its release. Even when completed, the plot seems to have been rather vague: a loose Orientalist fantasy involving a sultan, a sheik, a prince, a harem, a witch, a land of gnomes, and Kellerman as 'Anitia' who dances before the sultan and escapes capture by her dive from the tower into the sea. The reviews were not unqualified. One described it as 'a fanciful thing in which fairies, gnomes, and mythological characters appear'.[116] At least one reviewer disapproved of the nudity, describing the film as: 'a photoplay carefully calculated to shock the late Anthony Comstock and certain to please many others. There are long passages when Miss Kellermann wanders disconsolately through the film all undressed and nowhere to go... This business is carried rather far in the life in the palace of the Sultan where the picture suffers so from overexposure that you can scarcely say "A Daughter of the Gods" is merely released. It is positively abandoned'.[117] However, most reviews raved in superlatives about the film's spectacular effects (if not the plot) and described it as not to be missed. It was given substantial promotion. One advertisement, invoking the Harvard study, compared Kellerman's statistics with those of Cleopatra and Venus de Milo, proclaiming Kellerman the 'Most Perfect Woman in World's History' and as 'a model for all the world' before whom 'criticism is dumb'.[118]

A Daughter of the Gods played in Australia, as elsewhere around the world, largely to positive reviews – though one jaundiced critic claimed that several of the young women competitors at the January 1917 New South Wales Ladies' Swimming Association competition at the Domain Baths 'far surpassed' the one being hyped as 'the most perfect woman in the world'.[119] The film was such a phenomenon that *The Green Room*, which called itself *Australia's Greatest Stage Magazine*, ran features on it for months ahead of its arrival. The first was in August 1916, a three-page spread with five photographs, including one of the seemingly nude scenes, understatedly captioned 'A Striking Study of Annette Kellermann'. The article began with a list of 'Facts About the Film', including its unprecedented million-dollar cost, Kellerman listed as the 'star of the greatest motion picture spectacle ever seen', its elaborate infrastructure ('a city of more than 20,000 employees grew where a few hours earlier there had been nothing but tropical undergrowth'), and the fact that the 223,000 feet of film shot had been edited down to 12,000

116 'The New Plays', *The New York Times* 15 October 1916, p. X6.
117 'Kellermann Film Shown at the Lyric', *The New York Times* 18 October 1916, p. 9.
118 Advertisements, *The New York Times* 20 November 1916, p. 11.
119 *The Triad* n.s. 2 (10 February 1917), p. 6.

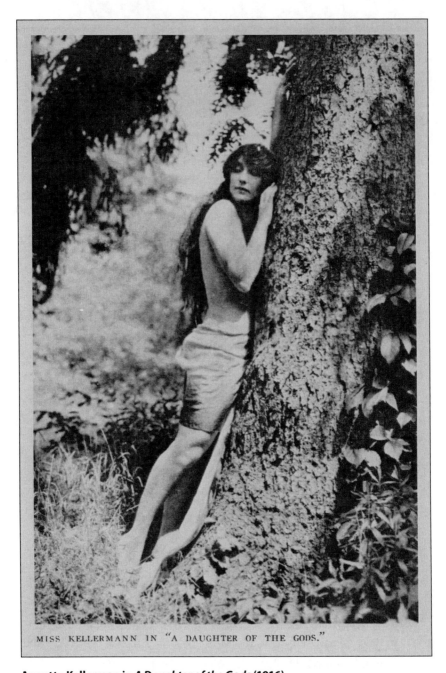

MISS KELLERMANN IN "A DAUGHTER OF THE GODS."

Annette Kellerman in *A Daughter of the Gods* (1916)

Source: Annette Kellerman, *Physical Beauty and How to Keep It* (London: William Heinemann, 1919).

feet for the picture.[120] The magazine reminded readers (as if they needed it) that the star was 'the well-known Australian', and lauded her as 'the greatest woman swimmer in the world, a graceful, creative genius' whose work 'in this new spectacular film will leave behind for all time a wonderful record of her daring attainments'.[121] The magazine sought to encapsulate the plot (for which readers may have been grateful), mentioning its mermaids and ocean scenes.[122]

Consecutive issues carried more stills from the film. One article focused on William Fox, the producer, and his summary of his ambitions for the film: 'I will make a picture so gigantic, so immense in its scope, that not in the next ten years will there be a man – manufacturer, or financier – who will dare to expend so vast an amount of money on a single picture. All my life I have dreamed of doing something big... I have dreamed of doing something that perhaps cannot even be paralleled in the future. The realisation of my dream is found in "A Daughter of the Gods"'.[123] After the film was finally screened in Australia in January 1917, the magazine gave it overwhelming praise. Not only did 'Annette Kellermann, the swimming Venus' add 'thrill to thrill', in one scene she seemed 'to achieve the impossible'. In sum, *The Green Room* judged:

> Anyone who misses seeing "A Daughter of the Gods" misses one of the greatest events that has ever happened in Australia. From the far-away sphere of the Unknown we are immediately borne, by this film, to a land of enchantment. Something of the wonder of the Arabian Nights, of the glory of the East, of our own war, of fairyland, of womanly power and eternal beauty, is manifested to us by this masterpiece of cinematography.[124]

Again, Kellerman soon returned to vaudeville, though the success of *A Daughter of the Gods* enabled her to demand large and expensive sets, modelled on the film. To accommodate their new top bill, who was to replace the star dancer Anna Pavlova (with whom Kellerman became friends), the New York Hippodrome built an eight-foot high steel tank in four sections, with a front of plate glass.[125] Kellerman called this production her 'big mermaid

120 'Annette Kellermann's Latest Success – A Movie Triumph – A 1,000,000 Dollar Fox Film', *The Green Room: Australia's Greatest Stage Magazine* 1 August 1916, p. 2.
121 'Annette Kellermann's Latest Success', *The Green Room*, pp. 2, 4.
122 Ibid., p. 4.
123 'A Daughter of the Gods – In Story and Picture', *The Green Room* 2 October 1916, p. 12.
124 'New Productions at the Sydney Theatres', *The Green Room* 1 February 1917, p. 9.
125 'What News on the Rialto?' *The New York Times* 24 December 1916, p. X5.

IT WAS IN THE TRAINING OF THE MERMAIDS THAT MISS KELLERMANN DEVELOPED THE NECESSITY OF TRAINING THE SWIMMER TO USE THE ARMS ALONE.

Annette Kellerman and other actresses in mermaid costume

Annette Kellerman, *How to Swim* (London: William Heinemann, 1918).

spectacle'.[126] Dressed in what would become perhaps her most iconic outfit, a sheer and near-transparent full-length swimsuit of silver scales, Kellerman's act was augmented by a setting like 'a veritable Niagara in cloth, canvas and electric lights' studded with 'wood nymphs, alligators, crocodiles, frogs' and mermaids in 'translucent pools'.[127] Although it is unclear whether she or her employer paid the expenses, another indicator of Kellerman's status that New York winter was that she rented a large ice-skating rink for her exclusive use for a session each day, in order to develop her skating skills.[128]

Her next films were *The Honor System* (1917) and *Queen of the Sea* (1918), which was also made by Fox. *Queen of the Sea* was shot in 1917 on a smaller budget than *Daughter of the Gods*. Kellerman herself was observed scouting the public swimming pool at Palisades Park in New York for potential mermaid talent.[129] The filming locations included the

126 Kellermann, *How to Swim*, p. 34.
127 'Diving Act at Hippodrome', *The New York Times* 23 January 1917, p. 7.
128 'The Movies', *The New York Times* 7 January 1917, p. X8.
129 'Flashes from Movieland', *The New York Times* 22 July 1917, p. 66.

US this time, at Bar Harbour in Maine. It was reported that watching 'Miss Kellermann and her school of mermaids disport themselves in the ocean' had become a daily local activity with more than '200 automobiles of every size and power from the lowly flivver to the costliest custom built machine' parked along the beach, and that 'the spectators are not women'.[130] The film included the usual aquatic feats, and some scenes were filmed in various parts of the Caribbean. As in *Neptune's Daughter*, Kellerman plays a mermaid who takes on mortal form and eventually marries her prince, and again the plot involves a tower, though this time her enemy is the 'king of the storms'.[131]

Kellerman tried to inject some excitement, particularly in one scene where she dived from a wire sixty feet up into the sea – an astonishing feat considering she did not employ stuntmen for her acts. But, despite some praise for the cinematography and a few positive reviews such as one in London in 1920,[132] in the US the film was compared negatively to *Daughter of the Gods* and seemed to suffer from aquatic spectacle fatigue. One reviewer commented that *Daughter of the Gods* 'exhausted Miss Kellermann's film possibilities, and the present picture can do little more than duplicate the tricks of the other'.[133] Yet again, once the film was made, she returned to the vaudeville stage, in New York and around the US; in 1917 and 1918 she also participated in patriotic concerts to raise funds for the American Red Cross and the war effort. One such event at the Metropolitan Opera House was the occasion of a performance that she rated as one of her lifetime best achievements: her ballet tribute to Pavlova's dying swan, conducted by Toscanini.[134] In 1920 she released two films, *What Women Love*, a comedy which poked fun at beachwear moralisers and was an attempt to break away from aquatic spectacles though it included swimming and diving, and one billed as 'educational', a slow-motion film called *The Art of Diving*, apparently intended as one of a series aimed to instruct women in health and exercise.[135] In 1924 she released her last proper film *Venus of the South Seas*. Her film career ended with the rise of talkies, to which she failed to make a transition, despite at least one attempt.

130 'Film Flashes', *The New York Times* 2 September 1917, p. 42.
131 Film record of 'Queen of the Sea', American Film Institute Catalog.
132 'Films of the Week', *The Times* 1 January 1920, p. 10.
133 'Annette, Queen of the Sea', *The New York Times* 2 September 1918, p. 7.
134 Undated letter to Colin Thompson, Kellerman Papers, Box 1, Folder 1.
135 'Screen People and Plays', *The New York Times* 24 October 1920, p. X2; Grace Kingsley, 'Annette Forms Company', *The Los Angeles Times* 6 September 1919, p. II 3.

Following her 1920–21 tour of the United States on the Orpheum vaudeville circuit, Kellerman made a highly successful, long vaudeville tour of Australia and New Zealand in 1921 and 1922, when vaudeville was still popular, prior to being eclipsed by cinema.[136] It was her first return home to Australia since her departure for England in 1905, a lengthy absence due in part to the fact that her family had since moved to Paris. Australians were very proud of their international star, her films (especially *A Daughter of the Gods*) were successful locally, and her career was tracked and narrated in the Australian media. Kellerman's Australasian tour was handled by J.C. Williamson, an experienced theatrical impresario. But Kellerman's needs presented the Williamson company with a challenge. They had planned to stage her Sydney show as the first act at the new Theatre Royal, but her cast was so numerous and her swimming tank so large that 'although relays of men were kept working night and day' it became impossible to finish enough of the building. On short notice, they had to contract with another impresario Harry Musgrove for her to perform at the Tivoli Theatre.[137]

The program reflects the meshing of vaudeville and cinema that preceded cinema's dominance and vaudeville's demise. Musgrove advertised that there would be 'photoplay novelties' along with Annette Kellerman's 'Big Show of Vaudeville de Luxe'. Kellerman's routine had become quite diversified. There was 'The Kellerman Ballet' with ten women dancers; Kellerman's dance solo 'The Sea Nymph'; the 'Kellerman Girls' in 'Breakaway Dance Specialty'; Kellerman herself in 'A Little Chat and the Bounding Wire Dance'; and 'The Little Tin Soldier' sung by Kellerman and others, which all preceded Kellerman in her famed 'Aquatic Specialty'.[138] The *Sydney Mail*'s review was enthusiastic: 'Her dancing is an important feature of the entertainment; she is a raconteur; she does exciting things on a wire rope; she is a clever impersonator; and her crystal tank display is quite unique, including some sensational diving from a high springboard'.[139] Kellerman's sister, Marcelle Wooster, recalled that while she was in Sydney, Kellerman rented a house at Point Piper; from Sydney, the company toured to Melbourne, Adelaide,

136 On the transition from vaudeville to cinema, see Richard Waterhouse, *Private Pleasures, Public Leisure: A History of Australian Popular Culture Since 1788* (South Melbourne: Longman, 1995), pp. 175–6.

137 'Annette Kellerman To Open at Tivoli Theatre', undated flyer, Ephemera Collection, Petherick Reading Room, National Library of Australia.

138 'Rickard's Tivoli. Harry G. Musgrove Presents Annette Kellerman', program in Ephemera Collection, Petherick Reading Room, National Library of Australia.

139 Quoted in 'Champion swimmer on Tivoli screen and stage', Katharine Brisbane (ed.), *Entertaining Australia: An Illustrated History* (Sydney: Currency Press, 1991), p. 192.

Hobart, Auckland, Rotorua (where Annette was warmly received by Maoris), Wellington, Christchurch, Dunedin, Invercargill and Nelson. Kellerman included physical culture elements in her shows on this tour, Wooster recalled, and 'she had the Antipodes women and girls doing ups and downs'.[140]

For Australians, Kellerman's appeal would have included their pride in her international stardom. Her exemplification of swimming and the ocean also resonated with the growth of beach culture in Australia, an identifiable phenomenon from the beginning of the twentieth century. As Australians embraced their urbanness, they also embraced the seaside settings of their cities. Swimming and sunbathing at the beach were considered celebrations of Australia's environmental riches, and emblems of Australian health and vigour, for both women and men. Kellerman was therefore something of a cultural ambassador, showing one of Australia's great resources to the world. In 1919 an Australian commentator suggested that American debates about appropriate swimwear for women, such as had occurred when several actresses in beach attire were arrested at Coney Island, would not happen in Australia, where beach behaviour was more casual and more about the pleasures of the sea. The American 'good folk who occupy beach chairs and mayoral offices would be overcome at sight of the Australian surf girl plunging in unshod, unstockinged, and wearing the mythical neck-to-knee'.[141]

Kellerman attained such iconic cultural status that as early as 1913 she became a figure used in literature – and would appear even in Japanese literature. American writers F. Scott Fitzgerald and Jack London both deployed her. In his 1920 novel *This Side of Paradise*, Scott Fitzgerald referred to her in passing to set the stage for a beachside incident in which a modern young woman dares a man to do a high dive just as she does. Kellerman and the female character together represent the audacity and challenge of modern women.[142]

Jack London used her in two different works, *The Valley of the Moon* (1913) and *The Little Lady of the Big House* (1916). As in Scott Fitzgerald, Kellerman represents the modern woman who combines fitness, beauty and accomplishment. In the 1913 work London has one of his characters, in a long romantic speech to his lover, tell her she's even more beautiful

140 Marcelle Wooster, Typescript biography of Annette Kellerman, Kellerman Papers, Box 1, Folder 4.
141 "'Splash Me, Girls!" Illustrating some of the swimming costumes that the stars are wearing', *The Picture Show* 18 October 1919, p. 14.
142 F. Scott Fitzgerald, *This Side of Paradise* (New York: Charles Scribner's, 1920), p. 189.

than Kellerman: 'Say, d'ye know you've got some figure? Well, you have. Talk about Annette Kellerman. You can give her cards and spades. She's Australian, an' you're American, only your figure ain't. You're different.'[143] London's serious interest in Kellerman is more apparent in the 1916 novel, where the female protagonist Paula Forrest is overtly like Kellerman. London's heroine is a swimmer and diver of extraordinary ability, whom other characters compare with Kellerman, and like Kellerman she wears a revealing swimsuit. Andrew Furer argues that London created a series of 'New Women' heroines, of whom Paula Forrest is the third, all of whom represented remarkable physical fitness and daring, a physical liberation that was matched by their intellectual abilities and demands for social and economic, though not sexual, freedoms.[144]

Perhaps the most intriguing literary invocation of Kellerman is in the 1924 novel *Naomi* by Japanese writer Junichiro Tanizaki.[145] Tanizaki, who is sometimes cited as one of Japan's most important twentieth-century

Annette Kellerman being officially welcomed in Atlantic City, New Jersey

Source: Papers of Annette Kellerman, MLMSS 6270, with permission of the Mitchell Library, State Library of New South Wales.

143 Jack London, *The Valley of the Moon* (1913; New York: Macmillan, 1928), p. 129.
144 Andrew J. Furer, 'Jack London's New Woman: A Little Lady With a Big Stick', *Studies in American Fiction* Vol. 22 No. 2 (Autumn 1994), esp. 201.
145 Junichiro Tanizaki, *Naomi* ([1924]; New York: Vintage Books, 2001), p. 29.

novelists, used Kellerman to represent the ideal modern female body. In September 1919 Kellerman announced plans to travel to Japan as part of a world tour. On the tour, she would make films on the subject of exercise for women, and show those she had already made. She wanted to go to Japan in particular because 'Japanese women… she says, are constantly writing her regarding health exercises', but it is not clear if in fact she went.[146]

Naomi, apparently semi-autobiographical, is the story of a 'modern' couple in 1920s Japan, and their engagements with Western culture; it was considered both sensational and influential in Japan. The narrator details his relationship with the younger Naomi (he was 28 and she 14 when they met), to whom he is attracted because he thinks she is vaguely Western looking and he likes to shape her in Western ways. His shaping of her includes encouraging her to wear Western clothing, makeup and hair styles, teaching her to speak English, and also to dance. But the modern was very much about her physical posture, and its sexual connotations:

> We'd seen a movie called Neptune's Daughter, about a mermaid, starring the famous swimmer Annette Kellerman. 'Naomi', I said, 'let me see you imitate Kellerman'. She stood up with her arms straight over her head and showed me her 'diving' pose. As she stood with her thighs together, her legs, so straight there was no space between them, formed a long triangle from her hips to her ankles.

In another scene, shortly after this one, the narrator describes going to the theatre in the evening with Naomi, in a dramatic satin kimono and matching jacket, in contrasting reddish brown and light blue:

> She wore this outfit most often when we went to the theatre in the evening. Everyone turned to look as she walked through the lobby of the Yurakuza or the Imperial Theater in that glistening fabric.

> 'I wonder who she is?'

> 'An actress, maybe?'

> 'A Eurasian?'

> Hearing the whispers, we'd move proudly toward them.[147]

146 Grace Kingsley, 'Mermaids to go Cameraing', *The Los Angeles Times* 14 September 1919, p. III 1.
147 Tanizaki, *Naomi*, pp. 38–9.

For Tanizaki, both Kellerman and Eurasian women represented visual spectacles of female modernity. Kellerman's modernity, in his view, was cosmopolitan.

Women were at the centre of the Japanese conundrum of whether modernity was necessarily Western. As Kendall H. Brown has put it, 'the modern girl… sporting pumps, short dress, bobbed hair, and conspicuous in such modern spaces as cafes and urban streets – represented, at the least, an enchantment with the material surface of Western modernity. She also held the promise or threat of cultural and sexual liberation'.[148] Vera Mackie has recently studied the 'moga', the Japanese version of the 'Modern Girl' in the 1920s. 'Moga' was the term for young women who represented modernity, both as consumers – of clothes, cosmetics, cigarettes and films – and as spectacles to be consumed. Such young women wore clothes that were fusions of East and West, and they were linked to the erotic. They were Japanese women with a Western flavour, which meant that, like Naomi, they could be considered racially ambiguous.[149] Thus, in 1920s Japan, Kellerman represented the archetypal modern Western woman, yet she could also be linked to racial uncertainty. Such linking was at least partly the product of Kellerman's own playing with racial categories, as well as her trading on the erotic dimensions of her acts, despite her chaste personal behaviour.

Racism, racial hierarchies and ethnic stereotyping were staples of popular culture in the late nineteenth and early twentieth centuries – in literature, on stage, and in the early film industry. Vaudeville relied on racist stereotypes for much of its humour and entertainment, and it included performers from a range of cultures and countries. In New York in 1910, for example, one vaudeville act included 'a troupe of Hindus and Cingalese', most likely men.[150] Orientalism saturated most cultural forms in this period, with representations promiscuously drawn from places ranging from Egypt to Japan, and along with many other performers Kellerman availed herself of the range in both her live and film productions. Kellerman's films drew on racial imagery, but loosely. *A Daughter of the Gods* included scenes representing Rome, 'an Eastern kingdom', and a 'Sultan and his harem of Oriental beauties', yet employed local Jamaican people for all of its extras

148 Kendall H. Brown, 'The "Modern" Japanese Woman', *The Chronicle of Higher Education* 21 May 2004, p. B19.
149 Vera Mackie, 'The Moga as Racialised Category in 1920s and 1930s Japan', in L. Boucher, J. Carey and K. Ellinghaus (eds.), *Historicising Whiteness: Transnational Perspectives on the Construction of an Identity* (Melbourne: RMIT Publishing, 2007).
150 'Miss Hoffmann's New Act', *The New York Times* 1 February 1910, p. 7.

and crowd scenes.[151] Perhaps because of this use of racialised imagery, she was herself described as possessing 'exotic beauty'.[152]

In particular, Kellerman, in repeatedly casting herself as a mermaid in order to feature her aquatic performances on film, played with the identity of South Sea Islander. Mermaids and Polynesian women were at times used to represent each other in early twentieth-century cinema.[153] While Kellerman never took the role of an indigenous Polynesian or Melanesian woman, in several films she cast herself as outside Western civilisation, as having been born and brought up in the south Pacific, and as being a better swimmer and diver than the islanders themselves, particularly the men. Following all of her mermaid and exotic ingénue films of the 1910s, in the early 1920s she planned to shoot a series of films on location in the South Seas.[154] It seems that the only one to eventuate was her 1924 film *Venus of the South Seas*, which was directed by her husband James Sullivan and presumably written by the two of them. Kellerman plays an innocent island girl who has no knowledge of proper European culture and its ways. Nevertheless, she charms a visiting wealthy young yacht-owner by her innocence as well as her physical prowess. Her innocence is epitomised by the scene which comes closest to the sexual, in which he chases her through the woods after she has swum ashore from the yacht, and is hence scantily clad and dripping wet. These film roles combined the ingénue, the primitive and the erotic in quintessentially modern figures that played with racial boundaries through drawing on long-established tropes of sexually available South Sea Island beauties.

A central element of Kellerman's modernity was gender transgression. Her fitness, strength and bravery were all masculine traits that she allied with her very obviously feminine sexual appeal. Her early fame rested on the strength and stamina required for long-distance swimming. Her diving had always excited audiences by its daring and grace as well as the other physical risks that she took. Her films carried the Kellerman trademark of aquatic feats requiring bravery and endurance – from long swims underwater, to wrestling with villains in the water, beating others to the underwater treasure, and trouncing the foes of her romantic lead, as well as her iconic dives from high towers, or wires (she had learnt high-wire walking), or into

151 'Annette Kellermann's Latest Success', *The Green Room* p. 4.
152 'STAE [sic]: Plays Hold Over', *The Los Angeles Times* 25 May 1919, p. III 13.
153 See, for example, Patty O'Brien, *The Pacific Muse: Exotic Femininity and the Colonial Pacific* (Seattle: University of Washington Press, 2006), p. 243.
154 'Flashes', *The Los Angeles Times* 6 June 1921.

alligator-infested water. Jennifer M. Bean suggests that Kellerman was one of a cohort of female stars in film's formative years in the 1910s whose 'heroic personhood' was created through their being '[a]gile and dauntless, ready to swim, race, fly, dangle, and fall for the sake of the screen'. In silent films including 'mystery-crime films, western adventures, slapstick comedies, jungle safaris, [and] deep-sea spectacles' women stars took risks, narrowly avoided (and sometimes met with) danger, and displayed a range of athletic abilities. The high dramas and extravagant sets favoured in these years sought to create a realism that would distinguish film from live theatre, and according to Bean, the risks taken by stars were all the more exciting when it was a supposedly more vulnerable female star's body in the way of harm.[155] Silent film's drive for plots with disorder and danger, then, was another historically contingent reason for Kellerman's success: her singular fame as a swimmer and her stamina and willingness to perform perilous feats were key ingredients in her rise to fame.

Annette Kellerman cross-dressing as 'the English Johnny' in a vaudeville routine

Source: Papers of Annette Kellerman, MLMSS 6270, with permission of the Mitchell Library, State Library of New South Wales.

155 Jennifer M. Bean, 'Technologies of Early Stardom and the Extraordinary Body', *Camera Obscura* 48, Vol. 16 No. 3 (2001), pp. 10, 14.

Kellerman had occasional accidents, news of which added to her reputation for bravery. In England early in her vaudeville career, she dived into an on-stage tank with which she was unfamiliar and shallower than she expected, hitting her head, and rising to the top with a severe gash that required stitches. On location for her first film, when she was hurled into the water, she hit her head, surfaced unconscious and had to be rescued. Also during the filming of *Neptune's Daughter*, in February 1914, the glass side of the tank in which she was performing ruptured, and she was washed out through the broken glass; both she and director Herbert Brenon were seriously injured.[156]

In July 1916, when there were several fatal shark attacks on New Jersey beaches, *The Washington Post* commissioned Kellerman to write a major article on the dangers of shark attacks, the behaviour of sharks, and what to do if one saw a shark in the water. Her authority as an expert on sharks included not only being 'the leading woman swimmer in the world', and familiar with 'the shark-proof inclosures of the Australian bathing beaches', but also having seen sharks and other dangerous fish up close on her film locations.[157] If brave feats and risks were traits identified as masculine even while she wore her famously brief costumes, from around 1920 she played overtly with gender boundaries. She developed a new item in her vaudeville routine, in which she cross-dressed as an elegant top-hatted and monocled gentleman, called 'the English Johnny'; it was a particular hit at her 1936 performances in Winnipeg, Canada, where as elsewhere she was compared to the renowned vaudeville cross-dresser Vesta Tilley.

Kellerman was one actor in an early-twentieth century performance genre that combined spectacle, physical feats and the exotic, both live and on film. With their success related to the huge transnational interest of the time in physical culture, performers included body builders like Eugen Sandow, the highly successful stuntman Houdini (with whom Kellerman sometimes shared a program), and the series of actors who played Tarzan, not least the swimmer Johnny Weismuller. Even lesser-known performers combined fitness and stunts, such as Arthur Cavill, one of the swimming Cavill family who had launched Kellerman's career. Arthur Cavill left Australia and moved to the US as a swimming coach. But he also, for example, swam across the bay at Tillamook, Oregon, with his hands and feet tied, and had himself lowered from a bridge in Pittsburgh tied in a bag. He died attempting to

156 'Annette Kellerman Hurt When Glass Tank Bursts', *Chicago Daily Tribune* 4 February 1914.
157 Annette Kellermann, '"Stockade" to Protect the Beaches from the Man-Eaters', *The Washington Post* 16 July 1916, p. ES3.

swim across Seattle Harbour in very cold weather.[158] And Alick Wickham, who participated in developing the Australian crawl around 1900, later had a performance career with events such as his 'Exhibition of Trick Swimming by a South Seas Islander'.[159]

Locating both exoticism and eroticism in the Pacific was, of course, a practice with long cultural roots in Australia and elsewhere, and the primitive was a central trope of high modernism. South Sea myths were revived in Western culture both prior to and then because of Gauguin's powerful influence in the late nineteenth century.[160] In the 1910s and 1920s, the 'South Sea Islands' were a favoured setting and theme for film-makers. In 1921 Arthur Shirley, for example, made a film called 'The Throwback' which was billed as 'a story of the South Sea Islands'; one publicity photo showed Shirley's 'leading lady' and three-year-old son dressed in recognisably Pacific accoutrements of grass skirt, beads and floral emblems.[161] Another 1921 film titled *Under Crimson Skies* was advertised as a 'red-blooded drama of the South Seas' that allowed the viewer to 'feel the sting of the salt sea spray against your face'.[162] From 1907 onwards, journalist and novelist Beatrice Grimshaw's prodigious works did much globally to popularise romantic representations of the South Seas, such as her 1922 novel *Conn of the Coral Seas* that was made into the 1928 film *The Adorable Outcast*. As they had in European culture since the eighteenth century, in these films the South Seas represented both escape and being marooned, the possibilities of paradise and damnation, beauty and treachery, and nature untouched by civilisation, in melodramatic plots.

Kellerman contributed directly to the cultural preoccupation with 'the South Seas', primarily from 1914 onwards through her island and water-themed films, but also with her writing. The stories in her 1926 children's book *Fairy Tales of the South Seas and Other Stories* had titles such as 'The Beachcomber and the Princess', 'The Sirens of the South Seas', 'The Vampire of the Coral Seas', 'Under the Southern Cross', 'The Enchanted Pearls' and 'Shipwreck Island'. Protagonists of the tales ranged from 'Gunta the Beachcomber' to 'Valeur the Pearl Dealer', 'three young brothers' from Cooktown, Queensland, a 'cannibal chieftain' on an island off New Guinea, Christine the ship captain's daughter, Hina the 'native' girl, a mermaid,

158 Clarkson, *Lanes of Gold*, p. 24.
159 Osmond and Phillips, '"Look at That Kid Crawling"', p. 57.
160 O'Brien, *The Pacific Muse*, pp. 216–226.
161 *The Picture Show* 1 March 1921, p. 27.
162 *The Picture Show* 1 March 1921, p. 67.

Margot the stowaway, and King Neptune. In another book Kellerman fantasised about her hope one day to see a real mermaid 'sitting on a damp grey rock combing her long green hair'.[163] Kellerman's playing with the category of South Sea Islander extended to including Australianness within it. For example, in *Fairy Tales of the South Seas*, the map showing 'the South Sea Islands' includes Australia, New Zealand, New Guinea, the Solomon Islands, Fiji, Samoa, the Cook Islands and Tahiti.[164]

The South Seas theme was a direct connection between Jack London and Kellerman, and probably one of the reasons for his interest in her. He too was one of the main producers of the contemporary South Seas cultural genre. London was a Californian political radical and writer, who based much of his writing on his own explorations and adventures – to both Alaska and the south Pacific. London's 1906–09 voyage to Hawaii, the Solomon Islands, New Guinea, Fiji, New Zealand and elsewhere became the basis for his 1911 memoir *The Cruise of the Snark*, a significant body of short stories such as the 1911 collection *South Sea Tales*, and three novels including *Jerry of the Islands* (1917). London's travels in the 'South Seas' also inspired other works, such as his wife Charmian's 1915 *The Log of the Snark*, and Martin Johnson's *Through the South Seas with Jack London* (1913).[165] Martin Johnson became well known himself as an 'explorer' and film-maker of the 'South Seas'. A crew member on Jack London's South Pacific voyage, Johnson's first film was the 1912 documentary *Jack London's Adventures in the South Seas*. A later film was titled *Among the Cannibals of the South Seas*.

In 1919, Johnson was described in the Australian press as the 'world-famed explorer, scientist, who daily risks his life for the films'. He was in Sydney preparing for a journey to Papua, the New Hebrides and the Solomon Islands, the point of which was to 'film the unexposed mysteries of the jungle man-eating savages', and which was described as 'perpetuating the work that Jack London began'. He told the reporter that he was setting off on this three-year expedition because 'I am anxious to go to the South Sea Islands because it is the nearest place to paradise on God's earth'.[166] Johnson's juxtaposition of cannibalism, savagery and paradise reflected the

163 Kellermann, *How to Swim*, p. 37.
164 Annette Kellerman, *Fairy Tales of the South Seas and Other Stories* (London: Sampson Low, Marston & Co., n.d. [1926]), opposite p. 46.
165 Biographical and bibliographic information is available at the Jack London Online Collection, http://london.sonoma.edu/ including a biographical sketch by Clarice Stasz. [Accessed 1 June 2008.]
166 'Martin Johnson and his Wife, Explorers, Go to Conquer Cannibals with a Camera', *The Picture Show* 10 May 1919, pp. 18–19.

metaphorical extremes united in contemporary representations of the Pacific. Rod Edmond contends that Jack London's representations of the Pacific foreground disease and violence, which he uses to condemn colonialism, racism and exploitation of the islanders by Westerners.[167]

In the first decades of the twentieth century these early films (as well as the books) thus promoted a transnational cultural understanding of the 'South Sea Islands' as a remote place, where primitive 'savages' lived in jungles and on islands, close to nature and amidst both wildness and beauty. The 'South Seas' also represented a place where Westerners could be dominant 'explorers', 'scientists' and 'film-makers'. Kellerman added to this repertoire of images with her diving and swimming ingénues and mermaids, a mix of innocence and sexuality, romance and exoticism, and aquatic feats. Australians were as much a part of this transnational imaginary construction of the 'South Sea Islands' as vaudeville and film audiences elsewhere, despite their geographical proximity. Yet their imaginations, and those of other film audiences, also conceived other locations in terms of wildness and exoticism. In 1919, for example, Australian cinema audiences could also watch locally made and racially charged dramas of the bush, with titles such as 'Through Australian Wilds' and 'A Romance of the Burke and Wills Expedition'.[168]

Throughout her life and career, Kellerman identified herself as Australian, such as by using the Australian bush call 'Coo-ee' in her performances, as well as a method of locating another Australian in a crowd.[169] Reportedly, Kellerman also maintained an Australian accent. Esther Williams observed that Kellerman's only hesitation about Williams representing her in *Million Dollar Mermaid* was that she was not Australian.[170] Kellerman saw herself as a natural product of Australia, because 'Australia occupies first place in the development of swimmers. There is no other country in the world that can boast of a greater number of good swimmers in proportion to size and population'.[171] Australians returned the affection. In 1916 a magazine editor proclaimed: 'This beautiful girl, who has done as much to advertise Australia,

167 Rod Edmond, 'Skin and bones: Jack London's diseased Pacific', Ch. 7 in his *Representing the South Pacific: Colonial Discourse from Cook to Gauguin* (Cambridge: Cambridge University Press, 1997).

168 Advertisement for films made by the Austral Photoplay Co. Ltd., an Australian film studio. *The Picture Show* 24 May 1919, p. 27.

169 One reported story is that she used 'Cooee' at a Los Angeles wharf to meet a visiting Australian stranger. 'Australians in the Studios', *The Picture Show* 4 October 1919, pp. 18–19. Moreover, apparently Kellerman called her dog 'Cooee'.

170 'Beauty who swam in the big pool', *The Sydney Morning Herald* 14 April 2004.

171 Kellermann, '"Stockade" to Protect the Beaches from the Man-Eaters'.

as all the information bureaus combined, is Australian through and through, and always will be, no matter how many the years which separate her from the land of her nativity'.[172] In 1919 an enthusiastic Australian reviewer of *Queen of the Sea* commented: 'with Annette Kellerman as the star, it must appeal to audiences here even more than it does to those elsewhere. To be able to say: "She's ours, she's Australian", is to give ourselves a very big reason for seeing and enjoying the film'.[173]

A core element of Kellerman's modernity was her nudity and near-nudity (including her use of flesh-coloured tights). Vaudeville paraded women's bodies as part of its popular appeal, one reason that it was considered a faintly vulgar form of entertainment. Following vaudeville, the rise of burlesque and striptease took women's on-stage nudity even further in the direction of scandal and the demimonde. Bodily display and nudity on stage and film were pervasive in the early decades of the twentieth century, drawing audiences more than they alienated them. Kellerman was part of the more daring world of silent film, prior to the film censorship that quickly followed the introduction of talkies. Yet there was also debate about the moral and artistic values of such display. In 1917, the Australian theatre magazine *The Green Room* ran articles discussing the issue, arguing for nudity's integral role in art, in painting, sculpture and on stage – and claiming that allowing titillating glimpses of women's limbs was invoking sex in a way that artistic nudity did not.[174] While these articles did not mention Kellerman specifically, their appearance following the Australian debut of *A Daughter of the Gods* cannot have been coincidental. Rather, they seem to be supporting Kellerman's claims to the artistic merit of her nude scenes. On the other hand, in 1921 the London *Times* complained that the British Board of Film Censors 'cannot have paid very careful attention when they gave [*What Women Love*] their sanction for exhibition'.[175]

Kellerman sought to balance the shock and titillation of her bodily display with the respectability of her athleticism and career as an expert in physical culture. Kellerman's respectability was shored up by the vegetarianism (by which she meant avoiding red meat) that was part of her physical culture methods. By casting herself as a fitness guru, and a record-winning champion, she repeatedly claimed that her immodest swimsuits

172 'An Australian Venus' Hints on Swimming', *The Green Room* 2 October 1916, p. 17.
173 'Annette Kellerman Triumphs', *The Picture Show* 27 September 1919, pp. 18–19.
174 'Naked Girls on the Stage', *The Green Room* 1 February 1917, p. 5; 'Is it Rude to Pose in the Nude? The Decline of Art and the Development of Modesty into Wowserism', *The Green Room* 1 June 1917, pp. 1–2.
175 'The Film World', *The Times* 15 August 1921, p. 6.

were a matter of practicality. Invoking Venus and mermaids placed her bodily exposure in the fanciful realm of mythology, thus claiming an ancient cultural legitimacy. She urged other women to swim and take up other forms of physical exercise, for their own health and vitality. Though Kellerman's message was one of liberation, as well as modernity, she was (as mentioned earlier) not a feminist; for example, her arguments for women to exercise included their need to stay physically attractive to their husbands, because '[a]ll our religion and all our morality has failed to keep men good'.[176] But she also advocated abandoning corsets, and wearing less restrictive clothing. In the publicity surrounding *A Daughter of the Gods* in 1916, she boasted:

> I have taught a hundred mermaids who appear with me in many scenes
> of the picture to do with ease things they never dreamed of attempting
> before… These feats of modern mermaids are always followed with
> great interest by the public, for they bring fresh evidence of the splendid
> influence which the growing popularity of swimming is exerting upon
> the feminine sex.[177]

She believed that she could assist others to achieve health and fitness, and therefore greater vitality and happiness. Physical beauty would be the result of health and fitness, she promised: 'I insist that swimming is not only a splendid sport for women but that it is *the* sport for women', the one in which they could compete with men on equal terms.[178] While Kellerman was influential because of her visibility, in turn she succeeded because her message resonated with her times. Women were becoming more interested in exercise; from around 1909 onwards, fashion began to emphasise the slim figure; and her vaguely women's rights message echoed the first-wave feminism that was so prominent, without actually taking a provocative feminist stance.

Kellerman had become a celebrity early in her career with her long-distance swimming, and her vaudeville and then film careers escalated that fame. She became synonymous with swimming and diving when those activities were themselves considered symbolically modern behaviour. Miscellaneous forms of recognition reflect her popular profile: she was compared to Nellie Melba as the most internationally recognised Australian woman (and in fact, she

176 Annette Kellerman, *Physical Beauty: How to Keep It* (New York: George H. Doran Co., 1918), p. 13.
177 'An Australian Venus' Hints on Swimming'.
178 Kellerman, *Physical Beauty*, p. 85.

knew Melba through her mother, who had been Melba's piano teacher in her youth in Melbourne[179]). By 1914, young women divers competed annually at Madison Square Garden or elsewhere in New York city for the 'Annette Kellermann Cup'.[180] In 1917 there was an art contest for 'the best full-length pose of Annette Kellermann', with over a hundred entries, and the winner announced at a special luncheon at the Hotel Astor.[181] The contest was linked to *A Daughter of the Gods* with the winning picture to be displayed in the lobby of the Lyric Theatre where the film was being screened; and like the film, the full-length poses showed Kellerman with very little on – only 'a tango sash'.[182] In American popular culture in the 1920s, she was such a household word that reports of baseball games used the term 'an Annette Kellermann' to mean a diving catch.[183] In 1939 she was listed as one of the 'glamour girls' of film history, along with Clara Bow, Dorothy Lamour, Hedy Lamar, Greta Garbo and others.[184] In 1952 a film was made about Kellerman's life, called *Million Dollar Mermaid* and starring Esther Williams; including a Busby Berkeley water ballet extravaganza, it had originally been slated as *The One-Piece Suit*, denoting the swimsuit that had become synonymous with Kellerman.[185]

Patty O'Brien argues that, after the ethnographic films of the 1910s–20s that blurred documentaries and fictional cinema, few indigenous actors were employed until the 1960s. While South Seas films were popular in the intervening decades, Hollywood whitened Polynesian women with actresses who were Mexican or otherwise more European in appearance. The cinematic colonising romance between European men and islander women was rendered more acceptable through this racial masking.[186] It was a whitened version of the South Sea Island nymph for which Kellerman was at least partially responsible.

The South Seas imagery and its sexual dimensions would linger in Australian popular culture. Partly this was due to the transnational circulation of images of Pacific islands as tropical paradises and tourist destinations, images that were linked to the mid-twentieth century icon of the hula girl. After its nineteenth-century suppression by missionaries, in

179 John Hetherington, *Melba* (London: Faber & Faber, 1967), p. 20.
180 'Women Enter Garden Swims', *The New York Times* 24 December 1914, p. 7.
181 'Wins Annette Kellermann Prizes', *The New York Times* 5 January 1917, p. 11.
182 Phyllis, 'In the Looking Glass', *The British Australasian* 25 January 1917, p. 20.
183 For example, 'Pickups and Putouts', *The New York Times* 16 July 1925, p. 15.
184 Frank S. Nugent, 'Glamour Girls: A Film Cavalcade', *The New York Times* 25 June 1939, p. SM5.
185 'Hollywood Memos', *The New York Times* 9 December 1951, p. 131.
186 O'Brien, *The Pacific Muse*, pp. 244–50.

the 1920s and 1930s hula dancing made a dramatic comeback in Hawaii, tied to the rise of tourism and the commodification of island culture. Following World War II, tourism, the enormous popularity of hula dancing and emblems of island culture were all part of the integration of Hawaii into the United States, formalised in 1959. As Adria L. Imada has argued, it was a Hawaiianness 'signified primarily through the spectacle of women's bodies', an eroticised and submissive femininity that represented Hawaii's yielding to American economic and military domination.[187] Hula dancing and hula hoops, along with images of island paradises as tourist destinations, became part of global commodity culture.

Kate Hunter's evocative research on rodeos and bush carnivals in rural Australia from the 1930s to the 1950s shows how this set of images became available for eroticised racial masking. Rodeos and bush carnivals showcased the riding and other physical feats of white men; Aboriginal men and a few white women were accorded minor roles in the main events. In the sideshows of these widespread events, though, there were tents where women would put on 'leg shows', striptease events that were well attended. The women performers in these tents were often Aboriginal or mixed-race: the only kind of performance Aboriginal women were permitted. Hunter shows that the women performers commonly had Pacific island personas and names, such as 'Fifi from Tahiti' and 'Gigi from French Polynesia', names that hid Aboriginality in a pretence of dusky, islander, hula-dancing glamour.[188] Aboriginal and mixed-race women's performing as eroticised South Sea Islanders in the bush towns of mid-twentieth century Australia was a continuation of the racialised codes of feminine modernity in which Annette Kellerman had been so influential. Kellerman's live performances and films placed Australia firmly within transnational popular culture, and enabled Australians to imagine themselves as part of global modernity – a modernity that was fundamentally structured through racialised understandings of Australia's place in the world, including its local imperial power in the South Seas.

187 Adria L. Imada, 'Hawaiians on Tour: Hula Circuits through the American Empire', *American Quarterly* Vol. 56 No. 1 (March 2004), p. 134.

188 Kate Hunter, '"Fifi from Tahiti" and other Koori girls: Untangling race and gender in travelling shows to the 1950s', paper presented at the Australian Historical Association Conference, University of New England, Armidale, September 2007. Cited with kind permission of the author.

Chapter 2

Rose Quong

Appropriating Orientalism

Rose Quong, an Australian actor, lecturer and writer, was born and brought up in Melbourne but left in 1924, at the age of 44, with an ambition to make it on the London stage. Quong's career, which would span Britain, the United States and even China itself, was the result of her marketing of her mixed cultural heritage. She became a skilled purveyor of cultural mixing and cultural difference, casting herself as an essentially qualified interpreter of Chinese culture to the Western world. Yet Quong's measurable success creating a theatrical and lecturing career as a professional Chinese woman must be seen as a compromise. When Quong arrived in London, she brought with her a successful reputation from repertory theatre in Melbourne, as an actress well versed in Shakespeare and the theatrical canon of the day. Shakespeare was her lifelong first love as a poet and playwright, but her desire to perform on the metropolitan stage as a Shakespearean or mainstream actress ran up against racial stereotyping. Partly from her own choice and interest, and partly through the repeated suggestions and encouragement of Australian and English friends, Quong carved out instead a niche for herself as a lecturer on Chinese culture and philosophy, an 'Oriental' actress and a reciter of Chinese poetry. Her successes – such as acting alongside Laurence Olivier and Anna May Wong, reciting on BBC radio, appearing on a BBC television program as early as 1935, publishing two books with a major American publisher, and being cast as herself in a 1971 film – testify to her talent, hard work, energy and determination. But they need to be juxtaposed with Quong's separation from her home and family, the marginality of her material standard of living, and the cultural stereotyping that precluded a career in Shakespeare and pushed her instead towards her

own careful appropriation of Orientalism. Quong's story leads us to consider how Orientalism – that edifice of Western representations of 'the East' as exotic, mysterious, barbaric and sensuous, among other characteristics – could be appropriated by 'Orientals' to their own ends. It also compels us to think about how Quong juggled her mixed Australian, British and Chinese identities – stressing each in particular ways and at different times.

A generation ago Edward Said drew attention to the discursive structures of 'Orientalism', which he saw fundamentally as 'a Western style for dominating, restructuring, and having authority over the Orient'. Further,

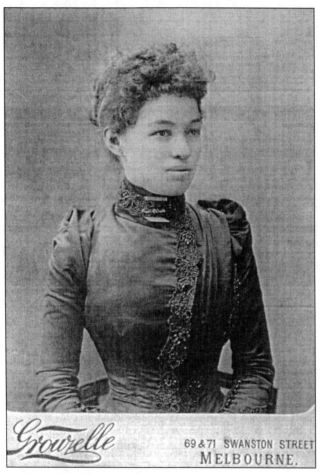

Portrait of Rose Quong taken in Melbourne

Source: Rose Quong Papers, MSS132, Historical Society of Pennsylvania, with permission of the Historical Society of Pennsylvania.

Said contended that Orientalism was the mechanism by which European culture 'manage[d]' and 'produce[d]' 'the Orient politically, sociologically, militarily, ideologically, scientifically, and imaginatively during the post-Enlightenment period'.[1] Although Said focused mostly on the Middle East, an ensuing generation of scholarship has applied his insights further afield, including to the relationship between 'the West' and East Asia. Orientalism continues to engage scholarly attention despite critiques of Said's original thesis, and challenges such as David Cannadine's controversial counter-proposition of 'ornamentalism' as a better descriptor of dominant British imperial attitudes.[2] Yet we still do not fully understand the historical evolution of Orientalism as a constellation of assumptions and attitudes, its efflorescence globally, its intersections with European colonialism in different sites, nor its twists and turns in the twentieth century. As Ann Curthoys has noted, the history of attitudes towards the Chinese in Australia must be linked to the evolution of British and other European Orientalisms, notably the shift from an eighteenth-century 'Orientalist wonderment and fascination with Chinese art and learning' to a mid- to late-nineteenth century rising belief in European superiority and perception of mobile Chinese labourers as a threat.[3] As practices of discrimination were undergirded by purportedly scientific theories of social Darwinism, and the global modernist proclivity for racial stereotypes reached its apogee in the late nineteenth and early twentieth centuries, Western Orientalist taxonomies of 'the East' held their purchase through continuing evocations. The constellation of racist immigration and labour policies in multiple Western countries, articulated and ubiquitous racial stereotypes, and continuing Orientalist cultural fascination and condemnation, were virtually impossible to escape for those marked as 'Chinese', 'Asian', 'Hindoo' or 'Moslem'.

It is important historical context for Rose Quong's story that Chinese immigration to Australia was restricted temporarily from 1855 to 1867, then 'permanently' from 1880 to 1887, prior to being banned under the 1901 Immigration Restriction Act, the first substantive piece of legislation passed

1 Edward W. Said, *Orientalism* (New York: Vintage Books, 1979), p. 3.
2 For a critique of Said see, for example, Lisa Lowe, *Critical Terrains: French and British Orientalisms* (Ithaca: Cornell University Press, 1991); David Cannadine, *Ornamentalism: How the British Saw Their Empire* (Oxford: Oxford University Press, 2001).
3 Ann Curthoys, '"Chineseness" and Australian Identity', in *The Overseas Chinese in Australasia: History, Settlement and Interactions*, eds Henry Chan, Ann Curthoys and Nora Chiang (Taipei: Interdisciplinary Group for Australian Studies, National Taiwan University, & Canberra: Centre for the Study of the Chinese Southern Diaspora, Australian National University, 2001), p. 25.

by the new Commonwealth of Australia.[4] This act, of course, codified what was informally known as the White Australia Policy and which would operate as Australia's overtly racist immigration policy until 1966. Henry Chan has argued that we need to see Chinese people not just as victims of the White Australia policy, but as historical actors in their own right, with individual lives, and family and community ties. He contends that we need to identify continuing links between families and villages in China and Chinese migrants in Australia, and to see this history as integral to a broader transnational, transpacific history of the Chinese diaspora.[5] Chan's emphasis on the transnational dimensions to the history of the Chinese in Australia makes very good sense.

What I want to suggest is that Rose Quong reveals *another* transnational dimension to the history of Chinese-Australians, a dimension so far overlooked in this area of scholarship, and that is the role of London and Britain as imperial metropole. Quong presents us with the perhaps startling realisation that the Australian colonial connection to London could and did provide a venue in which she articulated her identity as part of another diaspora and tied to another homeland, that of China. Quong's story forces us to recognise that British imperial identity, Australian colonial and national identity, and Chinese cultural identity were not mutually exclusive but in fact could work to reinforce each other. This recognition negates the explicit assumption by some scholars of Chinese history in Australia that Britishness and Chinese cultural identities were antagonistic formations. The one scholar who has already pointed towards this possibility is Ann Curthoys, who has contended that the history of immigration in Australia must be seen within the framework of the history of colonisation, and that Anglo-Celtic and Chinese Australian identities were both formed through dispersed populations moving back and forth between Australia and an imagined homeland.[6] Rose Quong's life story pushes Curthoys's point one step further by demonstrating that British-Australian and Chinese-Australian identities were not just parallel or comparable but could in fact be intersecting, overlapping constructions of self.

The story of Rose Quong becoming Chinese in interwar London thus presents a new dimension to the formation of Chinese-Australian identities, and raises interesting questions about Australian and British anti-

4 Andrew Markus, 'Government Control of Chinese Immigration to Australia, 1855–1975', in Chan, Curthoys, and Chiang (eds), pp. 70–72.
5 Henry Chan, 'The Identity of the Chinese in Australian History', in *Queensland Review* 6, no. 2 (Nov. 1999), pp. 1–9; H.D. Min-his Chan, 'Becoming Australasian but Remaining Chinese: The Future of the Down Under Chinese Past', in Chan, Curthoys and Chiang (eds), pp. 1–15.
6 Curthoys, '"Chineseness" and Australian Identity', pp. 21–22.

Chinese sentiments – such as why the imperial metropolis was a context in which Quong could pursue a professional theatrical career better than in Melbourne, yet found more success in her self-constructed Chineseness than in mainstream roles. In Melbourne, Quong's Chineseness seems mostly to have been tacitly ignored; she seems to have been accepted on her own merits, more or less as an honorary Anglo-Australian, perhaps not unlike the way in which prominent businessman and philanthropist Quong Tart was accepted and even celebrated in Sydney in the last decades of the nineteenth century.[7] Both Rose Quong and Quong Tart were accepted at least in part because they overtly embraced British culture. For her part, Quong seemed to believe that she had not been discriminated against in Australia. In 1942 she asserted that she scaled her 'first racial barrier' only on her first entry into the United States – and that that experience was not as bad as Canada's exclusionary laws.[8]

In 1939 *The Australian Woman's Mirror* blamed British racism for Quong's career not going according to its original plan:

> Many Melbourne people remember Rose Quong, the accomplished elocutionist, to whom when she went abroad a successful stage and screen career seemed assured. The British public, however, apparently did not appreciate the idea of a Chinese woman reciting Shakespeare, and she could not persuade film magnates that there was room for a second Chinese star beside Anna May Wong. So Rose tried another path. She studied Chinese poetry, art and legends, and then, wearing exquisite Chinese costumes, she launched herself as a lecturer on Chinese art and literature. Success came at last, and on her latest lecture tour of Great Britain some of her audiences numbered 3000 people.[9]

Despite this Australian self-congratulation, there is evidence that her success in amateur theatre in Melbourne occurred despite prevalent racism.

Rose Quong presents an illuminating case study in relation to John Fitzgerald's argument about what he terms Australia's 'big white lie'. Fitzgerald contends that Chinese immigration to Australia was restricted, and Chinese people in Australia were subordinated, on the basis that they held values that were antithetical and inassimilable to Australia's cherished democracy and egalitarianism. Dismantling this argument with a wealth of historical evidence,

7 Rose Quong and Quong Tart were unrelated; indeed, the 'Quong' in Quong Tart is a given name, not a family name. Robert Travers, *Australian Mandarin: The Life and Times of Quong Tart* (Kenthurst, NSW: Rosenberg Publishing, 2004).
8 Rose Quong, 'Spiritual Forces and Race Equality', in Harry W. Laidler (ed.), *The Role of the Races in Our Future Civilization* (New York: League for Industrial Democracy, 1942), p. 35.
9 'Mrs. J.G.R.', *The Australian Woman's Mirror* 14 February 1939, p. 20.

Fitzgerald shows that Chinese settlers in Australia often specifically valued democratic and egalitarian philosophies, argued against their discrimination on the basis of their right to equality, and participated in Australian economic, cultural and even religious life. Fitzgerald argues: 'Chinese were among the first Australians to embrace modern technologies and take up modishly modern lifestyles. In the 1890s they rode the latest bicycles, in the 1900s they wore sober business suits and flounced dresses, in the 1910s they picnicked by the seaside... Modern and mobile as they were, however, Chinese Australians could never qualify as white Australians'.[10] Rose Quong's story exemplifies the Chinese-Australian embrace of the new (in her case, for example, feminism and repertory theatre) and of the possibilities available in rapidly changing Australia and its metropole. At the same time, she reflects the ambivalence of Anglo-Australians towards their Chinese compatriots.

Portrait of Rose Quong, presumably in Australia

Source: Papers of Rose Quong, NLA MS 9796, with permission of the National Library of Australia.

10 John Fitzgerald, *Big White Lie: Chinese Australians in White Australia* (Sydney: University of New South Wales Press, 2007), p. 29.

While the White Australia policy was in full swing, the Australian community in London adopted Quong as one of their own – taking pride in her accomplishments, including her in their communal social life, nurturing her career, but, like numerous English people, encouraging the trajectory of that career towards a professional enactment of being Chinese. The story of Rose Quong in London, like the later part of her life in New York from 1939 until her death in 1972, provides us with insight into the contingent historical evolution of Orientalisms and their twentieth-century possibilities for those marked as 'Chinese' or 'Asian'. From the 1920s to the 1970s British and American Orientalist fascination with 'the East' provided Quong with audiences and a market, even as racist assumptions and barriers steered her career away from the iconic English idiom of Shakespeare and towards Chineseness.

Quong was not the only Chinese-Australian woman in early twentieth century London: her sister Florence lived with her for an extended period in the 1930s, and we also have some record of Justine Kong Sing, a miniature painter from Sydney who was in London at least from 1912 to 1922 and whose successes included showing at the Royal Academy in 1915.[11] The early twentieth-century decline in the Chinese population in Australia occurred partly because of the departure of younger people; it is possible that more than just these three headed for London. Rather than claiming significance based on numbers, however, we ought to consider Quong's story as a micronarrative. Advocates of the micronarrative as historical method have argued that a close reading of the exceptional can alert us to new meanings in larger structures.[12] If Quong was unusual as a Chinese-identified Australian who left for London, and unusual in London in her juggling of British, Australian and Chinese identities, her deployment especially of her Chinese persona illuminates the plasticity, availability and circulation of ethnic identities in this period.

Although Quong's papers are, very fortunately, preserved at the National Library of Australia and the Historical Society of Pennsylvania, they mostly begin in 1924 with her voyage to London. What we know about her early life in Australia is rather more sketchy. Rose Maude Quong or Rose Lanu Quong (as she variously gave her full name) was

11 *The British Australasian* 4 April 1912, p. 19; 17 April 1913, p. 21; 29 April 1915, p. 19; 30 September 1915, p. 18; 30 September 1920, p. 16; 13 July 1922, p. 20; 20 July 1922, pp. 20–21; *The British Australian and New Zealander* 23 January 1936, p. 8.
12 A useful article on this is Matti Peltonen, 'Clues, Margins, and Monads: The Micro-Macro Link in Historical Research', *History and Theory* 40 (October 2001), pp. 347–59.

born in East Melbourne on 15 August 1879, the first of four children born to Chun Quong and Annie Moy Quong. The family name is shown in some records as Ah Quong. Chun Quong was a merchant born in Canton, China. While a few Chinese men began arriving in Australia in the first decades of the nineteenth century, and worked in various capacities, their numbers rose in the 1840s with various schemes that brought indentured labourers to be shepherds, farm workers and servants; in the 1850s the numbers arriving leapt dramatically because of the gold rush. From the 1850s a proportion of these arriving Chinese men became entrepreneurs and merchants, with varying degrees of success.[13] Annie, born at Beechworth in northern Victoria, was much younger than Chun, only seventeen when she married him in Melbourne on 10 July 1878 and just eighteen at the time of Rose's birth. Coincidentally, Annie's father's name was John Quong (also a merchant) and her mother Mary's maiden name was Hayphee.[14] Beechworth was one of the gold-rush boom towns, and for Chinese men forced from the mid-1850s to disembark in Sydney due to Victorian restrictions on their arrival, Beechworth was a shorter walk than Ballarat and Bendigo. By 1855 there were 17,000 Chinese men working on the Victorian goldfields.[15]

Because most Chinese immigrants were male, there was a big sex ratio imbalance: for example, in Victoria between 1901 and 1921, women ranged from 8 to 18 percent of the Chinese population.[16] The 1901 national census showed that women constituted only 1.5% of the 30,542 Chinese people in Australia; New South Wales had the largest Chinese population, followed by Queensland and then Victoria.[17] Rose was born around the time of the nineteenth-century height of the Chinese population in Australia, when it was near 38,000, a level it would not reach again until the last decades of the twentieth century. In Melbourne, however, the Chinese population

13 Eric Rolls, *Sojourners: The Epic Story of China's Centuries-Old Relationship with Australia* (St. Lucia, Qld.: University of Queensland Press, 1992), esp. Chs. 1 and 2.

14 Death registration for Annie Quong, who died 12 October 1931, in St. Kilda, Victoria, Registry of Births, Deaths and Marriages, Melbourne. It is possible that, but unclear whether, Annie Moy Quong's ancestry included some Irish.

15 Ann Curthoys, "'Men of All Nations, except Chinamen': Europeans and Chinese on the Goldfields of New South Wales', in Iain McCalman, Alexander Cook and Andrew Reeves (eds.), *Gold: Forgotten Histories and Lost Objects of Australia* (Cambridge: Cambridge University Press, 2001), p. 105.

16 Sophie Couchman, 'From Mrs Lup Mun, Chinese Herbalist, to Yee Joon, Respectable Scholar: A Social History of Melbourne's Chinatown, 1900–1920', in Chan, Curthoys and Chiang (eds), p. 132.

17 A. T. Yarwood, *Asian Migration to Australia: The Background to Exclusion 1896–1923* (Parkville, Vic.: Melbourne University Press, 1964), p. 163.

would keep increasing for a few decades after Rose's birth.[18] The Chinese community in Melbourne revolved around Chinatown, centred on Little Bourke Street – where Rose's younger brother Norman was born in January 1887. By the time of Rose's birth, Chinatown had become a residential, commercial and communal centre, but as Sophie Couchman has observed, it did not advertise itself with the overt markers of Chinese culture that it assumed by the latter twentieth century.[19]

When Rose first achieved success in London, *The Australian Woman's Mirror* claimed that she was 'the daughter of a leading Melbourne Chinese merchant'.[20] Despite this claim, it is unclear whether the Quongs were respectable working-class, or more middle-class. At least at the time that Rose finished school, the family was living in a house named 'Cleveland' on Nicholson Street in Fitzroy. It *is* clear, though, that the Quongs encouraged their children's education. Rose attended University High School, which was founded in 1893 and located at the corner of Swanston and Grattan Streets in Carlton. Norman went on to a long career as a court reporter for the Supreme Court of New South Wales. He recalled in later life that all four children, including Florence and Eric, lived at home into adulthood and were educated together.[21] In extreme old age, Rose herself told a journalist: 'My perfect gentle little mother determined that as I grew up I should learn the best I could of the ways and culture of the west... I also went to the library and dragged out all the books on Chinese thought I could, reading translations. My parents were proud of me because I was a scholar, someone who loves books. That's the Chinese ideal'.[22] At least in this account, Rose Quong's self-construction as Chinese began very early in life.

In a brief autobiographical statement written a few months before she died in 1972, Quong claimed to have had several years of higher education from 1897 to 1900, that she planned to study medicine, and that 'my college teachers thought I was a genius'. (No doubt occasional immodesty was a helpful trait in a career that depended largely on self-advertisement.) But, she continues, 'I decided it was my brothers who needed education, and the theatre got hold of me'. Records show that in

18 Markus, pp. 69 & 71.
19 Couchman, p. 125.
20 'Women in the World', *The Australian Woman's Mirror* 9 June 1925, p. 18.
21 Deposition of Norman Quong, August 1960, Rose Quong Papers, MSS 132, Series I Correspondence, Historical Society of Pennsylvania, Philadelphia.
22 Kim Rosston, 'From Australia to the West Side: The 93-Year Journey of Actress Rose Quong', *Manhattan Tribune* 13 May 1972, pp. 7–9.

late 1896 she passed the matriculation examination at the University of Melbourne in nine subjects, including Latin, French, German, algebra, geometry and physics.[23] A 1930s magazine report described her as having been a university student, but there does not seem to be any record of her as a student at the University of Melbourne.[24] It is possible that what Quong glossed over here was that, as the eldest, she may have been supporting the family, earning an income so that her brothers might study. Chun Quong seems to have died relatively young; Rose took out a life insurance policy in August 1897, and the record of it lists Chun as deceased.[25] We *do* know that Rose Quong was a public servant, first appointed in June 1897 when she was 17 years old, and that from March 1901 she worked as a telephone switch operator for the Commonwealth Public Service. The public service was a respectable, secure and relatively well-paid area of work. By 1919 she had become a clerk in the Auditor General's Office, naval and military branch, and she seems to have held her public-service position until her departure for London in 1924; when she left, she took leave rather than resigning immediately.[26] When questioned by a journalist late in life as to why she never married, she responded: 'I never met anyone I've been interested in. Perhaps I've been too much of an actress. Perhaps I've always acted life'.[27] Certainly, when she left Australia at 44, by contemporary standards she would have been considered beyond normal marriageable age.

Quong traced the origins of her theatrical career to the training she received from an Englishman called Mr Chisley who, in Melbourne in the 1890s, taught her to read Shakespeare and poetry. While her love of poetry predated Chisley's teaching, 'he enabled me to acquire a quality of expression and appreciation, which has marked my acting and lectures ever since' and because of which she considered he 'was probably the greatest influence and benefactor in my life'.[28] In Melbourne her theatrical work

23 Matriculation examination registration form for Rose Quong 23 October 1896, and matriculation examination results lists November 1896 showing Quong's results as Candidate No. 507. Archives, University of Melbourne.

24 'Women in the World', *The Australian Woman's Mirror* 10 January 1933, p. 20.

25 J. R. Thompson, Australian Mutual Provident Society, Melbourne, to Mr N.L. Quong, 5 September 1960, Correspondence, Series I, Rose Quong Papers, MSS 132, Historical Society of Pennsylvania.

26 Commonwealth Public Service Lists, Mitchell Library, Sydney, and her brother Norman's deposition of August 1960, Correspondence, Series I, Rose Quong Papers, MSS 132, Historical Society of Pennsylvania.

27 Rosston, 'From Australia to the West Side', p. 9.

28 Letter to Axel Harvey, 2 July 1972, Rose Quong Papers, MSS 132, Series I, Historical Society of Pennsylvania.

never went beyond the amateur, yet she made a name for herself on the local stage, firstly in elocution competitions. In August 1907, *The Bulletin* noted that: 'Miss Rose Quong, a competition star, gave an elocutionary recital at Glen's on Tuesday. She did Poe's "Raven" to a pianoforte accompaniment; also Longfellow's "Excelsior". Anything more banal than "Excelsior" under any circumstances couldn't very well be imagined; but Miss Quong described the visitation of Poe's fateful fowl with some force and imaginative power.'[29]

Repertory theatre was an international movement from around the turn of the twentieth century, a movement that sought to produce serious and experimental as opposed to commercial plays. In writer and critic Nettie Palmer's view, the repertory theatre movement in England had succeeded in producing short runs of changing plays, of such literary quality that homegrown playwrights of the calibre of John Galsworthy, J.M. Barrie and George Bernard Shaw achieved fame and success. In Australia, on the other hand, Palmer considered that the repertory theatre of the 1910s and early 1920s borrowed too heavily from England and failed to allow Australian drama to fully flourish.[30] Palmer's negative judgment about the success of repertory theatre in Australia in this period was influenced by the short life span of the group with which she and her husband, writer (of plays and other genres) Vance Palmer, were associated. The Pioneer Players had been launched in Melbourne in 1921 as a movement to promote Australian drama, one aspect of the postwar enthusiasm to build an Australian national culture. Key protagonists, beside the Palmers, included the playwright Louis Esson, and his wife Hilda who both acted and performed secretarial work for the group. But they only lasted until 1924, a demise that Nettie Palmer later blamed on Melbourne audiences (in comparison to the Brisbane repertory group who were interested in Vance's work in the later 1920s), and on young people's attraction to the cinema.[31] Other commentators thought that the group's emphasis on realism and its lack of good administrative support were factors in their dissolution.[32]

29 *The Bulletin*, 29 August 1907, p. 21.
30 Vivian Smith (ed.), *Nettie Palmer: Her Private Journal 'Fourteen Years', Poems, Reviews and Literary Essays* (St. Lucia, Qld.: University of Queensland Press, 1988), pp. 336–39.
31 Nettie Palmer, *Fourteen Years: Extracts from a Private Journal 1925–1939* (Melbourne: Meanjin Press, 1948), pp. 16–17; Vivian Smith (ed.), *Letters of Vance and Nettie Palmer 1915–1963* (Canberra: National Library of Australia, 1977), pp. 37–38.
32 Deborah Jordan, *Nettie Palmer: Search for an Aesthetic* (Melbourne: History Department, The University of Melbourne, 1999), pp. 188–190.

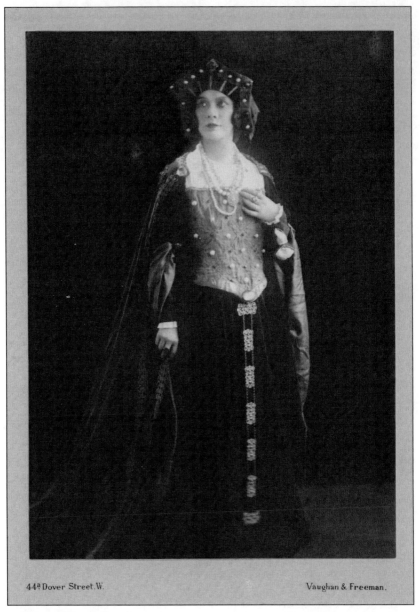

44ª Dover Street.W. Vaughan & Freeman.

Rose Quong in medieval costume
Source: Papers of Rose Quong, NLA MS 9796, with permission of the National Library of Australia.

The Pioneer Players were just one relatively brief incarnation of the early twentieth-century repertory theatre movement in Australia, which emerged in different parts of the country in the years preceding World War I. In

Melbourne, William Moore organised several 'Australian drama nights' starting in March 1909, and the Melbourne Repertory Theatre began under the direction of Gregan McMahon in 1911.[33] It is unclear when and how Rose Quong first set foot on the stage (possibly at school), but she seems to have been a member of McMahon's group. She worked as well with Henry Tate, an influential musicologist and poet in 1910s and 1920s Melbourne, who was connected with Louis Esson and William Moore.[34] A 1923 article about her commented: 'Miss Quong has been connected with pretty well every dramatic movement in Melbourne from Repertory onwards'.[35] The Melbourne Repertory Theatre company, which survived in this incarnation until 1918 and was successful enough to refurbish what became known as the Playhouse Theatre in the city centre, produced European plays by Shaw, Galsworthy, Ibsen, Arnold Bennett and Anton Chekhov, and rather fewer Australian plays.[36] In the wake of the demise of the McMahon group, in September 1919 a new group announced itself, called the Mermaid Play Society. Seemingly, those interested in serious theatre in Melbourne were a fluid and interconnected movement. In 1921 the Mermaid Play Society was joined by the Melbourne University Dramatic Club, and in 1923 it changed its name to the Mermaid Repertory Play Society. In 1924, apparently wishing to claim the mantle of the earlier McMahon group, it renamed itself again as the Melbourne Repertory Theatre Society which it stayed until it collapsed in 1929. Moreover, there was overlap in membership between the Mermaid Play Society and the Pioneer Players.[37]

Rose Quong was one of the organisers of the Mermaid Play Society in 1919; indeed, one commentator called her 'the most active organiser'.[38] Quong herself apparently agreed, at the end of her life recalling that 'I started the repertory theatre there on my own. I sold the University officials on the idea, developed it successfully, and acted in it for a period of years'.[39] Another major force was the producer Arthur Goodsall, who had worked in contemporary

33 Leslie Rees, *The Making of Australian Drama* (Sydney: Angus & Robertson, 1973), pp. 114, 115, 120.
34 John Carmody, 'Tate, Henry (1873–1926)', *Australian Dictionary of Biography*, Volume 12 (Melbourne: Melbourne University Press, 1990), pp. 172–173.
35 Marjorie Clark, 'Miss Rose Quong in Repertory Delights and Stimulates: Intellectual Melbourne pays tribute at her shrine', *The Era* 28 June 1923, quoted in Kerry Kilner, 'Performing Women's History: Re-assessing the Role of Women in Melbourne's Little Theatre Movement 1901–1930', MA Thesis, Centre for Women's Studies, Monash University, 1996, p. 28.
36 'Melbourne Repertory Theatre Company' in Philip Parsons (ed.), *Companion to Theatre in Australia* (Sydney: Currency Press, 1995), pp. 356–357.
37 Kilner, 'Performing Women's History', pp. 24–28.
38 Clark, 'Miss Rose Quong in Repertory Delights and Stimulates'.
39 Letter from Quong to Axel Harvey, 2 July 1972, Correspondence, Series I, Rose Quong Papers, MSS 132, Historical Society of Pennsylvania.

Elizabethan theatre in England. The Mermaid Play Society named itself after the famous tavern of Shakespeare's day and at first sought to specialise in mediaeval and early modern English theatre. Quong was acclaimed as one of the best actors of the society. In its first production, *The Knight of the Burning Pestle*, she played the citizen's wife; one reviewer commented that she 'played throughout with a true appreciation of the character'.[40] It was in the next production, the traditional English morality play *Everyman*, that she galvanised attention. Based on a production in which he had been involved in England, Goodsall made the arguably modernist move of casting a woman, Quong, as 'Everyman'. *The Bulletin*, which was not known for glowing reviews of non-Australian plays, ran a strong review of it that noted: 'Miss Quong talked and posed without lapsing into [theatricalism]... and from the time when Everyman's least alarmed friends helped him (i.e., her) to dress for interment, the play hadn't an unimpressive minute'.[41] A Professor Berry, the first treasurer of the Mermaid Play Society, later recalled that *Everyman* 'was the most impressive and profoundly moving play ever produced in Melbourne... That one play alone made possible the Repertory movement, in its post-war form, in Melbourne'.[42]

Marjorie Clark, in a 1923 article in the magazine *The Era*, commented that Quong's 'remarkable acting' in *Everyman* 'caused Melbourne to sit up and take electric notice'. But, according to Clark, she was equally impressive in other roles in subsequent productions: 'as Mary Boake in the "Lighthouse Keeper's Wife", as Masefield's "Nan", as Peer Gynt, Asa Solveig, and a dozen others, she flashes up in the memory a clear flame of artistic joy'.[43] Clark's tribute to Quong was impassioned:

> For years she has given to this city exactly what she saw fit; she has never for a second pandered to popular taste... And Melbourne holds out its plate and asks for more.

> One might wander on for a long time over her technique and intellect, or the pure beauty of her voice, but it is that last peculiar quality, the final, intricate, indefinable thing, temperament, which brings us to our feet in instant recognition before she has said four words.[44]

40 *The Herald* 26 September 1919, quoted in Kilner, 'Performing Women's History', p. 29.
41 'Sundry Shows', *The Bulletin* 6 November 1919, p. 34.
42 Professor Berry, 'The Early Days of The Melbourne Repertory Theatre Society', *R.T. Make This Your Theatre* (Melbourne: Melbourne Repertory Theatre Society and Ramsay Publishing, 1928), pp. 5–6.
43 Clark, 'Miss Rose Quong in Repertory Delights and Stimulates'.
44 Clark, 'Miss Rose Quong in Repertory Delights and Stimulates'.

No wonder Quong began to believe that she might be able to forge a career in London.

After *Everyman*, the society staged two Shakespeare plays, then in 1920 when Elizabeth Apperly, a young Irishwoman newly arrived in Melbourne, took over as director, the group turned to more modern productions including plays by J.M. Synge and Arnold Bennett. Quong developed a reputation for tragic roles, helped partly by her success in 1921 in the title role in John Masefield's *The Tragedy of Nan*. One reviewer commented: 'Miss Rose Quong gave a well-thought-out, highly dramatic characterisation of the heroine... Altogether it was splendidly acted, and more than one of the audience admitted to being haunted by Nan's tragic figure for some time after'.[45]

For a full understanding of both Quong and this slice of Australian culture, it is pertinent to note that the Mermaid Play Society had feminist leanings. According to Dennis Douglas and Margery M. Morgan, Gregan McMahon's Melbourne Repertory Theatre too had been influenced by the feminism of the turn of the century theatrical world.[46] The Mermaid Play Society's main historian, Kerry Kilner, argues that it was significant that the society had women at the helm, and featured the work of women playwrights, some of which dealt with women's issues. Under Elizabeth Apperly's direction from 1920 to 1924, six plays by Australian women playwrights were produced.[47] As an amateur theatre group that believed in supporting the community, the society raised funds that it donated to various causes, some of them women's causes, including the free kindergarten movement, and the fund to build a women's college at Melbourne University.[48] When in 1922 the society gained its own orchestra to play at its performances, the Mermaid Society Orchestra too was 'dominated by women'.[49] One of the more feminist plays was *The Lighthouse Keeper's Wife* by Mary Wilkinson, in which Quong played the title role. According to a review in *The Argus*: 'The finished performance of Miss Rose Quong, as Mary Boake, the lighthouse keeper's wife was one of the best pieces of amateur acting seen at the Playhouse. Her command of voice and gesture and her sustained simulation of incipient insanity induced by long years of loneliness on a seagirt island, received generous recognition'.[50]

45 *The Book Lover* 21 May 1921, quoted in Kilner, 'Performing Women's History', p. 33.
46 Dennis Douglas and Margery M. Morgan, 'Gregan McMahon and the Australian Theatre', *Komos* Vol. ii, No. 2 (1969), pp. 53–54.
47 Kilner, 'Performing Women's History', p. 62.
48 Kilner, 'Performing Women's History', pp. 30, 34.
49 Kilner, 'Performing Women's History', p. 39.
50 *The Argus* 21 April 1922, quoted in Kilner, 'Performing Women's History', p. 38.

Quong did not openly espouse feminism in her diary or interviews, yet her own foundational role in what was seen as a feminist-leaning group, her leading roles in plays such as *The Lighthouse Keeper's Wife*, and her association with other feminist organisations such as the Lyceum Club (both in Melbourne and later in London), all speak to feminist sympathies. In this regard, it is telling that the day after landing in London, she went to a newsagent in search of the newly published feminist newspaper *Time and Tide* to which a friend in Melbourne had alerted her. The search provides a minor comic moment in her diary, where she records that she mistakenly asked the newsagent's assistant for a paper called *Ebb and Flow*: the shop assistant, Quong and her friends were all very amused by her error.[51]

One of the most striking aspects of the reviews and accounts of Quong's work in Melbourne repertory theatre is the near absence of commentary on her being Chinese, or of this being a possible obstacle to her success in European and Australian roles. Clearly there was some discussion of her racial identity, however, reflected by a little uncertainty as to whether or not she was fully Chinese. One report commented that she 'shows her half Chinese very slightly, but it was sufficiently marked to lead to her being offered a part in a play… in which the tragedy of a half-caste girl is depicted. She indignantly declined the role'.[52] Quong's reported indignation suggests that she felt the idea of such typecasting as a sting, and not the canonical kind of role she sought.

Most of the reviews and critical commentary from her Melbourne years are glowing, showing that she was a successful amateur actor in a mostly European theatrical repertoire, and suggesting that racial stereotyping did not significantly impede her at this stage. But racial thinking was pervasive in Australian culture, and must have impacted on Quong to some extent. Edith Young was one of the Mermaid Play Society; like Elizabeth Apperly, Young was a young Irishwoman recently arrived in Australia, and whom Apperly cast in some of the Irish plays she staged, such as Synge's *Riders to the Sea*. Young had become connected with Nettie and Vance Palmer, and through them mixed with Melbourne's literary circles. In her autobiography, Young comments on the racism she was surprised to find amongst this group. Herself the radical daughter of theosophists who had spent some of her childhood in New York, she believed in racial equality. She comments:

51 Entry for 8 March, Diary 1924, Papers of Rose Quong, MS 9796, National Library of Australia.
52 'Women in the World', *The Australian Woman's Mirror*, 9 June 1925, p. 18.

One thing that surprised me was that the group of Melbourne writers and intellectuals I was later to meet through the Palmers, though marvellously free of both money snobbery and the class distinctions I had become accustomed to at home [in London], seemed to take for granted that the aborigines [sic] – the real natives of Australia – should be treated as almost a subhuman, inferior race, impossible to educate other than in the elementary laws of hygiene. The general view was that the Blacks were only fit to be herded into government reserves or relegated to forced labour in the back blocks, preferably in the Northern Territory where the climate was tough. Once when I protested I was told that I didn't know what I was talking about. It was useless to point to the success of the Chinese as market gardeners in and around Melbourne, or say that with more of them and more water the desert interior could blossom like a rose. The 'Chinks', I was told, breed like rabbits. Within a generation there would be a racial problem in Australia, equal to America's. The White Australia policy was a must.[53]

Curiously, despite this specific mention of Chinese people, Young does not mention Quong by name in her autobiography, though it is clear from Quong's diary that they were friends – Young even came to the dock to bid Quong farewell when she left for London. In London, Quong socialised with Edith Young's husband, musician and critic Gibson Young, as soon as she arrived – Gibson had preceded Edith on their return.

On balance, the evidence suggests that Quong's theatrical colleagues and Melbourne audiences accepted her as an Australian with considerable acting ability, who just happened to be of Chinese descent. Moreover, seemingly, her reception in Melbourne led her towards consolidating her culturally inherited Britishness, both her aspiration to perform Shakespeare and her decision to go to London. Her performances were such that, according to *The British Australian and New Zealander*, the newspaper for London's Antipodean community, 'her many friends in Melbourne... urged her to bring her talent over to Europe'.[54]

Her own explanation of her decision to leave for London might have been given by any number of ambitious Australians, and reveals an archetypal British colonial sensibility, and conception of London, its attractions and possibilities. 'I was crazy on Shakespeare and Dickens. I wanted to go to

53 Edith Young, *Inside Out* (London: Routledge & Kegan Paul, 1971), p. 111.
54 W.G., 'Miss Rose Quong: A Charming Chinese Australian', *The British Australian and New Zealander* 15 January 1925, p. 5.

London. I wanted to meet Ellen Terry and Melba. I needed a new experience, change'.[55] There is no hint in this capsule explanation for her major life decision to leave the country of her birth, to which she would never return, of any frustration with anti-Chinese discrimination in Australia, nor of her desire to develop her own Chineseness. Rather, this articulation suggests a desire to claim and develop her Britishness. Yet I think we need to note, as part of the context for her leaving Australia, that she did so in the period (1901–1933) that historian Andrew Markus has characterised as having the harshest policies against Chinese immigration and Chinese communities in Australia. In these decades the Chinese population of Australia declined through death and emigration from around 30,000 to 8,600, a decline surely indicative of a hostile environment; although the decline in Melbourne's Chinatown population did not occur until the 1930s.[56] Interestingly, Quong's life reflects some larger patterns of Chinese-Australian history. Not only was she born around the time of the peak of the Chinese population in nineteenth-century Australia, her permanent departure from Australia occurred only three years later than the largest annual number of Chinese departures in the first half of the twentieth century: 4633 Chinese men and 220 Chinese women left in 1921.[57] If it was difficult for any ambitious woman to build a career in early twentieth-century Australia, there must have been particular obstacles for a Chinese-Australian woman.

Rose Quong embarked for London on 17 January 1924 on the *SS Ballarat*, travelling with Louise Matters, a friend from the theatrical world. In true Australian style, a sizeable group of friends and family came to see them off. While there are other sources for Quong's years in London and New York, such as newspaper articles, most of what we know comes from the diary that she began when she embarked in Melbourne. Her first entry dramatically announces 'My great adventure begins'. 'A day of glorious Australian sunshine', she continues, followed by a precise list of all those who came to the dock to bid her farewell.[58] Seemingly, she intended her diary as a travelogue, and as an *aide memoire*. She wrote regular and apparently long letters home (which seem not to have survived), perhaps using the diary as a source for those. She also seems to have used it to help her remember the names and contact information of people whom

55 Rosston, 'From Australia to the West Side', p. 9.
56 Markus, pp. 70, 74; Couchman, p. 127.
57 Shen Yuanfang, *Dragon Seed in the Antipodes: Chinese-Australian Autobiographies* (Carlton South, Vic.: Melbourne University Press, 2001), p. 47.
58 Diary 1924, Papers of Rose Quong, MS 9796, National Library of Australia.

she met. In the early years, she usually recorded at least a paragraph per day, sometimes much more. From early on, the diary performed multiple functions, including her budget accounting, notes on lectures she heard, her own critiques of the plays she so avidly saw. The multiple small notebooks that constitute her diary continue on into the 1940s, in their latter years losing their earlier travelogue aspects, and becoming more a repository for her reading notes, as well as a brief record of outings. Interestingly, Quong is not introspective in her diary; it is a record of her doings, but not of her feelings, and only to a small extent of her thoughts – mostly limited to theatre reviews. In that sense, it is not a particularly useful source for her emotional life (let alone any sexual life), and only of limited help for analyzing her subjectivity.[59] It is, however, a wonderfully informative record of her professional and social life, and her travels.

The *Ballarat* took the South African route, and Quong enthusiastically enjoyed her sightseeing at Durban, Cape Town and Las Palmas in the Canary Islands, recording long descriptions of each in her diary. On board, she took French lessons, enjoyed the community dancing, and was elected to both the committee to write the ship's newspaper, and the sports committee. One evening at a shipboard dance she lost a small purse containing five pounds in cash. Her attempts to reclaim the purse were to no avail; a group of her fellow passengers chipped in to make good the lost cash, claiming that it was in thanks for her shipboard work. Their generosity suggests that she was well liked by her travelling companions.[60]

On their arrival at Tilbury on 7 March 1924, Quong and Matters were met by Rose's friend Winifred Lockyer. Lockyer was a ballet dancer who had spent a good deal of time touring North America in the 1910s; originally from Melbourne, she and Rose must have known each other there. She made Quong and Matters's arrival in London easy and comfortable; she had already rented a very pleasant flat for the three of them in St John's Wood. Quong quickly established herself, checking in at Australia House, arranging her financial affairs at the Commonwealth Bank, and rapidly beginning a social life by attending functions, for example, at the feminist-leaning Lyceum Club.[61] The Lyceum Club was a natural venue for her, as the Melbourne branch was associated with the repertory theatre movement. By

59 On historical sources and the construction of subjectivities, see Angela Woollacott, 'The Fragmentary Subject: Feminist History, Official Records, and Self-Representation', *Women's Studies International Forum* 21, no. 4 (1998) pp. 329–339.
60 January and February entries, Diary 1924, Papers of Rose Quong, MS 9796, National Library of Australia.
61 Diary 1924, Papers of Rose Quong, MS 9796, National Library of Australia.

August her address was St. James' Terrace, and in September she moved to 7 Nevern Place, Earl's Court.

Not only were Quong's articulated reasons for going to London typical of the thousands of Australian women making the pilgrimage 'home' in this period, her life in London was similar in many ways to those of her compatriots there.[62] In fact, compared to some other Australian women in London around the same time whose papers I have read, she was better integrated into the Australian community. In her first years there she lived in boarding houses in Earl's Court, mixed often with Australian friends (some of whom she had known in Australia but some not), attended Australian social and community functions, and engaged in all the usual activities of the colonial tourist. In August and September 1924, in typical fashion she spent several weeks in Paris, absorbing all of the art and historic architecture, practising her French, browsing the book stalls along the Seine, and shopping in the department stores. In London she visited the National Gallery, the British Museum and Westminster Abbey, attended lectures on subjects ranging from art history to speech patterns to Shakespeare, explored Soho, went to concerts and the ballet, took French lessons, milled in the throng of people at Piccadilly Circus waiting for results on an election night, repeatedly visited the 1924–25 British Empire exhibition at Wembley, and went to the theatre as often as she could and recorded her critical comments in her diary afterwards. Like other Australians in London, she wrote frequent long letters 'home', eagerly awaited the Australian mail, visited Australia House, and in the first two years dithered anxiously about whether and when to return, although in the end she never did.[63]

Her busy social life revolved around her Australian friends, particularly close women friends with whom she spent much time, some of whom lived either in the same boarding house or another close by. Beside her close friends Louise and Winifred, whose son Jack was at boarding school in England, she regularly saw several Australian musicians achieving success in London, such as Gertrude Johnson, Anne Williams and Wilma Berkeley. Evenings with her Australian friends included, for example, one when she and Winifred called first on their friend Edith Young (who had been in the Mermaid Play Society in Melbourne), and then on their friend Ada Maclaren, where they

62　On this topic, and for details of Australian women's lives in London in this period, see Angela Woollacott, *To Try Her Fortune in London: Australian Women, Colonialism, and Modernity* (New York: Oxford University Press, 2001).

63　She didn't resign from her Australian public service job until she'd been in London about six months, and for the first couple of years continued to think of going back.

met Percy (P.R. or Inky) Stephensen, a Rhodes Scholar from Queensland – whom Winifred would later marry and who would become a noted writer, publisher and editor. Quong noted in her diary that they all 'had a good yarn'.[64] She spent a great deal of time with Winifred in the early stages of her sojourn in London, though they seem to have drifted apart later, perhaps as Winifred began to spend more time with Stephensen. Winifred returned to Australia with Stephensen in 1932, and presumably she and Rose never saw each other again. But they must have stayed in touch; it was Winifred's son Jack who donated Rose's first diary, and some other papers, to the National Library.[65] Winifred had first met Miles Franklin in America, then she and P.R. spent time with Franklin in London,[66] but there is no evidence that Quong met her.

Some diary entries suggest the explicit sharing of an Australian identity. One entry refers to an evening with 'our own crowd', while another relates a dinner conversation among Australians who all appreciated a story about the Limbless Soldiers' Association, the point of which was that Melba's generosity meant that the Australian branch had considerably more money than the English branch, which was reportedly run by snobbish aristocrats.[67] Quong met Melba on more than one occasion, and her diaries show Melba's dominant and supportive presence in the Australian community in London. In fact, in 1922 Melba had agreed to become a patron of the Mermaid Play Society,[68] so Quong had that indirect connection before she arrived. There is some evidence that she got to know Melba quite well during her London years. She was invited repeatedly to gatherings of Australian artists at the home of the very successful concert singer Ada Crossley. On at least one such occasion the men in the group sang, then Rose performed scenes from 'Macbeth'. And she attended significant Australian community events such as an Australia Day church service, followed by a concert by Australian musicians and singers.[69]

Quong's social life in London thus testifies especially to her sense of herself as an Australian and her acceptance in the Australian community. But there are also some clues in the accounts of her social activities to her self-construction as Chinese: her frequenting, often with Australian

64 Diary entry for 8 January 1925, Journal 1924–1925, Rose Quong Papers, MSS 132, Series II, Box I, Folder 7, Historical Society of Pennsylvania.
65 Note from J.W. Lockyer, July 1974, with Diary 1924, Papers of Rose Quong, MS 9796, National Library of Australia.
66 Jill Roe, *Stella Miles Franklin: A Biography* (London: Fourth Estate, 2008), p. 326.
67 Diary entry for 15 October 1924.
68 Kilner, 'Performing Women's History', p. 38.
69 Diary entry for 26 January 1925.

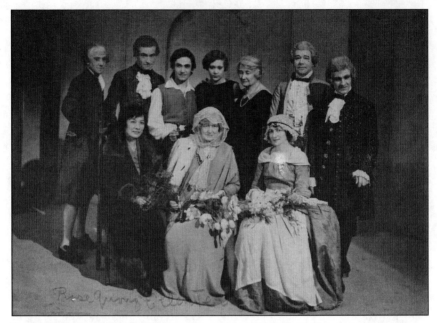

Rose Quong (front left) with legendary actress Ellen Terry (front centre), and Laurence Olivier (standing behind Quong)

Source: Papers of Rose Quong, NLA MS 9796, with permission of the National Library of Australia.

friends, of Chinese restaurants, and her marked proclivity to give Chinese objects, usually decorative household items, as Christmas and birthday presents. Beyond these clues, her articulation of a Chinese identity occurred mostly in her career.

Quong considered enrolling at the Royal Academy of Dramatic Art, but instead won a scholarship to study drama at the academy of Rosina Filippi, a Shakespearean actress. The judge of scholarship competitors who picked Quong was Edith Craig, the feminist and lesbian theatre director and daughter of the legendary nineteenth-century actress Ellen Terry. This professional association with Craig would continue to benefit Quong, such as when she acted in a provincial production of Craig's in February 1925.[70] Her classes began at the end of April 1924, and consisted of lessons in drama, movement, diction, and theatre history.[71] Quong's voice – apparently deep and powerful – won her praise at this point as it would later, and she was considered so accomplished at diction that she gave private elocution lessons to other aspirant performers. The fact that critics often commented on her

70 W.G., 'Miss Rose Quong'.
71 Diary 1924, Papers of Rose Quong, MS 9796, National Library of Australia.

'flawless English diction' probably just indicates their surprise at such speech from a Chinese person, but Quong also admitted to friends that she sought to acquire a perfect English accent as opposed to an Australian accent.[72]

The gravity of the issue of accent, for a colonial actress arrived in England, and the edifice of racial prejudice she confronted among some in the theatre world, are both revealed in an exchange of correspondence between the Australian scholar Gilbert Murray and a playwright or producer Mr W.G. Archer in 1924. Murray, who was a great booster of Australian careers in the metropole, had apparently met Quong at an afternoon tea party, hosted by either Lady Stanley or Lady Bell. Seemingly impressed by Quong's deportment and the glowing references given by Stanley and Bell, he wrote to Archer recommending that he consider her for a Spanish-sounding role in the play he hoped to produce. Archer had already heard of Quong, and replied:

> Miss Quong is certified to be a startling genius by a greater authority than either Lady Stanley or Lady Bell – namely Rosina Fillippi [sic]. On the other hand some say that she is a detestable actress and all seem to agree that she is anything but beautiful. Now an ugly Beatrice Joanna is a contradiction in terms, for if she were ugly she couldn't get away with her villainies. You don't mention that Miss Quong is a Eurasian and speaks the vilest Australian cockney, which, however, she is said to throw off when she plays Lady Macbeth.

Curiously, Archer followed this extended dismissal with the statement: 'I keep an open mind regarding her. Can you tell me where she can be seen acting? I should be very much interested to see her.'[73]

Filippi acted as something of an agent, introducing Quong to theatre critics and producers with a view towards professional opportunities. In late 1924 Quong began a taxing round of auditions, preparing scenes and hiring costumes and props for arranged or advertised viewings of her work. During this period, Quong's signature acting for informal recitals or performances for her friends and acquaintances was Shakespeare, usually scenes from *Macbeth*. Occasionally she chose to do a scene from *Antony & Cleopatra*, which is indicative of her own and others' sense that she was suited to the category of exotic roles. For two of her first professional auditions she

72 Diary entry for 8 February 1926, Rose Quong Papers, MSS 132, Series II, Box 1, Folder 8, Historical Society of Pennsylvania.
73 Mss. Gilbert Murray 48, 'General Correspondence, 1924', New Bodleian Library, Oxford. I am grateful to my colleague Marnie Hughes-Warrington for sharing this note with me, from her own research on Murray.

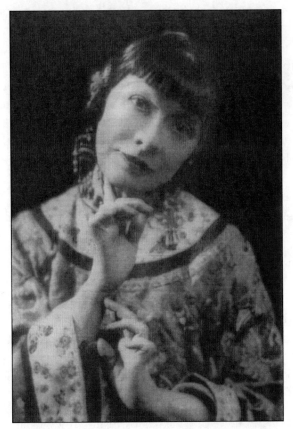

Rose Quong in one of her early Chinese costumes

Rose Quong Papers, MSS 132, Historical Society of Pennsylvania, with permission of the Historical Society of Pennsylvania.

performed excerpts from the character of 'Ulah' in a play Filippi wrote called *The Contract*. 'Ulah' was an Oriental role, about which Quong had misgivings, especially after an evening spent with a couple who had lived in China, with whom she discussed her qualms. Nevertheless, she went ahead with the role, going to considerable trouble to arrange a 'Chinese' costume and props. For one audition, for example, she wore a hired purple robe and trousers, a Chinese crown, and had her hair cut with a fringe.[74]

If initially she felt ambivalent about presenting herself professionally as Chinese, the evolution of her career in that direction was the product of

74 Diary entries for 17 and 18 November 1924, Journal 1924–1925, Rose Quong Papers, MSS 132, Series II, Box I, Folder 7, Historical Society of Pennsylvania.

several interconnected factors. Despite determined perseverance at contacting theatre directors, critics and agents, and some initial successes, eventually it became clear that she was not going to make it as a Shakespearean or general actress. Her friends and advisers began to urge her towards a specialised niche career, that of exotic or Oriental reciter, actress and performer. There is evidence that she had begun giving recitals before she left Australia, so it was not new to her as a genre. And at the same time, her own genuine interest in Chinese culture and philosophy, and her desire to develop that dimension of her identity, led her towards professional Chineseness. In her first year in London she frequented the Kensington Public Library; and in October 1924, for example, she recorded that she borrowed a book of 'Chinese Folk Tales', although she did not elaborate on her reasons.

In December 1924 and January 1925 she received a sudden flurry of press interest, with interviews by *The Daily Express*, *The Daily Graphic*, *The Glasgow Morning Post*, *The Sketch*, and *The British Australian and New Zealander*. In the midst of all this and her auditions, she had publicity photos taken by a professional photographer, for some of which she chose to wear a 'Chinese gown'. Her quest for the right Chinese outfit to perform in was protracted, partly because some she found did not seem appropriate, and having one made was expensive. In her first years in London she often borrowed items of clothing and props that she thought would produce the right background; her descriptions of these clothes and props sometimes read like a pastiche of 'Oriental' objects. For her performance at the Writers' Club on 27 October 1925, for example, she wore 'blue & greenish sort of wide trousers Edith Craig had lent me', a coat borrowed from someone else, pearl and flower ear ornaments she had made for her role in *The Contract*, and she carried a fan and fan-holder also lent by Craig.[75]

In fact in her first years in London she won roles in a fair number of plays, both early modern and contemporary. But the notices were often brief, and the reviews could reveal racism. In March 1925, when she appeared as the wife of a Dartmoor farmer in Lady Bell's rather gruesome *The Fog on the Moor*, the review in *The Times* ran:

> It was, in short, the husband's blood that stained the fingers which Miss Rose Quong, an Anglo-Chinese actress, held out in horror towards the final curtain. Miss Quong's acting has, on occasion, an effective violence of an unfamiliar sort: it is as if a hungry animal were seeking something to tear; but whether or not she is capable of emotional or

75 Diary entry for 27 October 1925, Journal 1924–1925.

intellectual attacks rather more subtle and less zoological, it is, perhaps, too early to judge.[76]

Comparing Quong to an animal hardly conceals the writer's prejudice about Quong being 'Anglo-Chinese' – an epithet that did not occur in her reviews in Melbourne. In 1925, Quong also appeared in two Renaissance plays at the New Scala Theatre, *The Maid's Tragedy* in May and *The White Devil* in October, the latter produced by Edith Craig.[77]

Her own predilection to present herself as Chinese was reinforced negatively by her lack of success at other roles, and positively by the encouragement and success she found in this new persona. By September 1925 she had met Arthur Waley, the renowned translator of Chinese poetry, who advised and encouraged her. Her performance at the Writers' Club the following month consisted of her reading Waley's translations along with Waley himself. By then she was also in demand at private receptions. In late November 1925 when she recited and commented on Chinese poetry and stories on BBC radio, her success was celebrated by *The British Australian and New Zealander* which reported that 'there were many Australians interested' in the broadcast, and 'several who had not wireless apparatus in their homes sallied forth to those of their friends or to public places'. The paper applauded her 'faultless enunciation', the clarity of her voice and the charm and intelligence of her explanations of the poems, noting that Quong 'though Australian, is of Chinese parentage, [which] accounts for her perfect understanding of these poems that portray Chinese tradition and legends of the fifteenth century'.[78]

Such essentialism pervaded the comments of those who supported her. For example, when in September 1925 she read some of his translated poems to Waley, he told her that 'he had nothing whatsoever to suggest – he didn't hope to hear them read better. Said the rhythm was perfect – Could only be instinct'.[79] Some commented on her mysteriousness and exoticism. Her friend Gertrude Johnson told her that her 'voice sounded sexless – too deep for a woman's and too soft for a man's', and another supporter effusively commented, according to Rose, that 'Chinese poetry was so unique, & my

76 'Garden Theatre: Three Plays', *The Times* 17 March 1925, p. 12.
77 'The Theatres', *The Times* 11 May 1925, p. 12; 'The Theatres', *The Times* 24 September 1925, p. 10; 'The Theatres', *The Times* 5 October 1925, p. 12.
78 Phyllis, 'In the Looking Glass', *The British Australian and New Zealander*, 3 December 1925, p. 14.
79 Diary entry for 1 September 1925, Diary 1925–26, Rose Quong Papers, MSS 132, Series II, Box 1, Folder 8, Historical Society of Pennsylvania.

personality, voice & everything about me were different'.[80] The theatre critic
for *The Illustrated London News* wrote to her that a performance of hers 'had
the real Oriental flavour'; and another acquaintance told her that 'what gave
[her] such power over people was a kind of Eastern hypnotising power!'[81]
A woman associated with the Writers' Club was frank in her professional
advice to Quong: 'the Orient always had a fascination for Western people, &
[she] could represent Eastern characters as no one else here possibly could –
Shakespeare lots of actresses could play more or less adequately – … but for
success one must specialize'.[82]

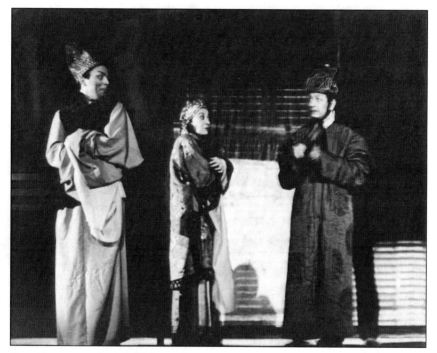

Rose Quong on stage in Chinese drama
Rose Quong Papers, MSS 132, Historical Society of Pennsylvania, with permission of the
Historical Society of Pennsylvania.

The fact that Quong appreciated these essentialist compliments and herself
subscribed to Orientalist attitudes is reflected in one of her habitual brief theatre
criticisms in her diary. After seeing a performance of *Antony & Cleopatra* at the
Old Vic she commented that the actress Edith Evans had good technique 'but

80 Diary entries for 30 November and 6 December 1925.
81 Diary entries for 19 October 1925, and 15 March 1926.
82 Diary entry 31 March 1926.

didn't seem to have the real eastern feeling'.[83] This perhaps jealous criticism is underscored by the fact that Quong had appeared with Edith Evans in *The Maid's Tragedy*. While she worked at casting herself as specifically Chinese, her denigration of Evans's performance suggests she felt she had a claim to a range of Oriental roles, a broad definition encouraged by others, such as a woman she met who thought she might be suitable for either a Japanese or a Tibetan role. Yet by 1926 she had become systematic about studying Chinese literature and art, steeping herself in the culture she increasingly sought to represent. Even so, she still took other work if she could, such as appearing in the play *Martinique* at the Shaftesbury Theatre in June 1926.[84]

Arguably Quong's greatest success came in March and April 1929 when she starred with Laurence Olivier and the well-known Chinese-American actress Anna May Wong in *The Circle of Chalk*, a play by the German dramatist Klabund, based on a fourteenth-century Chinese play, first translated into English in 1929, and which would later be adapted by Bertolt Brecht. The 1929 production at the New Theatre, which consisted of 48 performances and was directed by Basil Dean, was probably the pinnacle of Quong's career. The plot concerns a young woman sold first into a tea-house and later to a wealthy man; Quong played the part of the jealous elder wife who accuses the young woman of murdering her husband. Anna May Wong, whose career had been in films, made her stage debut as the young heroine, and Laurence Olivier played her lover, the prince.[85] One notice of the play called Anna May Wong 'the Chinese film actress' (omitting any reference to her being American), and called Quong 'another Chinese actress'.[86]

The full review in *The Times* noted that 'there is a flash of genuinely evil passion in Miss Rose Quong'; another review noted that '[p]articularly good was Miss Rose Quong, who insinuated imagination into every word and movement as the jealous and revengeful Yu-Pi'.[87] Her performance certainly helped establish her name in London, and it was registered in Australia. The Sydney-based magazine *The Home* reported that her 'striking success' was 'acclaimed alike by critics and public'. Moreover, the magazine asserted, Quong had outshone Anna May Wong; she had 'scoop[ed] most of the praise from the critics' and indeed 'is credited with having popularized the Chinese literary cult in London'. The 'Melbourne Repertory Society', the review concluded,

83 Diary entry 18 December 1925.
84 'The Theatres', *The Times* 3 June 1926, p. 14.
85 'The Theatres', *The Times* 7 March 1929, p. 12; 'The Theatres', *The Times* 11 March 1929, p. 14.
86 'The Theatres', *The Times* 11 March 1929, p. 14.
87 'New Theatre: "The Circle of Chalk"', *The Times* 15 March 1929, p. 14; *The Era* 20 March 1929, p. 1.

'may well be proud of the [most?] famous member it has so far produced'.[88] *The Circle of Chalk* was revived in London in January 1931, following a production in Birmingham, and Quong again played the same character, Yu-Pi. This time the production was at the Arts Theatre, and included neither Anna May Wong nor Laurence Olivier; *The Times*, which preferred this second version of the play, commented approvingly that 'Miss Rose Quong's study in Oriental cruelty goes as deep as the play demands'.[89]

In October and November 1929 Quong appeared at the Embassy Theatre, Swiss Cottage, in *A Gambler in Brides*, described as a 'new comedy of Jewish life'.[90] Her recognition at this point was such that in March 1930 she gave two recitals of poetry, drama and dance at the Rudolf Steiner Hall, including a one-act play that had been written specially for her by Paul Swan, as well as excerpts from *The Circle of Chalk*. *The British Australian and New Zealander* announced the production, calling Quong 'the well-known Australian actress', whereas the notice in *The Times* called her 'the Chinese actress'.[91]

Some of Quong's early success in London occurred in private homes, in events called 'At Homes' to which hosts would invite guests to mingle and be entertained by varied programs; artists were sometimes paid for such performances. Perhaps inspired by that model, by 1932 Quong had launched what she called her 'Circle', a regular event on alternate Sunday evenings at which she would lecture on Chinese themes and recite poetry, or to which she would invite a guest speaker, and would usually include a musician or singer on the program. One report noted that Quong could 'rely on a crowded and appreciative audience'; one Sunday evening her subject was 'Symbolism in Chinese Art', and her 'beautiful voice, with its many inflections, turned what might have been a theme only appealing to the few, into a most fascinating talk'.[92] She charged 2s 6d admission for these events, no doubt in part because her overall income was never robust, though she later recalled that it was during her years in England that she made more money than before or after. By this time she had her own flat on Chatsworth Road at Willesden Green, NW2, which served as the venue for her 'Circle'.[93]

88 'Melbourne Musings', *The Home*, June 1929, p. 13.
89 'The Theatres', *The Times* 15 January 1931, p. 10; 'Arts Theatre: "The Circle of Chalk"', *The Times* 23 January 1931, p. 12.
90 'The Theatres', *The Times* 10 October 1929, p. 12.
91 *The British Australian and New Zealander* 27 February 1930, p. 12; 'The Theatres', *The Times* 27 February 1930, p. 12.
92 *The British Australian and New Zealander* 22 December 1932, p. 10.
93 Printed invitation card for 'The Rose Quong Circle', Rose Quong Papers, MS 9796, National Library of Australia.

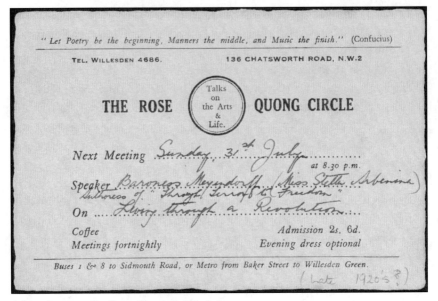

"*Let Poetry be the beginning, Manners the middle, and Music the finish.*" (Confucius)

TEL. WILLESDEN 4686. 136 CHATSWORTH ROAD, N.W.2

Talks on the Arts & Life.

THE ROSE QUONG CIRCLE

Next Meeting *Sunday 31st July* at 8.30 p.m.

Speaker *Baroness Meyendorff (Miss Stella Arbenina) Authoress of "Through Terror to Freedom"*

On *Living through a Revolution*

Coffee Admission 2s. 6d.
Meetings fortnightly Evening dress optional

Buses 1 & 8 to Sidmouth Road, or Metro from Baker Street to Willesden Green.

(Late 1920's?)

Advertisement for Rose Quong's 'Circle'

Source: Papers of Rose Quong, NLA MS 9796, with permission of the National Library of Australia.

Quong continued her occasional performances on BBC radio, such as those she gave in March 1933.[94] According to *The British Australian and New Zealander*, her career at this point was so 'triumphant' that she was 'gaining fresh laurels each week in different parts of the British Isles' including Cardiff and Bolton.[95] She was always willing to travel for an engagement (again at least in part to maximise her income), such as the lectures she gave to the Leeds Women's Luncheon Club and the Belfast Alpha Club in late 1932. A newspaper report of the latter address described her as 'attired in a Chinese costume consisting of bright green trousers embroidered in gold and a kimono-like top in soft yellow patterned with snakes'. Her lecture covered the contemporary position of women in China, the 'Bandit problem', Chinese language, poems and stories.[96] If her audiences were often female, in April 1933 she was on the program of the After-Dinner Club's reception at the New Burlington Galleries for a distinguished group including foreign ministers, and in October that year at Lymington she lectured to 'highly

94 'Broadcasting', *The Times* 18 March 1933, p. 4; 'Broadcasting', *The Times* 22 March 1933, p. 8.
95 Phyllis, 'In the Looking Glass', *The British Australian and New Zealander* 19 October 1933, p. 10.
96 *The British Australian and New Zealander*, 8 December 1932, p. 12; Clipping marked 'Belfast, Oct. 21, 1932', Rose Quong Papers, MSS 132, Box 4, Series III, Loose Materials from Scrapbook, Printed Materials and Ephemera, Historical Society of Pennsylvania.

placed retired army men and their relations'.[97] At the end of her life, Quong recalled one of her triumphs as the time when two thousand people listened to her lecture at the City Temple in London.[98]

In February 1934 Quong embarked on an eleven-month visit to the United States and Canada, lecturing, being honoured at receptions and interviewed by the press. She must have employed an agent to arrange bookings for her prior to the trip, because she began making appearances as soon as she arrived. She used at least one agent during the trip; a flyer advertising her performances was printed in October 1934 by William B. Feakins, Inc., of Fifth Ave., New York, with the following testimonial: 'Miss Quong gave her program to an audience of over five hundred women at our Club House last Thursday, and I can truly say I have never seen an audience as completely charmed as they were. Her simplicity, her ability to bring us the heart of China in so few words are rare qualities and when combined with her deeply radiant personality – well, it makes a perfect program. I thank you sincerely for recommending her to us. We all hope to have her again. Very truly yours, Lillian S. White'.[99] Interestingly, her appearances in New York included functions with more of a political or moral cast than her work in England, which was limited to the cultural and intellectual. On 24 February she spoke on 'The Philosophy and Religions of China' at a meeting of the Society for Ethical Culture.[100] On 27 February she was billed as 'Rose Quong, well-known Chinese diseuse, in costume' for a luncheon held by the League for Political Education at the Astor to raise funds for unemployed single women.[101] In July 1934 she appeared at the Ritz in New York, again with Anna May Wong, in an event that one newspaper described as '"Occidentals feast[ing] on [the] Beauty of Two Stage Stars"'.[102]

While she was based in New York, she travelled extensively for speaking engagements: in March, April and November she was in Chicago, where she performed more than once at the Cordon club.[103] Her itinerary in the United

97 'Court Circular', *The Times* 4 April 1933, p. 19; *The British Australian and New Zealander*, 19 October 1933, p.10.
98 Rosston, 'From Australia to the West Side', p. 9.
99 Handout from William B. Feakins, Inc., New York and San Francisco. MSS 132, Rose Quong Papers, Box 4, Series III, Printed Materials and Ephemera, Loose Materials from Scrapbook, Historical Society of Pennsylvania.
100 'Religious Services', *The New York Times* 24 February 1934, p. 16.
101 '"Forgotten Women" Luncheon', *The New York Times* 21 February 1934, p. 24. A 'diseuse' is an artist who entertains by spoken monologue.
102 Entry for 19 July 1934, Diary 1934–1938, Rose Quong Papers, MSS 132, Series II, Writings, Box 1, Folder 10, Historical Society of Pennsylvania.
103 'Footnotes', *Chicago Daily Tribune* 11 March 1934, p. F6; 'Footnotes', *Chicago Daily Tribune* 8 April 1934, p. E4; 'Footnotes', *Chicago Daily Tribune* 11 November 1934, p. F6.

States was partly facilitated by the extensive network of women's clubs spread across the country and which all had programs of regular events. It was therefore quite appropriate that she performed at a dinner at the annual convention of the New York State Federation of Women's Clubs at Buffalo in November; perhaps ironically, one of the convention agenda items concerned tightening the law to ensure registration of aliens.[104] So important was it to Quong to announce her Chineseness that she managed to get herself ejected from a train across the US that passed through Canada. At the Canadian border in Detroit, she was refused entry because she was considered Chinese and, like Australia, Canada had racially based immigration laws. She told her story to a policeman at the Detroit train station, where she was stranded overnight. The policeman, she later recounted, was 'bewildered as I had been. Canada was part of the British Empire; I was born in Australia and was therefore a British subject. "But," I added, "I happen to be Chinese." Puzzled, [the policeman] asked: "And how did they discover that?" "Why I told them so." "Holy Mike, born in Australia, speaking English as you do, why the devil did you drag in China?"'[105] The policeman's puzzlement reflects the ambiguity of her identity in everyday street dress, rather than her 'Oriental' outfits.

When she returned to London in January 1935, *The British Australian and New Zealander* boasted that 'Miss Rose Quong has just returned to London after a stay in the States lasting nearly twelve months, which has been one constant succession of triumphs'.[106] In London in July 1935 Quong appeared in an early television broadcast, a low definition form known as the 'Baird Process'.[107] At the end of 1935 she embarked for the US for another extensive lecture tour, announced in early January 1936 by *The New York Times* as 'Rose Quong, Chinese actress born in Australia' who had arrived 'to make a tour of the United States in a one-woman show depicting the culture, wit and philosophy of China'[108]; it would be her last visit before moving permanently to New York in January 1939. On this second trip in 1935–36, again she was based in New York, and again she travelled widely giving talks, but this time she went further – as far as her imagined homeland itself. In March she toured California, visiting

104 'Alien Drive Urged on Women's Clubs', *The New York Times* 28 October 1934, p. N1; 'Clubwomen Urged to Aid Crime Drive', *The New York Times* 13 November 1934, p. 19.
105 Rose Quong, 'Spiritual Forces and Race Equality', in *The Role of the Races in Our Future Civilization* ed. Harry W. Laidler (New York: League for Industrial Democracy, 1942), pp. 35–6.
106 *The British Australian and New Zealander* 10 January 1935, p. 8.
107 *The Times* 22 July 1935, p. 7.
108 'Rose Quong Here for Tour', *The New York Times* 7 January 1936, p. 24.

Los Angeles, Palm Springs, Santa Barbara and San Francisco. *The Los Angeles Times* described her as a 'Cantonese charmer, born and educated in Australia' who was 'a very attractive person' with a 'seductive voice'.[109]

Then on 30 May 1936, on what must have been for her a momentous voyage, she sailed from San Francisco to China, arriving in Shanghai. In China, she took lessons in Mandarin (she had taken Chinese language lessons in London from a Mrs Wang, starting in January 1935[110]), was interviewed by the press, travelled to 'Peiping' and went sightseeing, and enrolled for a few weeks at a college of Chinese studies. In 'Peiping' she apparently socialised with elite European and American expatriates, being entertained at a dinner by the professor of English literature at the university, and the guest of honour at a luncheon where American women mixed with Chinese noblewomen.[111] In late September she departed China and sailed back to America; it would be her only visit. She lectured to sizeable audiences across the United States both on the way to China and on the way back, mostly at women's clubs. In Detroit she had an audience of 1500 for her lecture at the town hall. The return trip talks consisted largely of her travel observations in China. One handwritten draft of these talks exudes her excitement at actually being there. By this time, her identification as Chinese was so complete that, in a talk in San Francisco on the way back, for example, she referred to '[o]ne of *our* great poets, Po Chu' [my emphasis].[112] At another time, she spoke of '[w]e in China', 'my Westernized head' and 'my Chinese heart', and '[o]ur ancient sages and philosophers'.[113]

Back in London, she studied Chinese culture and literature avidly, and by 1938, if not earlier, had become a welcome guest at the Chinese embassy.[114] In the view of *The British Australian and New Zealander*, by this time Quong had fully reached her potential, 'to her own advantage and the benefit of scores of thousands of people who have heard her talk or lecture or preach in this country, America, Canada and the East'. The paper was especially impressed that she had 'studied the language and literature so assiduously and successfully that she can read the Chinese sages in the original, and on a

109 Alma Whitaker, 'Today's Sugar and Spice', *The Los Angeles Times* 29 March 1936, p. D11.
110 Diary 1934–38, Rose Quong Papers, MSS 132, Series II, Writings, Box 1, Folder 10, Historical Society of Pennsylvania; *The British Australian and New Zealander*, 4 March 1937, p. 14.
111 Cousin Eve, 'Cousin Eve Tells of Stirring Trip to Wall of China', *Chicago Daily Tribune* 4 October 1936, p. F2.
112 'China', handwritten in notebook, Rose Quong Papers, MSS 132, Box 3, Folder 1, Historical Society of Pennsylvania.
113 Quong, 'Spiritual Forces and Race Equality', pp. 33, 34.
114 Diary entries for 7 and 19 March 1938, Diary 1934–38, Rose Quong Papers, MSS 132, Series II, Box 1, Folder 10, Historical Society of Pennsylvania.

recent visit to China she was able to give an address to a critical audience in Mandarin, the official and literary language of Pekin [sic]'. In its judgment: 'In interpreting East to West and West to East, and helping mutual understanding and good will, Miss Quong is doing valuable work for both, which was greatly appreciated in high quarters in China'.[115]

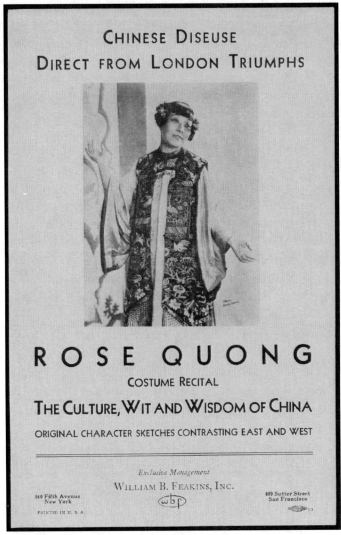

Advertising flier used by Quong's New York agent

Source: Papers of Rose Quong, NLA MS 9796, with permission of the National Library of Australia.

115 Rollingstone, 'Here and There', *The British Australian and New Zealander* 4 March 1937, p. 14.

Perhaps the growing tensions in Europe were a factor in Quong's decision to move to the United States, or perhaps the success of her two trips had convinced her that she could do even better there than in London. Living in America was sufficiently important to her that she persevered with considerable difficulties in acquiring legal permission to stay, which seem at least in part to have been caused by the absence of a formal registration of her birth in Melbourne. Her struggle for legal residency in the United States was so protracted that as late as 1960, her brother Norman supplied a legal deposition about her birth and their family, which was accompanied by a letter from Dr. H.V. Evatt, Chief Justice of the Supreme Court of New South Wales and Norman's employer, testifying to his character.[116] In New York, she continued to travel and lecture, beginning as soon as she arrived. In January 1939 she lectured on 'The Soul of China' to the Columbia University Institute of Arts and Sciences.[117] In February she performed at a meeting of the Theatre Club at the Hotel Astor, and in May, billed as 'Miss Rose Quong from China' she spoke at the 25th biennial conference of the American National Council of Women, as part of a session on 'Women in the World Crisis' that was also broadcast on the radio.[118] Women's clubs continued to be a staple part of her work and income, and she also ran a 'Circle' just as she had done in London.[119] She seems to have established a recognised public profile: in 1944, a miniature painting of her featured in an art exhibition in Chicago of portraits of 'stage stars'.[120]

By the late 1930s Quong had adopted a role she would emphasise for the rest of her life, that of cultural interpreter between East and West. She went so far as to tell an American audience that Westerners would have to hurry up and learn Chinese language and culture, otherwise China would gain the advantage and relations between East and West would tilt in the favour of the former.[121] This stance underlay the books she published, *Chinese Wit, Wisdom and Written Characters* (Pantheon Books, 1945) and a work of translation titled *Chinese Ghost and Love Stories* (Pantheon Books, 1946). *Chinese Wit, Wisdom and Written Characters* sought to explain the derivation, philosophy

116 Correspondence, Series I, Rose Quong Papers, MSS 132, Historical Society of Pennsylvania.
117 'Events Today', *The New York Times* 27 January 1939, p. 15.
118 'This Week's Calendar of Club Activities Here and in Near-by Communities', *The New York Times* 25 February 1940, p. 48; 'Institute Program Lists 40 Speakers', *The New York Times* 21 May 1939, p. D5; 'Today on the Radio', *The New York Times* 25 May 1939, p. 50.
119 For example, in March 1940 she spoke at the College Club of White Plains, 'Activities Among Women's Clubs Scheduled for This Week in the Metropolitan Area', *The New York Times* 31 March 1940, p. 54.
120 Eleanor Jewett, 'Joliet Artists' League Shows a Fine Exhibit', *Chicago Daily Tribune* 6 August 1944, p. F2.
121 Quong, 'Spiritual Forces and Race Equality', p. 35.

and meanings of Chinese characters to a Western audience. A brief review in *The Los Angeles Times* called it 'A beautiful book of Chinese characters in which one may learn much concerning the relationship which holds between Chinese thought and art'.[122] The *Chicago Daily Tribune* commented:

> Rose Quong has told the story of the development of some of the more basic Chinese picture-characters, and her telling is a gem of wit and wisdom in itself. Her aim is to 'show how thought and form have combined to make of the Chinese written character – further than a symbol of meaning – an expression of philosophy, as well as of art'. With the help of Dr. Kinn Wei Siiaw's beautiful calligraphy, she succeeds admirably.[123]

The book was republished in New York in 1968, four years before Quong's death, by Cobble Hill as *Chinese Written Characters: Their Wit and Wisdom*.

In *Chinese Ghost and Love Stories* Quong translated traditional Chinese folk tales that had been collected by Pu Sung-Ling in the late seventeenth century. Quong selected and translated forty from the around four hundred that Sung-Ling had collected, and which were published in 1740. Her book was extensively illustrated and bore an introduction by Martin Buber. In his review in *The New York Times*, Carl Glick praised Quong's work:

> Miss Quong in a fresh, sparkling and delightful style has brought new meaning and new life to these fascinating folk tales. They are as enduring as the collections of folklore retold by Hans Christian Andersen and the brothers Grimm; the only difference being that these are Chinese, and consequently have a rare charm all their own. In her most excellent translation Miss Quong has made these stories lively and reasonable… Miss Quong has now and then added a comment of her own… Miss Quong has done a service to the Western world in bringing to us these immortal folk tales of old China.[124]

The positive reception of her books suggests that the years she had spent studying Chinese language and culture had paid off; her language skills particularly must have reached a high order for her to become a successful translator.

Yet she continued to cast her Oriental authority as exceeding Chinese culture. Her interest in representing Asian culture beyond Chinese was apparent as early as in Melbourne in 1923, when she announced that she would soon 'give recitals

122 'Literature and Arts of China Exemplified', *The Los Angeles Times* 3 December 1944, p. C6.
123 Will Davidson, 'Chinese Writing Shows Character of Its Culture', *Chicago Daily Tribune* 11 February 1945, p. E9.
124 Carl Glick, 'Oriental Otherworld', *The New York Times* 15 December 1946, p. BR11.

from Tagore, and the old Japanese plays'.[125] Her notebooks from the late 1930s show that she read widely on meditation, yoga, the Vedas, the Upanishads, the Mahabharata and the Bhagavad Gita, clearly intent on absorbing South Asian culture too. In May and June 1940 for five weeks in a row she was billed as presenting at the Sunday evening meetings of the Yogashrama, at Carnegie Hall.[126] She would continue this pan-Oriental stance into the 1940s and 1950s.

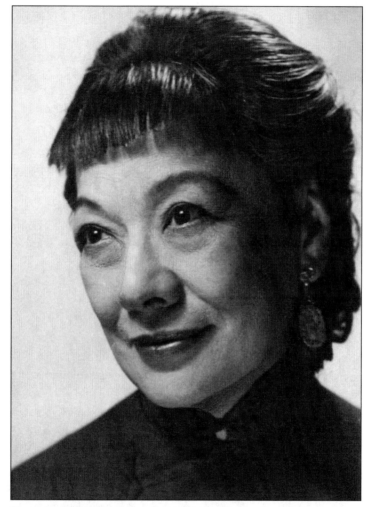

Portrait of Rose Quong, presumably during her New York years

Source: Rose Quong Papers, MSS132, Historical Society of Pennsylvania, with permission of the Historical Society of Pennsylvania.

125 Clark, 'Miss Rose Quong in Repertory Delights and Stimulates'.
126 *The New York Times* 12 May 1940, p. 48; 19 May 1940, p. 45; 26 May 1940, p. 37; 2 June 1940, p. 45; 9 June 1940, p. 47.

Quong's papers contain typescripts of two plays, plays that show her engagement with early Cold War politics in relation to Asia. By the 1940s she seems to have been considered a political authority: she spoke at at least one patriotic event during World War II, and was part of a broadcast session of the October 1943 conference held at the New York University Faculty Club by the Women's Council for Post-War Europe.[127] One of the two typescripts preserved in her papers is that of John Patrick's 1952 play based on the 1951 Vern Sneider novel *The Teahouse of the August Moon*.[128] Like the novel, the 1954 Pulitzer-prize winning play is set in postwar American-occupied Okinawa, and centres on the American Captain Fisby's attempts to institute democracy and stimulate industry in the village under his charge. The theme of the play is East meets West, but rather than the villagers simply absorbing the lessons of the American Occupation Force, Fisby learns to appreciate Okinawan culture and abandons his attempts to enforce the Occupation plan. For instance, he lets the villagers build a teahouse with the building materials intended for a school, and solves the village's economic crisis by selling their sweet-potato brandy to officers' messes all over the island. In a complicated piece of gender politics, Fisby's going native includes his learning to accept the Geisha woman whom the villagers give him. The denouement comes when his commanding officer arrives unannounced, only to find Fisby and his sidekick the army doctor both in kimonos and Japanese sandals, singing 'Deep in the Heart of Texas' to the enthralled villagers in the teahouse. The play can be read as a light-hearted critique of America's global politics and attempts to enforce Westernisation.

The other play is set in British Malaya in the 1940s or 1950s. While it is essentially a murder mystery about the disappearance of the wife of a British settler, the background context includes British colonial attempts to suppress the Malayan Chinese guerrillas.[129] Curiously, despite the fact that Quong preserved both typed playscripts among her papers, neither has a title page, playwright attribution, or any evidence as to why she had copies of the unpublished scripts. Because she mixed in theatrical circles in New York in the 1950s, it is conceivable that she was consulted by someone associated with the production of the first play. *The Teahouse of the August Moon* ran at

127 The patriotic event was a tea organised by the National Women's Division of the Committee to Defend America, *The New York Times* 7 March 1941, p. 18; 'Women to Discuss Post-War Europe', *The New York Times* 17 October 1943, p. 31.
128 Vern Sneider, *The Teahouse of the August Moon* (New York: G.P. Putnam's Sons, 1951); John Patrick, *The Teahouse of the August Moon* (New York: G.P. Putnam's Sons, 1952).
129 Scripts, Rose Quong Papers, MSS 132, Series III, Box 4, Printed Materials and Ephemera, Folder 6, Historical Society of Pennsylvania.

the Martin Beck Theatre from October 1953 to March 1956. While the cast includes a few minor roles for older women, Quong is not listed in the cast for the opening night at least – though it is possible she may have been considered for a role.[130] Quong's interest in these two plays seems to be an assertion of a pan-Oriental expertise. By the evolving Cold War of the late 1940s and the 1950s, China had become a more complicated commodity to sell to American audiences, and she may have been strategically broadening her claimed cultural authority. By the 1950s, she may also have needed to cloak her own political sympathies. Her views are evident from a speech she gave at a 1942 symposium organised by the democratic socialist League for Industrial Democracy; at that point at least, she supported Mao's Communist forces. Speaking on a program with other participants such as Pearl S. Buck and the socialist Norman Thomas, she endorsed 'the spirit of China today' that she saw in 'guerrilla troops, ill-equipped, battling now for five years against a powerful modernly equipped enemy; ... University professors, teachers and students, treking with their books thousands of miles into the hinterland, carrying on their work as they go; ... men, women and children hewing roads through mountain ranges with axes, hammers, spades and even food-choppers'.[131]

In New York as in London, Quong continued to win roles in various theatrical productions, despite her advancing age. In March 1941 'The Circle of Chalk' was performed by the Studio Theatre at the New School for Social Research, off Broadway. Quong played her old role of Mrs Ma, the rich tax collector's wife, and was described in the press as heading the cast, with 'an excellent performance of coarse and cruel duplicity'.[132] In December 1941 to January 1942, she appeared in 'Portrait of a Lady' at the Majestic in Boston.[133] At the age of 79, she appeared in the Broadway production of the Rodgers and Hammerstein musical 'Flower Drum Song' in 1958–59, based on the successful novel of the same name, set in San Francisco. A story of

130 Information on *The Teahouse of the August Moon* from the Internet Broadway Database http://www.ibdb.com/production.asp?ID=2377 accessed 23/06/08. I should acknowledge that in my published article, 'Rose Quong Becomes Chinese: An Australian in London and New York', *Australian Historical Studies* No. 129 (April 2007), pp. 16–31, I incorrectly asserted that Quong wrote these plays. My mistake was because the copies of the scripts in her papers bear no title page or playwright's name, because she was actively writing and publishing East-meets-West material in those years, and because I was then unfamiliar with the Sneider novel and Patrick play *The Teahouse of the August Moon*.
131 Quong, 'Spiritual Forces and Race Equality', p. 34.
132 'News of the Stage', *The New York Times* 25 March 1941, p. 27; Brooks Atkinson, 'The Play', *The New York Times* 27 March 1941, p. 28.
133 'News of the Stage', *The New York Times*, 5 January 1942, p. 21; 'News of the Stage', *Christian Science Monitor* 5 January 1942, p. 11.

generational conflict in a Chinese immigrant family, the production was at the St. James Theatre, and was directed by Gene Kelly. The production apparently did well; the review in the *Chicago Daily Tribune* singled out Rose Quong as one of the 'outstanding players' for her role as Liu Ma.[134]

In her last decades, Quong evinced a growing interest in astrology and the metaphysical, which was reflected in the venues for some of her later public talks. In October 1942, for example, she addressed the New York Forum at the Hotel McAlpin, on the 'Spirit of China'; other contemporary speakers to the same group covered topics such as hypnosis, astrology and magic.[135] Around this time, she justified her interest in spiritualism by stressing the ideas of balance and harmony in ancient Chinese philosophy.

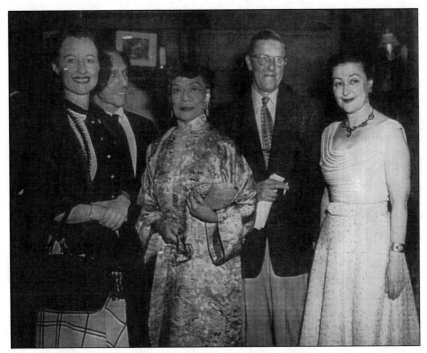

Rose Quong at an opening night at the White Barn Theatre in Westport, Connecticut
The accompanying newspaper caption identified 'Rose Quong, Chinese authoress' as part of the New York theatre world's 'Celeb Mecca'.
Source: Rose Quong Papers, MSS 132, Historical Society of Pennsylvania, with permission of the Historical Society of Pennsylvania.

134 '"Flower Drum Song" is Lovely Show', *Chicago Daily Tribune* 4 December 1958, p. C19; 'Theatre: Oriental Music', *The New York Times* 2 December 1958, p. 44.
135 Advertisements, *The New York Times* 24 October 1942, p. 18.

Quong claimed that equality, unity and peace would only exist in the world 'when the intellectual scientists of the West and the spiritual philosophers of the East can meet in mutual understanding and respect'.[136] By 1967, her interests seem to have become more mystical. In January that year, when she was 87 years of age, she was the guest of honour and featured speaker at the annual meeting of the Society for the Investigation of Recurring Events, held at the New York Academy of Sciences. Billed as 'Rose Quong, Actress-Artist-Author' who in her earlier career had 'interpreted China's culture to the world', advertising for the event claimed that:

> Miss Quong's present career is the result of years of study and writing in the field of Chinese philosophy. She has concentrated on studying cycles in cosmic events – and on the possible impingements of these cycles on earthly events. The Chinese "I CHING", written some 4000 years ago, provides a take-off-point for her soaring philosophy. Men working in harmony with cosmic change, she will tell us, are better able to effect change here on earth. The Yin-Yang theory of the "I CHING" might even permit us to reconcile ancient sage and modern scientist.[137]

At times during her decades in New York she mixed in glamorous social circles. But she continued to work and perform for most of her long life, presumably partly because of her energy and desire, but also because she had to earn her living. She was still speaking at women's clubs and presenting her recitals into the 1950s. Her modest standard of living is reflected in the facts that she spent the last thirty years of her life living in one room in a residence hotel (first at the Murray-Hill Hotel close to Grand Central Station, then from 1956 the Commander Hotel on West 73rd Street), worked for a while as secretary to a Chinese businessman in her eighties, and could not pay her doctor's bills during her last illness.[138] It must have been gratifying to be cast as herself (Rose Quong, 'Chinese astrologer') at the age of 91 in the Canadian and Warner Bros. film 'Eliza's Horoscope' starring Tommy Lee Jones, but the money would have been equally important.[139] The film was made between 1970 and 1974; by the time it was released Quong was dead. She died in New York on 14 December 1972, aged 93. Being Australian was still part of her identity in old age, despite the fact that she spent the

136 Quong, 'Spiritual Forces and Race Equality', p. 36.
137 Printed Materials and Ephemera, Loose Materials from Scrapbook, Box 4, Series III, Rose Quong Papers, MSS 132, Historical Society of Pennsylvania.
138 Correspondence, Rose Quong Papers, MSS 132, Series I, Historical Society of Pennsylvania.
139 'Movie Call Sheet', *The Los Angeles Times* 4 November 1970, p. 112; 'Movie Review: Eliza's Rocky Horoscope Show', *The Los Angeles Times* 15 June 1977, p. G22.

second half of her life elsewhere. The year she died she told a journalist that she recalled wandering in the Australian bush as a child 'crushing in my hands eucalyptus leaves…sniffing their tangy aroma while watching a koala bear on a low branch of a tree nibble the juicy leaves'.[140] She must especially have felt her distance from Australia when family members died, such as her mother in 1931 and her sister Florence in 1959.

Quong's story amply illustrates the constructedness, plasticity and transportability of ethnic identities, through her own adoption and adaptation of her Chineseness, and her strategic deployment of broader categories of the 'Oriental'. One remarkable feature of Quong's career is her reshaping of identity as she moved from Australia to London and then to New York. While we do not know a great deal about her early life in Australia, her theatrical work in Melbourne was within the Western canon of the day – despite her childhood reading of Chinese literature. It appears that she did not much advertise or publicly celebrate her Chineseness in early twentieth century Melbourne, even though Melbourne's Chinatown stood out for its size and resilience in the first decades of 'White Australia'. Her colleagues and audiences in Melbourne's amateur theatre world seemingly accepted and praised her, leading her to believe that a professional theatrical career in London was worth pursuing on the basis of her Australian and British identities. In interwar London, Quong juggled Australianness, Britishness and Chineseness, managing an identity that included recognisable aspects of all three, while working to foreground the Chinese element. The transportability of constructed ethnicity is highlighted by the fact that she could move this identity to New York, and sell herself there as Chinese in a context of the emerging category of Asian American, which scholars have suggested was a mid- to late-twentieth century artefact.[141] Quong exemplifies the transnational formation of Oriental and other race-based stereotypes, and their modern global circulation.

For the history of interwar Britain, Quong helps to complicate what we know of Orientalist representations of Chineseness. As we know from the work of Marek Kohn, in post-World War I Britain a panic about drugs was tied to Chinese men, gambling, opium, and especially Chinese men's perceived sexual attraction for young white women. Chinese communities had sprung up around the turn of the century, in port cities such as Liverpool and Cardiff, and in the docklands area of London. These 'Chinatowns' were

140 Rosston, 'From Australia to the West Side', p. 7.
141 Karen Shimakawa, *National Abjection: The Asian American Body Onstage* (Durham: Duke University Press, 2002), p. 2.

initially populated by merchant seamen, so not surprisingly most of the Chinese population was male. The fact that some Chinese men married white women sparked eugenicist anxieties about interracial unions, fears that fed stories about young white women being drugged and raped by Chinese and black men. Racist fears underlay the 1919 riots in which returned soldiers played leading roles, such as the Cardiff riots in which Australian soldiers were involved.[142] Rose Quong's celebrity in interwar London shows that domestic British Orientalism was multi-faceted, incorporating fascination as well as fear, and involving fantasies related to high-cultural productions as well as supposed dens of vice. No doubt the gendered dimensions were crucial here. If lower-class Chinese men were thought to represent a violent moral threat, an educated and well-spoken Chinese woman may have been seen as an intellectually respectable embodiment of Oriental sensuality. Yet Quong presents a complicated instance of the gendered politics of Orientalism. Orientalist representations have typically feminised Asians; Asian women especially have been seen as exotic, sensual and submissive. Quong cast herself as exotic but not erotic, and in asserting her status as an intellectual cultural authority, claimed a masculinised position.

Rose Quong's long career casts light too on the historical evolution of Orientalisms in the United States. Mari Yoshihara's book on white women and American Orientalism documents the ways in which American women appropriated and shaped Orientalism from the 1870s to the 1940s, as consumers, artists, performers, and writers. Yoshihara argues that white American women 'embraced the East' for complex reasons, not least because intervening in the developing ideology of Orientalism empowered them within domestic American culture.[143] American Orientalism, particularly in material culture and the arts, created a nationwide market for Quong's lectures and performances. In contrast to Anna May Wong, whose career in the 1920s–30s was primarily in film and mostly contemporary roles, Quong presented herself as an interpreter of centuries-old Chinese literature. Therefore, while Wong was often cast as a sexual figure in romantic or tragic roles, Quong – who was much older – represented intellectual and cultural Chineseness. As Karen Leong argues in her study of Wong, the specific nuances of Orientalism in these decades shifted with political events and diplomatic relationships. In the 1930s and early 1940s China was an

142 Marek Kohn, *Dope Girls: The Birth of The British Drug Underground* (London: Lawrence & Wishart, 1992), esp. Introduction, Ch. 4, and 148.
143 Mari Yoshihara, *Embracing the East: White Women and American Orientalism* (New York: Oxford University Press, 2003).

ally of Britain, the United States and Australia and therefore a subject of interest.[144] By the late 1940s, China was seen as more menacing. Both Wong and Quong's careers faded as the Cold War intensified. Quong's ability to maintain her career at all may have depended in part on her British and Australian identities.

The fact that she created a successful transnational career out of her Chineseness – in sites ranging from Britain, to the United States, and China – demonstrates the transnational marketability of Orientalisms in the early- to mid-twentieth century, and their construction through a process in which Westerners and those who identified as Asian were complicit. At the same time, it is imperative that we identify the power imbalance between the parties in this process. Quong's story shows that marketing herself professionally as Chinese was a compromise at which she arrived, not just from her own predilections, but because a career as a Shakespearean actress seemed foreclosed, and her British and Australian advisers urged her towards specialising in the exotic and Oriental. As Ien Ang has argued, the capacity of racism and Orientalism 'as forces that perpetuate and reinforce essentialist notions of the Chinese other should not be underestimated'. With Anglo-Celtic Australian and British people resisting Chinese-Australians' claims to Englishness or Britishness, and insisting that they should instead enact Chineseness, it is hardly surprising when Chinese-identified people embrace a sense of belonging to the Chinese diaspora.[145] Rose Quong's story shows such dynamics concretely at work. As Marilyn Lake and Henry Reynolds have recently charted, the late nineteenth and early twentieth centuries were the epoch in which being 'a white man' became a transnational racial identity with legal and regulatory powers that varied from site to site but reinforced each other in a global formation.[146] Quong's story exemplifies the diasporic Chinese identity of the same period, indubitably shaped in part in response to subordination and hegemonic whiteness, and also a transnational formation, one shaped by migration and the imagined cultures of modernity.

144 Karen J. Leong, *The China Mystique: Pearl S. Buck, Anna May Wong, Mayling Soong, and the Transformation of American Orientalism* (Berkeley: University of California Press, 2005).
145 Ien Ang, 'Can One Say No to Chineseness? Pushing the Limits of the Diasporic Paradigm', *Boundary 2*, Vol. 25, No. 3 (Fall 1998), pp. 236, 235, 238–9.
146 Marilyn Lake and Henry Reynolds, *Drawing the Global Colour Line: White Men's Countries and the Question of Racial Equality* (Carlton, Vic.: Melbourne University Press, 2008).

Chapter 3

Merle Oberon

Nationalism and Negotiating the Exotic

In early twenty-first century Australia, curiosity about racial mixing is sufficiently pervasive that one commentator has declared: 'Eurasians are "in", "they've got the look" and they are all over the place… In Australian media Eurasian young women increasingly appear on catwalks, stages and advertisements. They have the "Look", the red-hot fantasy-fused "Look" eagerly sought by fashion, music and advertising agencies'.[1] It is as though Eurasian women have come to represent global modernity, as a Eurasian or East-West look did in 1920s Japan, a style to which Annette Kellerman was linked. Yet, as Julie Matthews argues, it would be erroneous to assume that this demand for Eurasians as models in contemporary Australia is the product of any post-racist cosmopolitanism. Interest in what Matthews terms 'happy hybridity',[2] rather, still depends on the hierarchies of race and sex established historically by colonialism, not least the desirability of whiteness or near-whiteness, and the ubiquity of representations of the female body as spectacle for visual consumption.

Colonialism has depended upon the plasticity of class status and racial categories, even as colonial elites sought constantly to shore up the boundaries and markers that sustained their elite status. As Homi Bhabha has helped us to understand, colonialism fostered subject positions in which the colonised were supposed to emulate the colonisers, only to be mocked for their mimicry of their superiors.[3] For the mixed-race, such as the Anglo-Indian community in late colonial India, any aspirations to be

1 Julie Matthews, 'Eurasian Persuasions: Mixed Race, Performativity and Cosmpolitanism', *Journal of Intercultural Studies* Vol. 28 No. 1 (February 2007), p. 43.
2 Matthews, 'Eurasian Persuasions', p. 44.
3 Homi K. Bhabha, *The Location of Culture* (London: Routledge, 1994), pp. 86–87.

accepted as fully British were constantly checked by structural exclusion and marginalisation. For the young woman who would become mid-twentieth century film star Merle Oberon, transnational mobility, her imperial access to the metropole, was a way of escaping those constraints and reinventing herself as part of the colonial ruling elite. That she did so through a fabrication of herself as another kind of colonial – Tasmanian – suggests the connections between transnational mobility, racial hierarchies and pretence, as well as the necessity of whiteness for stardom in the early to mid-twentieth century.

If some transnational life stories have hinged upon secrecy, suppression and even lies, in Oberon's case there was yet another element – the willing participation in belief of a colonial audience from a country in which she never set foot until three brief visits late in life. Oberon's lifelong pretence to be Tasmanian – an invoking of a safely remote, colonial location associated with white settlers – was enabled by the eager collusion of her imagined compatriots. Thus, a film star whose life was lived in the Northern hemisphere, purported to hail from a distant Southern hemisphere location, trusting in that very distance to preclude the possibility of detection. While Oberon and the London studio publicists who invented her story saw that geographic distance – close to the exact other side of the world – as a buffer, at the same time it strengthened the desires of Tasmanians and other Australians to claim her. The transnational imaginations – or the transnational lives of the mind – of those southern fans stretched around the globe to incorporate someone none of them had met, as one of their own.

Merle Oberon's life was transnational in real ways: she moved from Calcutta to London to establish her career, then back and forth between London and Hollywood before settling in the latter, later to Mexico, and back to Hollywood. We know these basic elements from the work of biographers Charles Higham and Roy Moseley, whose book *Princess Merle* was published in 1983. From them we know too about the propaganda work of the London studio publicists who in the 1930s invented her 'Tasmanian' birth in order to locate her as a colonial and at once to obscure her lower-class and mixed-race origins. From Cassandra Pybus's 1998 essay 'Lottie's Little Girl', and Maree Delofski's 2002 film *The Trouble with Merle*, we know about the tenacious Tasmanian mythology of Oberon's imagined Tasmanian birth to Chinese hotel worker Lottie Chintock. In the late 1980s and the 1990s Pybus followed stories and leads in northeastern Tasmania. Confronted with the clear absence of a Tasmanian birth certificate for

Oberon, and a remarkable set of variations of the Tasmanian story, in her essay Pybus muses on the power of narratives.[4]

Delofski conducted both archival research and oral interviews in the process of making her documentary. One startling result of her research was a revision of Higham and Moseley's biography. Higham and Moseley had consulted Harry Selby, an Anglo-Indian Canadian resident who said at the time that he was Oberon's nephew, and who provided the biographers with much of the material on her early years in Bombay. Selby shared with Delofski some key facts he had not been prepared to tell the earlier researchers because of his then concern for his own family. With a birth certificate to prove it, he claimed that he and Oberon had had the same mother – that he was not Oberon's nephew but half-brother. Their mother Constance Selby had become pregnant by her stepfather, was 15 at the time of Oberon's birth, and had given her daughter to her own mother to raise.[5] Yet this archival revelation was only one of the film's concerns. The heart of the film is the late-twentieth century and continuing mythology that denies Oberon's birth in Bombay and locates her instead as Tasmanian. Through interviews with descendants of Lottie Chintock and other Tasmanians, Delofski evokes the emotional investments of the storytellers. As Delofski wrote in an article about making the film: 'The Tasmanians' stories of Oberon's upbringing had been, in the main, second- or third-hand accounts exchanged across generations and, generally, outside the lived experience of the storytellers. Ultimately, their significance lay more in what they revealed about the tellers' struggle for identity than as authenticated information about Oberon's provenance'.[6]

Both Pybus and Delofski's work documents the cultural processes in which the mythology of Oberon's Tasmanian birth has been shaped and sustained in recent decades, and the attachment of some Australians to it. Even in the early twenty-first century, some Australians – particularly Tasmanians – perpetuate the mythology of Oberon's Antipodean birth in part because of the transnational cultural legitimacy it lends them. In recent years that process has had a boost from an unrelated source, the celebrity of Tasmanian Mary Donaldson, now Crown Princess of Denmark; another story of a Tasmanian attaining international glamour, albeit a demonstrably

4 Cassandra Pybus, 'Lottie's Little Girl', in *Till Apples Grow on an Orange Tree* (St. Lucia, Qld.: University of Queensland Press, 1998), pp. 91–111.
5 Maree Delofski, 'Storytelling and Archival Material in *The Trouble with Merle*', *The Moving Image* Vol. 6, No. 1 (Spring 2006), p. 91.
6 Delofski, 'Storytelling and Archival Material', p. 94.

true one. It should be added that this tenacious mythology was supported by Oberon's own lifelong adherence to the studio-publicity fiction of her birth; she never admitted to her mixed-race, Indian origins, and herself provided various versions of her life that linked a Tasmanian birth with brief time spent in India. One instance is the version she provided *The Washington Post* in March 1935, according to which: 'I was born Estelle Merle O'Brien Thompson in Hobart, on the island of Tasmania, February 19, 1911. My father, who died before I was born, was an English army officer; my mother is English and French-Dutch'. In this account, Oberon travelled from Tasmania to Calcutta, where she lived with her mother and an uncle, was educated in the style of army families, and graduated at 16 from 'La Martinere College'. After college, she performed with the Calcutta Amateur Theatrical Society (a fashionable set known as the 'Cats'), and at 17 toured Europe with the aforementioned uncle. This imagined uncle was supposed to be quite rich: wealthy enough that, when she purportedly informed him that she did not want to return to India, he allowed her to go to England and provided her with the security of a ticket home and some cash. In London, according to this story, when her money ran out she worked as a cabaret dancer at the Café de Paris, before she began to get work in films. In this representative version of her life, as in others she gave at other times with minor variations, Oberon blended a few elements of truth into a largely fictional story that specifically sought to locate her as a white colonial from the privileged classes of the mobile imperial elite. That her stories failed to allay completely the concerns to do with her origins is underscored by the fact that the *Washington Post* article in which this one appeared referred to her as 'an alien', and called her 'one of the most exotic of the cinema's contemporary decorations'.[7]

In this chapter I consider how Australians in the 1930s – including but not only Tasmanians – participated in the construction of Merle Oberon as Tasmanian. Rather than the mythology of recent decades, I examine the Oberon story as it was first being spread and elaborated through the popular press. The Oberon story is connected to Kellerman and Quong's stories as yet another variation of the racial interpretations of 'Australian' female celebrities from the 1910s to the 1930s; how in making themselves recognisable, a few women performers created newly modern, racially ambiguous Australian femininities, and how those ambiguities played out

7 Nelson B. Bell, 'An Exotic Young Star of the Screen Breaks Down and Confesses All, at Last', *The Washington Post* 22 March 1935, p. 22.

in popular culture. This essay is about an imagined transnational life story more than an actual transnational life. It is also concerned with how popular culture shaped such stories, how lives have been transnational in fictitious as well as material ways, and how a belief that whiteness was necessary to success underpinned both colonial cultures and the emergent world of film. The geographical mobility facilitated by colonialism, such as the colonial pilgrimage to the metropolitan 'Home', enabled some mixed-race colonial subjects to reinvent themselves as quite 'white'.

Oberon was in fact born Estelle Merle O'Brien Thompson in Bombay in 1911; her mother was Anglo-Indian (actually from Ceylon), and her father English. It is unclear whether Oberon knew that the woman whom she called her mother (Charlotte Selby Thompson) was in fact her grandmother, and that the woman she regarded as a half-sister (Constance Selby) was her mother. Charlotte and Constance had a fraught relationship, partly due to Constance's Irish father's rejection of them both, due to which Charlotte had left Colombo where Constance was born, and moved to Bombay. Their relationship was not helped by the fact that Charlotte's lover (and later her husband) Arthur O'Brien Thompson, a railway engineer from Durham, became sexually interested in Constance and in fact impregnated her. After Oberon's birth when Constance was only 13 or 14 years of age, Charlotte and Constance became estranged; Constance married a Goanese man and remained in Bombay. Constance resented what she regarded as Charlotte's favouring of Queenie (as Oberon was known during her years in India, as were other girls her age due to the 1911 royal visit); disabled by a stroke at age 30, in later life Constance became bitter and importuning. After Oberon became successful and wealthy, Constance wrote her unhappy letters requesting money; Oberon occasionally sent her small amounts, but avoided seeing her. In 1917 Queenie and her (grand)mother moved to Calcutta, where for a while Queenie attended the prestigious boarding-school La Martiniere as a charity student. She left school early, attended business school, became a typist and telephone switchboard operator, and performed with the Calcutta Amateur Theatrical Society. In 1929, Oberon sailed for London, with a brief stop in Nice, her sights set on film acting. At first she resorted to work as a dance hostess, but before very long began to get work at Elstree Studios.[8]

8 Charles Higham and Roy Moseley, *Princess Merle: The Romantic Life of Merle Oberon* (New York: Coward-McCann Inc., 1983), pp. 17–42; Delofski, 'Storytelling and Archival Material'.

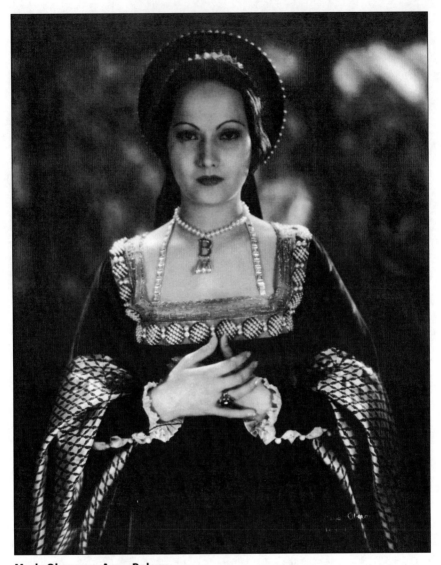

Merle Oberon as Anne Boleyn

Source: Special Collections, Cleveland State University Library, with permission of ITN Source.

Very briefly, Oberon's first film was *Alf's Button* in 1930 – a bit part. She had a few more bit parts before she was picked up by producer and director Alexander Korda in *Wedding Rehearsal* (1932). She was first really recognised as Anne Boleyn in *The Private Life of Henry VIII* by Korda in 1933. Then she was reasonably successful in, for example, *The Battle* 1934; *The Broken Melody* 1934; *The Private Life of Don Juan* 1934; and *The Scarlet Pimpernel*

1934. Oberon's first big hit was *The Dark Angel* in 1935; which was followed by *These Three* in 1936 by Sam Goldwyn co-starring Joel McCrea; *Beloved Enemy* in 1936 by Goldwyn co-starring David Niven; *Over the Moon* in 1937 by Korda, co-starring Rex Harrison; *The Divorce of Lady X* in 1938 by Korda, co-starring Laurence Olivier; *Wuthering Heights* in 1939 by Korda and William Wyler, in which she played Cathy opposite Olivier's Heathcliff, and many more. She featured regularly in films into the 1950s; made a few late films in the 1960s, and starred in a last one in 1973, six years before her death at age 68.[9]

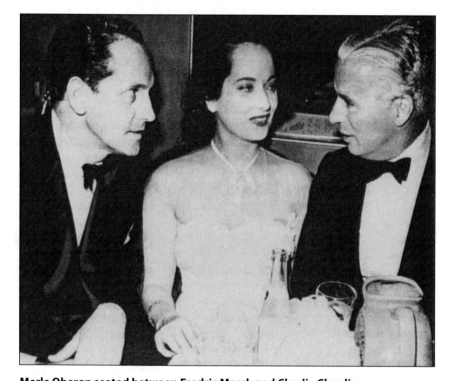

Merle Oberon seated between Fredric March and Charlie Chaplin

Source: Charles Higham and Roy Moseley, *Princess Merle: The Romantic Life of Merle Oberon* (New York: Coward-McCann Inc., 1983), with permission of Culver Pictures, Inc.

As befitting any film star, gossip and press coverage made much of Oberon's romantic life. In the northern summer of 1934 reports swirled of her engagement and supposed marriage to Hollywood film producer Joseph Schenck of Twentieth Century Pictures, soon followed by stories of

9 From the filmography in Higham and Moseley, *Princess Merle*, pp. 218–20.

a rift with Schenck and a romance with 'a handsome young member of the British nobility'.[10] By the end of the year, further stories involved Douglas Fairbanks Senior, Leslie Howard, and the film producer Alexander Korda.[11] Later gossip would suggest an affair with David Niven. In June 1939 Oberon married Korda in a civil ceremony in Antibes, France. The press had reported innumerable times that it was Korda's previous wife, Maria, who had first spotted Oberon's beauty when she was working as an extra at Elstree studios in London, because of which Korda gave her her first real opportunity.[12]

Alexander Korda was a Hungarian-born film entrepreneur who had a remarkably successful career, more in England than in Hollywood though he worked in both places. His first film work was in Europe, in Hungary, Germany, Italy and France; he brought his earlier experience and various European associates to London when he settled there, finding it congenial and determined to make British cinema competitive.[13] He was considered to have done so much for the British film industry from the early 1930s that in 1942 he was knighted, at which point Oberon became Lady Korda. Korda's two younger brothers Vincent and Zoltan both worked for him, so that his productions were very much a family enterprise. Michael Korda was the son of Vincent Korda, the film-set designer, and the actress Gertrude Musgrove; they separated when he was young, and Michael's childhood was divided between America and England. His own mobility combined with the fact that Oberon and Korda's marriage only lasted six years meant that Michael did not see a great deal of his Auntie Merle. Nevertheless, he became so obsessed with her that he wrote about her in his 1980 family memoir *Charmed Lives*, published only a year after Oberon's death, though twenty-three years after Alexander's. More significantly, he used her as the subject of his 1985 sensational novel *Queenie*. The fictional character assassination that Korda enacted on Oberon in *Queenie* is perhaps best understood as shaped by the Korda family dynamic in which Oberon was reviled as having used Alexander to build her career. Higham and Moseley suggest that Zoltan and Vincent's wives, who were also actresses,

10 'Schenck Announces Troth to British Film Actress', *The Los Angeles Times* 6 August 1934, p. 1; 'Joseph Schenck Marries British Screen Actress', *The Los Angeles Times* 8 August 1934, p. 1; 'Engagement Called Off: Schenck-Oberon Romance Fails', *The Los Angeles Times* 24 October 1934, p. 1.

11 Philip K. Scheuer, 'Intriguing "Myths" About Merle Oberon All Exploded', *The Los Angeles Times* 30 December 1934, p. A1.

12 'Merle Oberon Bride of Alexander Korda', *The Los Angeles Times* 4 June 1939, p. 1.

13 'Stage and Screen', *The Sydney Morning Herald*, Women's Supplement, 21 March 1935, p. 9.

were more accepted by the brothers because they were not as striking or successful as Oberon. Zoltan's resentment was such that he did not even attend Alexander's marriage to Oberon, despite being at the same hotel.[14] Zoltan also prevented her involvement in Korda productions in which she was interested; her own difficult behaviour on film sets as an actor perhaps contributed to the brothers' resentment.[15] Michael Korda notes that, despite their various pathological psychological dispositions, the three Korda brothers shared an exclusive closeness resulting from the hardships of their Hungarian childhoods, a closeness that exceeded their relationships to their wives and children.[16]

Michael Korda went on to a very successful career in publishing, both as a writer and as editor-in-chief at the New York publishing house Simon and Schuster. As an editor, Korda published highly commercially successful writers such as Jacqueline Susann and Harold Robbins. His own writing in the 1970s included commercially oriented advice books on power and success. His interest in power and success may have stemmed from his relationship with his domineering uncle Alexander. His book *Charmed Lives: A Family Romance* is essentially a biography of Alexander, interwoven with Michael's recollections of growing up in the Korda family and the movie world; one of its main concerns is to establish Michael's credentials as part of the famous filmmaking family. Alexander, as the eldest brother and head of the family enterprise, was a self-conscious patriarch, as well as being so influential that he was closely connected to Winston Churchill before and during World War II. It is not surprising then, especially given his own parents' separation and his shuttling between them, that Alexander was a powerful father figure for Michael, and in some ways more of an actual father than Vincent. Michael acknowledges at the end of *Charmed Lives* that 'a very large part of my life was built around Alex: he was somehow the central figure of my own myth'.[17]

Despite his obsession with Alexander, Michael Korda acknowledges in the book that his own social status among his peers derived more from Merle Oberon being his aunt. As an adolescent at school in New York, it was his connection to Oberon, not the Kordas, that won him kudos. Later as a teenager at an elite boarding school in Switzerland, where some of his classmates 'expected to inherit thrones', Oberon was so much the key to his

14 Higham and Moseley, *Princess Merle*, p. 113.
15 Higham and Moseley, *Princess Merle*, pp. 132–4.
16 Michael Korda, *Charmed Lives: A Family Romance* (London: Allen Lane, 1980), p. 10.
17 Korda, *Charmed Lives*, p. 419.

winning status that he 'kept a photograph of Merle on my desk'.[18] In this family memoir, Korda is quite complimentary to Oberon, acknowledging that she was the most successful of Alexander Korda's three wives and perhaps the one for whom he displayed the most passion. He also credits Oberon with having worked at getting on with Vincent and Zoltan, and with entertaining him and his cousin at her house in Bel Air – even if his memory of the house includes his own awkwardness and discomfort, not least at breaking one of her china tea cups.[19] Oberon's biographers support this picture of amity with the claim that she was actually fond of Michael Korda, entertaining him at her house of her own volition.[20] Above all, there is no hint in *Charmed Lives* of Oberon's mixed-race or Indian origins.

Korda saved that explosive topic for his 1985 commercially oriented novel *Queenie*. The perceived scandal of Oberon's provenance is so much the core of the 773-page novel that he opens it with an epigraph from Noel Coward:

…Half-caste woman,
Living a life apart,
Where did your story begin?
Half-caste woman,
Have you a secret heart,
Waiting for someone to win?
Were you born of some queer magic,
In your shimmering gown?
Is there something strange or tragic,
Deep, deep down?[21]

In the novel, the young woman who grows up in the Anglo-Indian community of Calcutta as Queenie Kelley moves to London and becomes the famous movie star Dawn Avalon, and the film producer who makes her a star and marries her is the Central European-born David Konig. Konig, who of course represents Alexander Korda, is unquestionably the hero of the novel; as one reviewer commented, Konig is the only character in the novel with any depth.[22]

While Queenie's mixed-race birth and her desperate attempts to cover it up and pass as white are the central plot device, Korda goes even further

18 Korda, *Charmed Lives*, pp. 11, 239–240.
19 Korda, *Charmed Lives*, p. 158.
20 Higham and Moseley, *Princess Merle*, p. 154.
21 Michael Korda, *Queenie* (New York: Warner Books, 1985), frontispiece.
22 Kristin Helmore, 'Korda's novel has the right ingredients, but the recipe flops', *Christian Science Monitor* 6 May 1985, p. 34.

in his incriminations of his fictional Oberon protagonist. A key figure in the story is her Uncle Morgan, an Anglo-Indian who makes a living as a nightclub musician. In fact, Oberon had no uncle, though her usual story of how she managed to get from Calcutta to London involved an imaginary rich uncle who paid her way and escorted her to Europe. Biographers Higham and Moseley suggest that the 'rich uncle' who actually funded her journey though did not accompany her may have been Sir Victor Sassoon; Oberon's story thus made this benefactor a literal relative.[23] Korda not only includes a fictional uncle in his story, but represents Uncle Morgan as incestuously in love with Queenie. In order to raise the considerable sum of money involved in leaving Calcutta for London – a sum she could not have raised on her own small earnings – Queenie goads Uncle Morgan into stealing a very expensive bracelet from his wealthy mistress. Once they reach London, their relationship deteriorates. Morgan rapes Queenie, and finally, in self-defence against his enraged and drunken assault, she kills him. Thus Korda saddled his Oberon character not only with her lower-class, mixed-race colonial background, but with the serious (and invented) offences of being an accomplice to theft and, later, of manslaughter in self-defence. These two offences, from both of which she escapes without punishment though not without fear, constitute Queenie's worst actions. Yet there are other moral indictments as well. Oberon admitted to having started work in London as a nightclub dance hostess; the fictional Queenie is a stripper. Throughout the novel she is also portrayed as greedy, ambitious, self-absorbed and uncaring. Kristin Helmore comments in her review: 'The worst thing about Queenie is not that she's ruthless, selfish, shallow, conniving, and cold – all *that* we could handle in a heroine. Her gravest, truly unforgivable fault is that she's made of cardboard'.[24]

Queenie may have sold well (with a printing of 150,000) but it was panned by reviewers. Michiko Kakutani in *The New York Times* noted that, given the quality of *Charmed Lives*, she had expected a book with some merit; instead the 'novel is quite devoid of interesting language, great characters, terrific dialogue or even insights into the workings of Hollywood'.[25] Nevertheless, the novel was turned into a television mini-series broadcast in the United States in 1987; it took even further liberties

23 Higham and Moseley, *Princess Merle*, p. 34.
24 Helmore, 'Korda's novel has the right ingredients', p. 34.
25 Michiko Kakutani, 'Books of the Times; Climbing the Ladder', *The New York Times* 6 April 1985.

with the story, and also received poor reviews.[26] Given Michael Korda's success with earlier books, the shortcomings of *Queenie* as a novel are perhaps surprising, especially considering the potential of the dramatic elements with which he had to work. It is as though the emotional imperative behind the book, to expose Oberon's racial secret, and to satisfy his own personal motivations, overwhelmed his writing style. The novel is clearly based on detailed knowledge of Oberon's life, though Korda has jumbled elements of her biography in order to fictionalise it. Thus, her marriages are presented somewhat out of order and with some conflating and mixing of her husbands' and lovers' characteristics; a car accident she had in London is transposed to Hollywood; a light-plane crash in the south of France that killed a man she planned to marry is shifted to the United States; and an episode of medical treatment is moved from New York to Mexico, among other inventions.

Yet what emerges powerfully from the novel, perhaps because it lay at the heart of Korda's purpose, is the sense of shame and secrecy that drove Queenie to cover up her Anglo-Indian past. The fictional Queenie is haunted throughout her life by the fear of being exposed by someone who knew her in India; she keeps running into people she desperately wishes to avoid. Oberon must have had similar fears, given her lifelong pretence to have been born in Tasmania. More than this, *Queenie*'s first chapters vividly evoke the subordination of Anglo-Indians in Calcutta. They describe the social hierarchy in which Anglo-Indians insisted on their respectability and Europeanness, in contrast to the Indians whom they employed as servants. Subordinated in material terms by the British, they formed their own sizable communities, and were customarily restricted to certain areas of employment. Anglo-Indian men worked on the railways and in clerical jobs; they were often favoured for the latter because they were fluent in both English and Indian languages. From the first decades of the twentieth century, Anglo-Indian women worked particularly as nurses and teachers, and in office work.[27]

In the nineteenth century, the term 'Anglo-Indian' signified the British resident in India. It was the Indian census of 1911, the year of Oberon's birth, that redefined the term to indicate the Eurasian or mixed-race community.[28] Anglo-Indians were known by the British as

26 John J. O'Connor, '"Queenie", Based on Korda Novel', *The New York Times* 11 May 1987.
27 Alison Blunt, '"Land of our Mothers": Home, Identity, and Nationality for Anglo-Indians in British India, 1941–1947', *History Workshop Journal* Issue 54 (Autumn 2002), p. 53.
28 Alison Blunt, *Domicile and Diaspora: Anglo-Indian Women and the Spatial Politics of Home* (Oxford: Blackwell Publishing, 2005), p. 1.

'chee-chees', a highly derogatory term; they themselves used the term 'domiciled Europeans'. The community had its origins in the marriages and sexual relationships between British men (who took advantage of the myriad jobs in the colonies) and Indian women, and the offspring they produced. Korda evokes a sense of Anglo-Indians' longing for the absent husbands and fathers who left them behind when they returned to Europe (as indeed Oberon's father had done, when he enlisted soon after World War I erupted, only to die during the Battle of the Somme). He conveys a plausible concern with skin colour and sun avoidance, as well as all of the fine distinctions and spatial exclusions enacted daily in British colonial life in India, by which Anglo-Indians were relegated to a life below the British. They themselves equally insisted on their place above Indians, who in fact rejected Anglo-Indians as outside their own communities. Not surprisingly, some Anglo-Indians thought of England as 'Home' even though most had never been there – just as did white-settler colonials in other imperial sites, including Australia.

Mark Haslam comments on the ways in which the *Queenie* television mini-series portrays stereotypes of Anglo-Indians, such as that they were 'lackeys' of the British – a stereotype represented in the weak character of Uncle Morgan. This stereotype derived, he observes, from Anglo-Indians' dependence 'economically, culturally, psychologically, spiritually and socially' on the British colonisers. Other stereotypes of Anglo-Indians that the series retailed include that of their desire for their British 'Home', and that of the sexual desirability of Anglo-Indian women. Anglo-Indians themselves, Haslam (an Anglo-Indian from Calcutta) suggests, have participated in this third stereotype through their own claims for their women's beauty – despite the fact that it includes connotations of sexual availability and even promiscuity.[29] As Alison Blunt points out, this stereotyping of Anglo-Indian women as exotic and objects of desire, and as more morally lax than European or Indian women, invokes 'assumptions about past inter-racial sex and its illegitimate progeny'.[30] Blunt further points to the complex gendering of Anglo-Indians' communal self-identity in the first half of the twentieth century, as Indian nationalism gained ground, independence became more likely, and the place of Anglo-Indians in an independent India loomed as an issue. Whereas 'a British imperial lineage was imagined through the figure of a British forefather', that of an Indian maternal ancestor was overridden

29 Mark Haslam, 'Queenie: Smudging the distinctions between Black and White', http://www.alphalink.com.au/~agilbert/queenie.html accessed 27 April 2006.
30 Blunt, *Domicile and Diaspora*, p. 54.

by the nationalist conception of Mother India, and a reemphasis on Anglo-Indian women's place as in the home. Despite their notional restriction to domestic roles, Anglo-Indian women's importance to the community was shored up by conceptions of Anglo-Indians' homes and domestic life as foundational to their being more European than Indian, and thus at least some Anglo-Indians' resistance to inclusion in the new Indian nation.[31]

The depth of Oberon's fear of her mixed-race origins being discovered is most poignantly reflected in the widely reported fact that, while her (grand)mother lived with Oberon in her early years in London, she largely kept her out of sight and, when necessary, introduced her to others as her maid or ayah.[32] Oberon's desire to become 'white' was such that she used a common bleaching cosmetic, a forerunner of the product still marketed in India today, by the Indian subsidiary of the British company Unilever, called 'Fair and Lovely'. According to biographers Higham and Moseley, while she used this bleaching makeup to lighten her skin, it did her considerable harm and caused her major medical problems for years. They record that even in her youth in India she was already suffering negative effects from it, and in London in 1934 she began to suffer rashes on her face, especially near her mouth. Despite her later use of special nonallergenic makeup, Higham and Moseley narrate a dramatic episode in 1940 in which Oberon suffered such a severe rash on her face and neck that she had to stop filming immediately and flew to New York for very painful and extended dermabrasion treatment. A specialist attempted to remove the scarring on her face, but it was not completely successful.[33] Oberon's second husband, Lucien Ballard, was a film cameraman who developed a special light to compliment her, which both whitened the appearance of the skin and removed signs of scarring; he patented it and called it 'the Obie'.[34] Further evidence of Oberon's skin eruptions comes from the autobiography of Irene Mayer Selznick, daughter of Louis B. Mayer of Metro-Goldwyn-Mayer, and wife of Paramount producer David O. Selznick. In her recollections of mixing with the Hollywood elite, Mayer Selznick includes that of Oberon failing to attend a dinner party at the last minute because her skin had become unsightly.[35]

31 Blunt, "'Land of our Mothers'", pp. 51, 64, 67–69.
32 Clive Barker, 'Oberon, Merle', *Oxford Dictionary of National Biography* (Oxford University Press, 2004) http://www.oxforddnb.com/view/printable/56978 accessed 29 September 2005; Higham and Moseley, *Princess Merle*, pp. 56–7.
33 Higham and Moseley, *Princess Merle*, pp. 32, 59, 80, 120–25, 157; also on this topic see Nicholas Shakespeare, *In Tasmania* (London: The Harrill Press, 2004), pp. 296, 298.
34 Higham and Moseley, *Princess Merle*, p. 161.
35 Louise Sweeney, 'L.B.'s daughter, Selznick's wife', *Christian Science Monitor* 24 June 1983, p. B2.

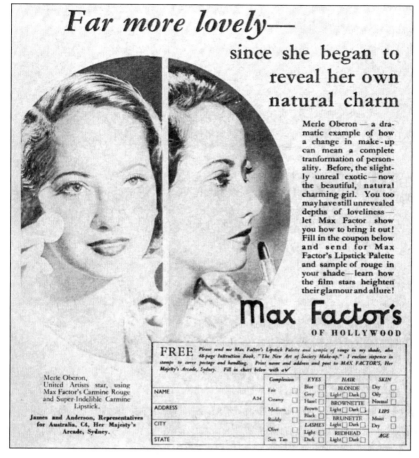

Merle Oberon in an advertisement for Max Factor cosmetics
Source: *The Australian Women's Weekly*, 10 July 1937, p. 66.

Early in her career, when she struggled against the label 'exotic', detailed descriptions of Oberon's appearance commonly noted her white skin, which is also apparent in photographs of her from the period – presumably partly due to the cosmetic bleaching. In 1934, for example, one Sydney paper described it as 'a creamy magnolia skin'.[36] Later in life, Oberon's skin often appears darker in photographs – perhaps partly from accumulated exposure to the sun in California and Mexico, and partly from her having abandoned the cosmetic bleach that had eventually damaged her skin, both of which may have been because by then she had less to fear from being perceived as dark-skinned. Oberon's third husband was a very wealthy Italian-Mexican industrialist, Bruno

36 'Tasmanian Girl Wins Screen Fame. Important Role for 21-Year-Old Actress', *The Sydney Morning Herald*, Women's Supplement, Thurs. 21 June 1934, p. 8.

Pagliai, and their opulent lifestyle included homes in Mexico City, Cuernavaca and Acapulco, as well as Beverly Hills. Photographs from this stage of her life show Oberon with a marked suntan, which she blamed on 'that Acapulco sun'. By that stage Oberon was sufficiently relaxed about this issue – unlike earlier in her career – that she could even tell a reporter: 'I don't really like black. I like to wear white – like Empress Josephine – because I'm dark, I suppose'.[37]

Oberon's resort to skin-lightening cosmetics was hardly unusual; rather, they were widespread in both the nineteenth and twentieth centuries. In the nineteenth century, when many women made their own cosmetics from household and herbal ingredients, one of the perceived general benefits of cosmetics was that of lightening the skin, even for those regarded as 'white'. A white complexion was seen as an index of gentility as well as racial status; sun exposure was linked to outside, manual work such as agricultural labour, which women of the poorer classes undertook. Cosmetics were thought to help reduce the effects of the sun or other damage. Nevertheless, skin whiteners were used from the mid-nineteenth century onwards by non-white women to lighten their skins.[38] In the United States, from the 1870s 'Laird's Bloom of Youth' was marketed as a skin lightener, and, as historian Kathy Peiss shows, the lead it contained was known to cause lead poisoning. In the later decades of the nineteenth century, face bleaches that were commonly advertised caused skin blotches and sometimes permanent injury. Such advertising included targeted messages of racial masking.[39] Concerns about the harmful effects of skin bleaches led to investigations by the American Medical Association in the 1920s, and the US Food and Drug Administration in the 1930s, which found that products on the market contained concentrations of ammoniated mercury sufficiently strong to cause serious skin irritation and damage.[40] While the manufacturers and product names were very likely different in India in the 1920s when Oberon was a teenager, it is quite possible that a skin bleaching cosmetic she used there may have contained similar levels of ammoniated mercury. That women resorted to such destructive products shows the impact of racial categories on individual lives, the exclusions and subordination that non-white women struggled against, and how important it was to them to pass as white if they could.

An examination of the 1930s Australian popular press shows racial ambiguities in representations and reports of Oberon, perhaps because

37 Marilyn Hoffman, '"At home" with Merle Oberon', *Christian Science Monitor* 20 December 1965, p. 6.
38 Kathy Peiss, *Hope in a Jar: The Making of America's Beauty Culture* (New York: Henry Holt and Co., 1998), pp. 9, 41.
39 Peiss, *Hope in a Jar*, pp. 10, 42, 85.
40 Peiss, *Hope in a Jar*, p. 212.

gossip and uncertainty about her origins circulated in transnational popular culture despite the official studio publicity story. Australians were drawn to Oberon partly because of her imagined exoticism, which suggests that their collusion in the myth of her Tasmanian birth was based on ambivalence about racial categories. Stories from the mid-1930s in papers and magazines including *The Australian Women's Weekly*, *The Australian Woman's Mirror*, *Everyone's*, *The Sydney Morning Herald*, and the Hobart *Mercury* show Australians struggling with racial ambiguities in relation to Oberon. They instantly accepted the claim that she was Australian, yet found themselves negotiating the ambiguities of her appeal in order to make her fully so.

My research has focused on the very early years when she was becoming known, in order to discover what Australians made of her when they first learned of her. In the 1930s the White Australia policy, which restricted immigration to Australia through the mechanism of a dictation test in any European language, was in its heyday. Chinese and other Asian immigration had dropped from various high points of the nineteenth century, not least because of the restrictions put in place from the 1880s, yet small communities existed, as did scattered and itinerant workers of Asian descent. As Debjani Ganguly has noted, traffic between India and Australia dates from European Australia's first founding. In the nineteenth century, Anglo-Indians in Australia included Colonel William Light, the surveyor who planned Adelaide, and the lawyer and journalist Henry Cornish who published a travelogue about Australia in Madras in 1879. One migration scheme was the shipload of Anglo-Indians who arrived in Sydney in 1854, including passengers from a military orphanage in Madras; a few years later, after the 'Mutiny' of 1857, under another scheme Anglo-Indians were granted farming land in Tasmania. With the 1880s introduction of immigration restrictions, that would become the White Australia policy, the arrival of Anglo-Indians in Australia was curtailed.[41] Popular Australian fears were fed from the late nineteenth century by pulp horror narratives of Asian invasion, as well as by widespread debate over Australia's 'empty' inland and north, putatively an incentive for such invasion.[42] By the interwar decades, racism and popular eugenics made miscegenation a hot topic. Governmental policy now included the removal of Aboriginal children from their mothers. As David Walker discusses, in these years Australians' racist talk of degenerative 'half-castes' included Eurasians – not least Anglo-Indians.[43]

41 Debjani Ganguly, 'From Empire to *Empire*? Writing the Transnational Anglo-Indian Self in Australia', *Journal of Intercultural Studies* Vol. 28 No. 1 (February 2007), pp. 32–33.
42 David Walker, *Anxious Nation: Australia and the Rise of Asia 1850–1939* (St Lucia, Qld: University of Queensland Press, 1999), Chs. 8 and 9.
43 Walker, *Anxious Nation*, pp. 183–189.

MISS MERLE OBERON.

TASMANIAN GIRL WINS SCREEN FAME.

Important Role for 21-Year-Old Actress.

Just 13 years ago a small girl of seven called Merle Thompson O'Brien was living the life of any youngster of her age in Hobart, Tasmania.

She went to school every day; she became film-struck, and adored "going to the pictures," where she could glory in her beloved Mary Pickford, Pauline Frederick, Louise Lovely, Theda Bara, Mary Miles Minter, and all the other big stars of the day.

To-day in London, at the age of 21, that small cinema enthusiast has blossomed into Merle Oberon—the girl who was chosen as leading lady for Douglas Fairbanks as the direct result of her performance as Anne Boleyn in the British film, "The Private Life of Henry VIII." Mr. Fairbanks saw shots of the film screened at Elstree before it was released to public view, and immediately requested that Miss Oberon be reserved to play opposite him in his first Elstree production.

You do not find a trace of that small girl who lived in Hobart in the soignee, sophisticated young woman who is Merle Oberon to-day. Since then she has lived with her parents in Calcutta for several years; has had four years' experience in London of the life of a struggling aspirant to film fame. She talks with perfect poise, and deprecates with delightful modesty any praise and congratulation.

Merle Oberon is small and slenderly built. She has warm brown curly hair to match her eyes, a creamy magnolia skin, and an expressive scarlet mouth. She was dressed all in brown when I met her—a lovely dyed ermine coat, with a sumptuous fur collar, a slim little wool frock beneath, and a brown beret tilted over one eye and caught with a gleaming diamond pin.

When she came to London with her parents on a holiday trip four years ago they had no intention of allowing her, a girl of 17, to remain behind in England in search of film fame. Two weary years passed before at long last she achieved a small part in a film. Ability and personality saw her through, and other parts followed.

"I've been lucky all the time," says Merle Oberon, "for I never had to play crowd parts. Just hanging around a studio on chance must in the end prove dreadfully dispiriting, I should imagine. I never had any previous training in dramatic work—just wanted to act, and it seemed to come naturally to me. Now, of course, I am busy with elocution and singing lessons, because I want to improve my diction and develop what voice I have in readiness for any singing parts that may be allotted to me in the future."

Although she is so modest about her voice, experts have expressed the opinion that, with the right training, it has the most brilliant possibilities. Allied with her dramatic gifts and good looks, this may well put her into the very front rank of world film stars.—K.R.

The Australian press instantly accepted Oberon as a 'Tasmanian girl'

Source: *The Sydney Morning Herald*, Women's Supplement, 21 June 1934, p. 8.

Tellingly, in making Oberon Australian, Australians happily stressed her Englishness or Britishness. Australianness became blended with Oberon's 'belong[ing] to a very great extent, to the Empire'. But in as far as that imperial belonging was a product of her 'working acquaintance with two of the largest countries in the British Empire',[44] Australia and India, it was entangled with questions of racial classification. Partly because they embraced Oberon as part of the empire, Australians sought to clarify her status as 'white', as part of the imperial ruling class. Australian fans' desire for Oberon to be 'white' reveals some of the complex, global cultural processes in which racial categories and hierarchies have been constructed.

Three main points are evident from the Australian press between 1934 and 1937. One is the instant and unquestioning eagerness with which

44 Cassie Marshall, 'Australian Merle Oberon Wins Fame! World Star Now', *The Australian Women's Weekly* 18 January 1936, p. 24.

Australians claimed Oberon as one of their own, despite the variations in stories about her provenance even then. A second point is their awareness of racial ambiguity surrounding her and her imagined 'exoticism'. And thirdly, the press reports show a transition that Oberon herself seemed to claim and that Australians participated in, from a worrying dark siren image, to becoming the English 'girl next door'.

As early as October 1933 the Australian press proudly drew attention to the fact that the cast of the highly successful Korda film about Henry VIII included 'two Australians in Judy Kelly and Merle Oberon'.[45] A representative press item about the new 'Australian' star soon after her emergence was typically proud, even as it raised the issue of recognition:

> Some of the mystery surrounding the identity of Merle Oberon, who leapt to fame in a hundred feet of film as Anne Boleyn in 'The Private Life of Henry VIII', has been dispelled by Stephen Watts in FILM WEEKLY – the English one. The actress is Estelle Merle O'Brien Thompson, aged twenty-two, Tasmanian born of Irish-French parentage with Indian associations. The Oberon of her new stage name is a modification of the family O'Brien. Taken by her Indian uncle for a holiday in England, she tried her luck in films. Australians have seen her (but not recognised her) in 'Aren't We All?' and 'Wedding Rehearsal'. She is now being featured in England in 'The Broken Melody', and will share feminine leads in Fairbanks's forthcoming 'Exit Don Juan'. Then America wants her. So the world is at her feet.[46]

At first, there was a bit of uncertainty about how her name should be rendered. In August 1934 *Everyone's* review of *Don Juan* referred to 'our little Tasmanian, Estelle Thompson, known to the public as Merle Oberon'.[47] They soon dropped the Estelle Thompson.

Yet the accounts of her Australian childhood varied:

> Just 13 years ago a small girl of seven called Merle Thompson O'Brien was living the life of any youngster her age in Hobart, Tasmania.
>
> She went to school every day; she became film-struck, and adored 'going to the pictures', where she could glory in her beloved Mary Pickford, Pauline Frederick, Louise Lovely, Theda Bara, Mary Miles Minter, and all the other big stars of the day.

45 '"Henry VIII" Smashes New York Record', *Everyone's* 18 October 1933, p. 38.
46 *The Australian Woman's Mirror* February 27, 1934, p. 20.
47 Constance Cotton, 'The Doings of Doug in "Don Juan"', *Everyone's* 22 August 1934, p. 10.

To-day in London, at the age of 21, that small cinema enthusiast has blossomed into Merle Oberon – the girl who was chosen as leading lady for Douglas Fairbanks as the direct result of her performance as Anne Boleyn in the British film, 'The Private Life of Henry VIII' ...

You do not find a trace of that small girl who lived in Hobart in the soignée, sophisticated young woman who is Merle Oberon to-day. Since then she has lived with her parents in Calcutta for several years; has had four years' experience in London of the life of a struggling aspirant to film fame. She talks with perfect poise, and deprecates with delightful modesty any praise and congratulation.[48]

While these early reports sought to explain her Australian origins, soon she was just reported as Merle Oberon, the Tasmanian girl, or the Australian actress, Merle Oberon, as a matter of fact. The repeated assertions of Oberon's Australianness may also have been intended to dispel imagined errors in some contemporary media accounts, such as the July 1934 assertion in *The Los Angeles Times* that Oberon was from New Zealand, followed the next month in the same paper by a reference to her as a 'young English film actress'.[49] It was all very well for Oberon to be considered English and British as well as Australian, but the Australian media wanted to make sure this last designation appeared regularly. One solution was to refer to her as 'the Australian-British film star'.[50]

Yet however automatic and standard the identification of Oberon as Australian became, worries about her racial identity were aired repeatedly. In the 1934 film *The Battle*, Oberon was cast as Japanese, not surprisingly exacerbating the anxieties about her so-called 'exoticism'. The film, which had overtones of *Madame Butterfly*, was set in 1904 during the Russo-Japanese war, and Oberon played opposite Charles Boyer as the Japanese wife of a naval commander who falls in love with a British official, leading her husband to commit suicide. The film was a tragedy in which Oberon's character loses her lover as well as her husband. Some reports sought to suppress the worry about her playing a Japanese role:

Merle Oberon, the Tasmanian girl... looks fascinating with her artificially elongated Oriental eyes; and she brings conviction to the heroine's mingling of Japanese and European traits in her movements and gestures.[51]

48 'Tasmanian Girl Wins Screen Fame', p. 8.
49 'Merle Oberon Lead Opposite Howard', *The Los Angeles Times* 30 July 1934, p. 7; 'Schenck Announces Troth to British Film Actress', *The Los Angeles Times* 6 August 1934, p. 1.
50 'Some Old Friends...', *The Australian Women's Weekly* 14 July 1934, p. 15.
51 '"The Battle"', *The Sydney Morning Herald* 8 October 1934, p. 5.

Other reports mixed Australian pride in Oberon's acting with anxiety about the ease with which she could appear 'Oriental'.

Interestingly, in this period in particular, descriptions of her often emphasised her affinity with and fondness for the colour brown, a theme that could well be read as an expression of racial ambiguity. *The Australian Women's Weekly*, for example, sought to balance these racial worries with an emphasis on Oberon's education and intellect, as though that would counteract the concern:

> Merle Oberon, the Tasmanian girl... is very petite, with bright brown hair. Her eyes are dark and almond shaped, so that she needed very little make-up to obtain the Oriental effect in the part of a Japanese beauty, which she took in 'The Battle', soon to be released in Australia.
>
> Merle is intelligent, and is always poring over history books...
>
> Everyone in the film world is enthusiastic about Merle Oberon. She is not only a very beautiful and appealing girl, and a fine little actress, she is a well-read and charming woman. More than that, she is reputed to be the best-dressed woman on the English films. She gets almost everything from Schiaparelli, and is particularly fond of an unusual shade of brown, which brings out all the bronze of her rich brown hair.[52]

But it was Oberon's imagined Australianness that trumped any such worries on the part of her Australian fans. *Everyone's* magazine even managed to turn Oberon's colouring into proof of her Australian identity: commenting on *The Private Life of Henry VIII*, it noted that the two 'Australian' actresses' 'brunette beauty registers vividly against the blonde preponderance of the English stars'.[53] When *The Battle* opened in Sydney on 3 October 1934, 'the fans flocked to the Prince Edward to see this magnificent product of the Apple Isle at work. They were not disappointed. As the beautiful Japanese wife, Mitsuku... she displayed the superb delicacy which had sent her to the top, giving depth to the passionate love which grows between her and the Englishman'. As the report exclaimed, Oberon was not only 'tiny, natural, beautiful', she was – crucially – 'Australia's first famous film star'.[54]

52 'Australian Stars Abroad!' *The Australian Women's Weekly* 25 August 1934, p. 20.
53 'Everyone's at the Box Office', *Everyone's* 22 November 1933, p. 2.
54 1934 advertisement for and report on 'The Battle', reprinted in *The Daily Mirror* 15 February 1972, p. 26.

Page Four | The Australian Women's Weekly MOVIE WORLD | January 30, 1937

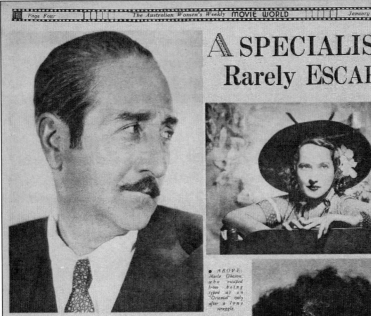

A SPECIALIST
Rarely ESCAPES

Misfortune of Creating
a Hollywood Type

● *ABOVE:
Merle Oberon,
who escaped
from being
typed as an
"Oriental" only
after a long
struggle.*

● *LEFT: The
years brought
relief to
Adolphe Men-
jou. Once a
sophisticated
lover, he has
never allowed to
be anything
else.*

OF course, you've heard the old, bewhiskered story of the comedian who yearned to do "Hamlet," and the tragedian who longed to cut loose as a first-class buffoon. And you know that the odds are at least 100 to 1 that neither of them will ever realise his desire. They won't get a chance—particularly on the screen.

Once typed in Hollywood, once a special talent is revealed, once the public shows approval of a certain characterisation, the actor's fate is sealed, his career mapped out in a series of parts inspired by the original role.

A SPECIALIST in pictures can continue with success at his or her own particular forte, but let them suggest to the producers a change of type, and the answer is NO, in large-sized letters.

A special talent is often a great misfortune. I am sure that a lot of versatile people have been passed over by producers who lack the imagination, the confidence to give a player a chance in a different role.

"Take a look at some of Hollywood's specialists. The dancers—Fred Astaire, Ginger Rogers, Eleanor Powell, Ruby Keeler; the comedians Eddie Cantor, Jack Oakie, Patsy Kelly, Alice Brady, Hugh Herbert; the screen's butlers Arthur Treacher, Eric Blore, Robert Greig, the masters of make-up and mystery—Warner Oland, Boris Karloff, Bela Lugosi, Peter Lorre. Think of any of these people, and you subconsciously picture them dancing, joking, butling, or scaring.

Hollywood has consistently shaken its head to their pleas for roles that will lift them out of character a chance to prove that they have

By
Mary Olivier

something else besides their stock-in-trade—that they possess versatility if only the thickheads would realise it.

Maybe they have. And maybe they haven't. But right or wrong, their chances of proving the issue are very remote. "You're specialists."

They are told, "Stick to your greatest gifts, and the public will be pleased."

It is well known that when R.K.O. was casting "Mary of Scotland," Ginger Rogers went on her bended knees for the role of Elizabeth. The fact that it was not the kind of picture that she had been making did not deter Ginger from camping for weeks on the casting director's doorstep. Here was a chance to show that she could do something else besides putting all her eggs in one basket (with or without the aid of Fred Astaire). Not that Ginger hasn't made a great

● *RIGHT:
Always a sinister
figure — Boris
Karloff, who is
never allowed to
be anything
else.*

success as a dancer and light comedian. But by establishing herself as a specialist she has never been able to reveal what she might do with a real dramatic part.

Ginger stopped at nothing in her endeavor to land that role. She enlisted the aid of make-up artist Mel Burns and wardrobe designer Walter Plunkett. Between them she emerged every inch a queen. She even persuaded the director to give her a test, which met with unstinted praise from the executive producer, Pandro Berman. Ginger thought the role was hers. But was it? No! Not that Ginger isn't an actress. Not that she couldn't have played Elizabeth. But her reputation as a dancer was far too important to risk in such a hazardous manner.

Her fans would never accept her in a serious role. They want to see her slim young body, her shapely legs. They want her to sing and look pretty, as only Ginger can. Let the seasoned actresses disguise themselves as Elizabeth. Florence Eldridge got the part practically over Ginger's dead body, and there was nothing else for our heroine to do but face the music and dance

*Continued on Page 5,
Movie Section*

Merle Oberon, featured in *The Australian Women's Weekly* **article, 'A Specialist Rarely Escapes'**

Source: *The Australian Women's Weekly*, 30 January 1937, p. 4.

The Tasmanian press did not actually need the injunction from *Everyone's* magazine that 'Tasmania should feel mighty proud of Merle Oberon'.[55] Not surprisingly, the Hobart *Mercury* was particularly strident in its enthusiasm for the film. Its October 1934 advertisement for *The Battle* lauded it as 'undoubtedly the finest naval film ever made', and ran a banner headline: 'Tasmania is proud of you..... MERLE OBERON. Your performance in "THE BATTLE" is superb!'[56] Another advertisement billed her as 'The Tasmanian Star', and by May 1935, *The Mercury* was boasting of 'Tasmania's Success' in relation to Errol Flynn, with the prediction that 'another Tasmanian is to join Merle Oberon among the stars of Hollywood'.[57] The paper even adopted a defensive tone with its protesting headline the same month: 'Tasmanian Nearly Banned'. The article reported that *The Scarlet Pimpernel* was nearly refused distribution in the United States, because the American League of Decency objected to Oberon's 'cleavage' in evening dresses in the film; *The Mercury* pointed out that historical accuracy was at stake, because despite Victorian women's moral propriety 'apparently they wore dresses cut too startlingly for Chicago'.[58]

The *Sydney Morning Herald*'s note on Oberon's appearance in the 1934 film *The Scarlet Pimpernel* at once combined serious racial concern with the view that this was merely a cosmetic issue:

> Merle Oberon makes Lady Blakeney a personage of exceptional loveliness and of delicate sensibilities, in keeping with this proud but generously impulsive character. The only disturbing feature is her tendency strongly to orientalise her appearance by means of facial makeup, and the slant of black brows.[59]

An advertisement for the film in the same paper's Women's Supplement endorsed it as 'The Best British Film of the Year', which perhaps reassured audiences.[60] The combined messages of these Australian press reports – despite the Tasmanian boosting – added up to clear unease with Oberon's origins, an unease that was reiterated in the very process of its apparent alleviation.

55 Cotton, 'The Doings of Doug in "Don Juan"', p. 10.
56 'Amusements, Etc.', *The Mercury* 30 October 1934, p. 8.
57 'Amusements, Etc.', *The Mercury* 27 October 1934, p. 10; 'Pictures and Personalities', *The Mercury* 4 May 1935, p. 12.
58 'Pictures and Personalities: Tasmanian Nearly Banned', *The Mercury* 11 May 1935, p. 13.
59 'Film Reviews ... Scarlet Pimpernel', *Sydney Morning Herald* Monday 25 March 1935, p. 6.
60 Advertisement for 'The Scarlet Pimpernel', *The Sydney Morning Herald's*, Women's Supplement, 21 March 1935, p. 9.

The American press went so far as to print the charge that Oberon was 'Eurasian', while also quoting her denial. According to *The Los Angeles Times*, Oberon refuted the charge, saying it was the product of 'odd coincidences', including that 'her eyes slant upward, she has lived in India and her studies have included Hindustani'. Yet the journalist comments that the impression of her being Eurasian persists on the film production set, partly because of her make-up; he sums up the impression by noting that, with her 'affected' or 'very English' accent, she 'looks like an aloof, oriental Fay Wray', invoking the actress who made her fame through her on-screen tussle with King Kong.[61] Into the middle of 1935, American newspaper reports continued to refer to Merle Oberon as 'exotic', and to allude to her 'slanting eyes'.[62] It was in 1935 that she first went to Hollywood, though she would continue to return to London to make films for Korda. Her first American film was *Folies Bergere*, in which she played opposite Maurice Chevalier; the *The Sydney Morning Herald* Women's Supplement thought her part in it 'more cheerful' than previous roles, and that it 'gives more scope for her acting ability'.[63]*Everyone's*, on the other hand, considered that in the film Oberon 'once more looks exotic and clever'.[64]

It was the 1935 film *The Dark Angel*, a remake of a successful silent film, which allowed Oberon and her Australian fans to whiten her, and turn her into 'an ordinary British girl'. An iconic story of the tragic losses of War War I, Oberon played the respectable English sweetheart at home, with Fredric March and Herbert Marshall playing the two male leads. The three are childhood friends in the provinces, the two boys being cousins who vie for Merle's [Kitty's] affections. When they grow up and the war erupts, the two young men valiantly go off to the front while Merle takes the quintessential female wartime role, waiting with her mother and aunt. Fredric March as Alan is captured and blinded in France; when he returns to England he refuses to disclose his name and tries to hide so that Kitty won't marry him out of pity. Merle as Kitty Vane is on the verge of marrying Herbert Marshall as Gerald instead but accidentally finds Alan, and the plot suggests that her true love for Alan overcomes his blindness. Merle/Kitty's self-sacrifice in accepting his blindness is linked to her class status and respectability, which for Oberon could be translated

61 Scheuer, 'Intriguing "Myths" About Merle Oberon All Exploded', p. A1.
62 Lydia Lane, 'Nature Gives Make-up Code', *The Los Angeles Times* 12 July 1935, p. A5; 'Actress Will Broadcast', *The Los Angeles Times* 31 July 1935, p. 14.
63 'Chevalier's Leading Lady: Strikes a New Note', *The Sydney Morning Herald's*, Women's Supplement, 6 June 1935, p. 9.
64 Review of 'Folies Bergere', *Everyone's* 5 June 1935, p. 11.

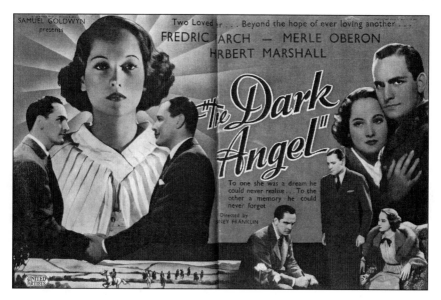

Merle Oberon in *The Dark Angel* (1935)

Source: *Everyone's*, 8 June 1936, p.12.

as whiteness – despite what seems now the irony of the film's title. Clearly, it was a boon to Oberon that the film was set 'in a lovely, quiet corner of rural England'.[65]

The film was a box office success in Australia and elsewhere. In the United States, Oberon was hailed as 'the sensational star' of the film.[66] According to an Australian press report, the London premiere was considered the season's 'most glamorous', as well as popular. The crowds at the Leicester Square Theatre were reportedly so dense that the police had to divert traffic before the screening, and after it 'police aid was necessary to control the crowds endeavouring to obtain a glimpse of the star'. All in all, *Everyone's* thought, 'Merle Oberon [was] Tops in "Dark Angel"'.[67] For the Australian media in the interwar period, not long after the emergence of the Anzac mythology that held the nation was born in the blood and sacrifice at Gallipoli in 1915, and when Australian society included significant numbers of returned soldiers who were maimed or disabled, it was a role that vindicated Oberon's Australianness and deflected concerns about her racial identity. No doubt it

65 'Merle Oberon Scales the Heights in "The Dark Angel"', *Everyone's* 1 January 1936, p. 21.
66 'Merle Oberon and Omar Kiam Team in Designing Wardrobe', *The Los Angeles Times* 13 September 1935, p. B2.
67 'Merle Oberon Tops in "Dark Angel"', *Everyone's* 2 October 1935, p. 13.

helped Australian audiences' reactions that Oberon was nominated for an Academy award for her role in the film. *The Sydney Morning Herald* Women's Supplement interviewed Oberon and shared her apparent pleasure at her newly British role:

> On the strength of her performance in 'The Dark Angel', Merle Oberon, the young Tasmanian girl, has been mentioned as a likely winner of the gold statuette presented by the Academy of Arts and Sciences for the best film acting of the year...

> And it is not the Merle who, after she came to America, characterised exotic and mysterious sirens. She has entirely changed her screen personality. Interviewed during the production of her latest picture, she said, 'I've given up those sirenish roles, and am going in for real honest-to-goodness human being parts. Mr Goldwyn feels that I can transfer my real self to the screen if I'm given the chance.' So, when 'The Dark Angel' comes to the Regent Theatre on Friday week you will have your first opportunity of seeing her minus those bizarre coiffures and that air of mystery with which she has been surrounded in her recent pictures. For the first time you will see her as a normal British girl – 'Which I really hope I am', says Merle.[68]

For *The Australian Women's Weekly* reporter Cassie Marshall, 'an Australian in Hollywood', recorded her surprise and pleasure at Oberon's new persona with the subtitle 'No Longer Exotic':

> I was first introduced to Merle when she was working on 'The Dark Angel'. Previously, I had seen her pictures, of course, and had always remembered her as creating exotic roles. As Kitty Vane in this new production, she surprised me. For the first time, I saw her playing a normal English girl of good family and social position. And, judging by her work on the lot, she was doing it brilliantly.[69]

The Hobart *Mercury* seemed particularly relieved that '[s]horn of exotic make-up, Merle Oberon is revealed as a natural and charming little actress', as 'a young English girl', a role that 'is far removed from anything she has attempted before the camera'.[70]

68 'An Australian Leads: Merle Oberon's Latest Success', *The Sydney Morning*, Herald Women's Supplement, Thursday 16 January 1936, p. 9.
69 Marshall, 'Australian Merle Oberon Wins Fame!' p. 24.
70 '"The Dark Angel": Drama at the Strand', *The Mercury* 17 February 1936, p. 5.

Oberon herself was very conscious of the stakes involved in consolidating her image as 'white', to 'reverse her type completely'[71] and thereby shake off the continuing concerns about her dark exoticism. She knew that her level of success depended on entrenching her white imperial Britishness, which would anchor her claims to respectability as well as dispelling the racial shadows. She spoke to the press about how much she had wanted Samuel Goldwyn to give her the role in *The Dark Angel*, and how together they were plotting her image transformation, including 'working on a new coiffure to supplant the so-called exotic ones she has used in the past'. Oberon claimed that as a small girl in Calcutta, she had seen the silent version of the same film, and it had remained with her, which made it all the more meaningful to her as a role. Above all, she saw it as the chance to move beyond the 'roles of sirens and exotic women' in which she had been cast to date, and 'to play a simple human honest British girl, without any of the exoticism I have been forced to assume in other pictures'.[72] Blaming her previous roles and hairstyles for being perceived as exotic was one strategy for deflecting racial doubts. Oberon's success was characterised by *The Los Angeles Times* as her being '[f]reed of the restrictions of exotic make-up' and instead of being limited as 'a type', now becoming a proper actress of importance and with a promising future.[73]

Oberon's vehemence and repeated commentary to the press on this topic indicate her full awareness of the sexual as well as racial implications of being labeled 'exotic'; the extensive press coverage of the issue also shows journalists' belief in the public interest in this coded topic. In one interview in September 1935, she exclaimed, in a formulation that inverted the past she wanted to leave behind with a future she feared: 'I detest "exotic" women! They represent everything I'd hate to be and that I'm scared to death of becoming'. Questioned by the journalist as to why she felt this way, she continued: 'They're so artificial... They've got no character. There's nothing normal about them. It's all a pose'. Defending herself, Oberon pointed out that the only role she had had that could fairly be labeled 'exotic' was that of the Japanese woman in *The Battle* (released in some places as *Thunder in the East*). The interviewer, determined to milk this issue as far as he could, pressed Oberon even further, asking what the term 'exotic' meant to her. She replied: 'Oh – you know. Smell of burning incense. Jasmine blossoms.

71 'Quick Sketch Tells Highlights of Merle's Life', *The Los Angeles Times* 13 September 1935, p. B6.
72 'Merle Oberon Wants to be Just Herself Off Screen', *The Los Angeles Times* 22 April 1935, p. 13.
73 Norbert Lusk, 'Film Writing Hits Peak in "Dark Angel"', *The Los Angeles Times* 15 September 1935, p. A3.

Or heaps of gardenias all over the place. Pretty sticky. And a long, slinky black dress'. When she had been labeled 'exotic', she felt that she had been seen as both a 'foreign interloper' and a 'vamp'.[74] Evidently, for Oberon, the term 'exotic' held dangerously Oriental meanings that could potentially expose her Anglo-Indianness, as well as suggesting sexual availability that may for her have been linked to the vulnerability of a lower-class and a mixed-race background. Dissociating herself from the term must have been linked to covering up her past, which was why playing a 'normal' respectable Englishwoman in *The Dark Angel* was such a milestone.

Nevertheless in February 1936, there was still a little anxiety expressed by *The Australian Women's Weekly* Movie World supplement. On the one hand, on 8 February 1936 it breathlessly announced:

Here's Hot News from all the Studios! ...

Merle Oberon likes to be surrounded by lovely things and doesn't hesitate to indulge herself. She has a most elaborate portable dressing room, and loves to entertain... At the entrance to her dressing-room is a table, and on it stands a small British flag. Australia's fair daughter is loyal.[75]

Yet three weeks later the same paper published an overtly racist cartoon obviously designed to unmask Oberon as Anglo-Indian. In a cartoon feature corner titled 'Screen Oddities by Captain Fawcett', with other jokes including one about Charles Laughton trying to lose enough weight to be able to play Captain Bligh, there is a caricature of Oberon. A pen drawing, it shows Oberon as very dark-skinned, with her hair in what would have been considered an Indian style (parted in the middle and with plaits wound around the back of her head), and wearing characteristically Indian jewellery. The cartoon is explained with the oblique caption: 'Merle Oberon wears earrings clasped to the side of her ear instead of the lobe'.[76] While the words 'Indian' or 'Anglo-Indian' are not used, the reference is very clear.

Just prior to this racist unmasking by another organ of the press, *The Sydney Morning Herald* was definitive that Oberon's transition to English respectability had been made. In its review of *The Dark Angel* the paper declared:

74 John R. Woolfenden, "'I Detest 'Exotic' Women", Says Exotic Merle Oberon', *The Los Angeles Times* 15 September 1935, p. A3.
75 *The Australian Women's Weekly*, Movie World, 8 February 1936, p. 36.
76 'Screen Oddities By Captain Fawcett', *The Australian Women's Weekly*, Movie World, 29 February 1936, p. 40.

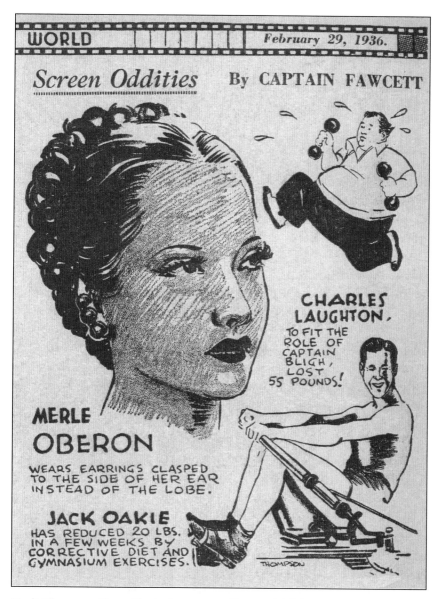

Merle Oberon as the subject of a cartoon, 'Screen Oddities'

Source: *The Australian Women's Weekly*, 29 February 1936, p. 40.

> a good deal of interest is added to the picture by the appearance of
> Merle Oberon surprisingly and very successfully transformed from the
> exotic, Oriental creature of her earlier films into an inhabitant of the
> everyday world. Except in the small part she played in 'The Private
> Lives of Henry VIII', Merle Oberon was never a complete success in
> her former character. This picture reveals that her real talent is in a
> diametrically opposite direction – that she is at her best not as a slant-
> eyed frail blossom from an Eastern garden, but as a natural, tender girl.
> *The lotus flower has been changed* (under the magic wand of make-up
> artists and an astute producer) *into a cornflower.*[77]

Thus even at the moment that Oberon achieved her first great success, and
some Australians celebrated her triumph and her arrival as a properly British
star playing 'white' roles, malicious gossip about her origins continued to be
printed.

The transition from 'lotus flower' to 'cornflower' was key for her career,
yet even as it was declared complete it was still shadowed. Ambiguity and
doubts about her racial identity lingered, eventually fuelling the Tasmanian
mythology of her birth to Lottie Chintock, the Chinese hotel worker. Such
ambiguities, scandals and anxieties circulated around the world in gossip
columns. *The Australian Women's Weekly* Movie World supplement could run
the cartoon because it would be instantly comprehensible to Australians.

Oberon's success both as an actress and in overcoming the racial anxieties
about her that circulated in both coded and overt ways in the transnational
popular press was consolidated by further roles that cast her as 'white' as well
as respectable, or even elite, in other ways. It was similarly reassuring when
the press reported, for example, that Oberon lived in a 'very modern and
comfy flat near Baker Street' in London, and was affluent enough to head
off to the Continent for holidays.[78] Her success in another Samuel Goldwyn
production, the 1936 film *These Three*, following on the heels of *The Dark Angel*,
was timely. *These Three* was a critical success and a significant film in that it
was directed by William Wyler and the screenplay was written by Lillian
Hellman. The plot revolves around two young women, friends from college,
who set up a small school together, and hinges upon their relationships with
both each other and the local doctor. For Oberon, it was significant that her
character was not only college-educated, but supposed to be descended from

77 Emphasis added. 'Film Reviews', *The Sydney Morning Herald* 27 January 1936, p. 2.
78 Muriel Segal, 'Australian Stars Abroad! Betty Stockfeld and Merle Oberon', *The Australian Women's Weekly* 25 August 1934, p. 20.

a line of New England gentry. Indeed, her impoverished but elite pedigree is in contrast to the other female lead, Miriam Hopkins's socially more marginal character. Oberon's character's respectability and status as the first of the two female leads is confirmed by the plot when she wins the heart of the doctor, played by Joel McCrea. The primacy and respectability of this leading role in such a successful film boosted Oberon's newfound status as a serious actor, and helped her to put the worst fears of being labeled 'exotic' behind her. Despite her success innoculating her against innuendo to some extent, gossip mongers never completely abandoned references to her 'exotic beauty', the 'oriental slant' of her eyes, and the fact that when she first arrived in London it was from Calcutta.[79] Some commentators on Oberon's career explained her transition from the doubts that clung to her early on, to her later transcendent stardom, as due to the fact that she had left behind the 'exotic Oriental roles' of the 'early days of her career', as though the problem had sprung from the roles rather than Oberon's origins.[80]

Even following *These Three*, Australian commentaries on Oberon's acting refused to relinquish the issue of her exoticism. One November 1936 review of her performance in a film titled *Hurricane* suggests connections between Oberon's career and both Kellerman and Quong's. Just as Kellerman could market herself as a South Seas islander, so apparently could Oberon; and like Quong, her exoticism was considered to make her ethnically versatile. John B. Davies and Judy Bailey imply that such versatility is an asset given the film world's demand for a range of roles: 'Merle Oberon again takes on her exotic personality for "Hurricane", where she plays a South Seas girl. The uncanny versatility of this dark-eyed beauty makes it possible to cast her in any type of role. Remember how beautiful and appealing she was as the young Japanese wife in "The Battle", and her finest playing was done in "These Three" as the typical American girl'.[81] On the one hand, this comment equates range with nationality (from Japanese to American); on the other, linking the terms 'dark-eyed beauty' and 'exotic', especially with 'South Seas girl', was an obvious reminder of concerns about that very exoticism. Interest in Oberon's looks was sufficient that *The Australian Women's Weekly* Movie World supplement ran full-page portrait studies of her in both May and August 1936.[82]

79 'Hedda Hopper's Hollywood', *The Los Angeles Times* 9 July 1938, p. A6.
80 'Actress *Shines* Nose for Natural Effect', *The Washington Post* 20 February 1941, p. 13.
81 John B. Davies and Judy Bailey, 'Calling Australia! Moviedom News As It Happens', *The Australian Women's Weekly*, Movie World, 14 November 1936, p. 27.
82 'Merle Oberon – A Special Australian Women's Weekly Study', *The Australian Women's Weekly*, Movie World, 23 May 1936, p. 31; and 'Merle Oberon, Starring in "These Three"', *The Australian Women's Weekly*, Movie World, 22 August 1936, p. 27.

In 1937 Alexander Korda decided to produce a film version of Robert Graves's novel *I, Claudius*, to be directed by Josef von Sternberg (who had made a star of Marlene Dietrich), with Oberon to play the role of Messalina opposite Charles Laughton. Some of the film was shot, but it was never completed, largely because in March that year Oberon was in a car accident in the centre of London, receiving serious cuts to her face and head. She recovered after several months, with minor scars that did not impede her career, but the interruption to filming meant that *I, Claudius* was never finished.[83] Despite this setback, Oberon would soon star in other successful films, including *The Divorce of Lady X* and as Cathy opposite Laurence Olivier's Heathcliff in *Wuthering Heights*. By July 1937, she was in the press again with an official invitation from the French government to attend a gala event at the Comedie Francaise.[84]

By 1938, Oberon was earning $US100,000 for each film she made, and dividing her time between Hollywood and London, where she had bought a house at Regent's Park. Contractually, she was shared between film directors Korda in England and Goldwyn in America, making two films for each per year. She complained to the press about her tax burden, with both the British and United States governments taking 70 percent of her earnings, because of her British residency status combined with her American income.[85] Hollywood gossip columnist Hedda Hopper reported that Oberon's affluence was such that she did not actually know how many fur coats she owned (somewhere between one and two dozen), as well as 'an emerald and diamond necklace once owned by Napoleon'.[86] In 1940 Oberon starred in her first technicolour film, *Over the Moon*, opposite Rex Harrison; the film was largely a vehicle for Oberon, with her changing clothes approximately fifty times.[87] By 1943, she began to speak of retiring from acting; by then her film career had passed its peak and, perhaps not coincidentally, her marriage to Korda would only last two more years.

The Australian press continued to track Oberon's career. When in 1973 at age 61 she financed, edited and starred in her own comeback film, *Interval*, the Melbourne *Herald*'s reporter commented that the 'Tasmanian-born Miss Oberon' did not look more than 35, that she 'is the youngest-looking

83 Higham and Moseley, *Princess Merle*, pp. 91–99.
84 *The British Australian and New Zealander* 1 July 1937, p. 15.
85 Alma Whitaker, 'Merle Oberon Finds Taxes Eat Up Most of Earnings Here and In Britain', *The Los Angeles Times* 26 June 1938, p. C1.
86 'Hedda Hopper's Hollywood', *The Los Angeles Times* 9 July 1938, p. A6.
87 'Star Radiant in Color', *The Los Angeles Times* 16 August 1940, p. A11.

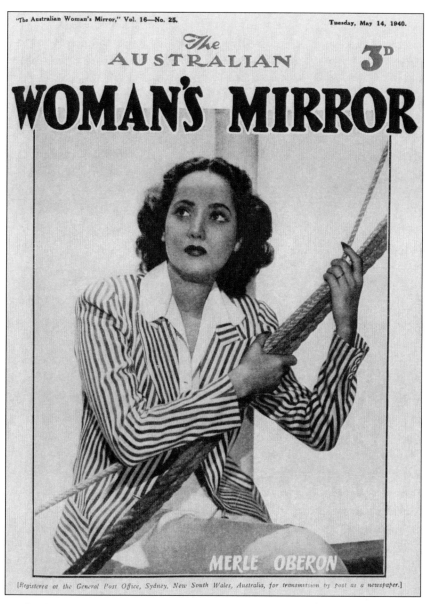

Merle Oberon on the cover of *The Australian Woman's Mirror*

Source: *The Australian Woman's Mirror*, 14 May 1940.

old woman I've ever met and still a stunning looking woman'. The article described the film and summarised Oberon's career and some of her life, assuring readers that she was such a part of the 'jet set' that her 'Acapulco house has been a meeting place for royalty and world dignitaries for many years', an assertion presumably intended to convey the level of success this 'Australian' had attained.[88] *The Australian Women's Weekly*, which had had a long-standing interest in Oberon, reminded its readers that she had become 'Mexico's high-society movie star… untouchable and unattainable since she married Mexico's richest businessman and retired into secluded luxury' at her palatial home overlooking the Pacific Ocean in Acapulco. Journalist William Hall further pointed out that the film, the script of which had been written especially for Oberon, was about an older woman on holiday in Mexico, who falls for a younger man. And of course, his article included the gossip that Oberon's relationship with young Dutch co-star Robert Wolders was off-screen as well as on-screen.[89] The Sydney *Daily Mirror* soon announced: 'Fairy-tale marriage is over for the girl from Tasmania who became a movie queen'.[90]

Woman's Day soon boasted a feature article with photographs of Oberon and Wolders taken in New York. It informed readers of the 'Australian-born actress's romance that had bloomed while *Interval* was being shot in Mexico. Oberon explained to the interviewer that her marriage to Italian-Mexican industrialist Bruno Pagliai had failed because he was always working rather than spending time with her, and she could not live in Mexico City, his work base, because the altitude made her ill. Indeed, she said, 'I even thought of buying a ranch in Australia as a second home to get away from Mexico City'. Oberon also pointed out that, in the garden at her new house in Malibu, she had an Australian Christmas bush. In response to a question about whether she would visit her 'homeland', Oberon replied: 'I've always wanted a connection with Australia and I love the fact that Australians still consider me one of their own. That's certainly a good reason for wanting to go and visit the country again. But now I've got even more interest there – I've bought into a British company that owns a sheep station, but I can't remember where. I definitely would love to go back soon'.[91] Even if she was vague about the location of the sheep station, Oberon seemed keen to convince Australians of her continuing loyalty.

88 Ivor Davis, 'She's the youngest-looking old woman I've met', *The Herald* 6 January 1973, p. 21.
89 William Hall, 'Return to Yesterday', *The Australian Women's Weekly* 24 January 1973, p. 5.
90 Ray Kerrison, 'Merle Oberon Divorce', *The Daily Mirror* 6 April 1973, p. 2.
91 Don Riseborough, 'A New Starring Role… and a New Love', *Woman's Day*, 20 August 1973, pp. 10–11.

Not surprisingly, in late 1978 and 1979 the Australian press covered the story of Oberon's final illness and death. In November 1978, the Brisbane *Courier-Mail* reported that 'Australian-born actress' Oberon was recovering well in Cedars-Sinai hospital in Los Angeles after a coronary-bypass operation that included replacement of a heart valve.[92] A year later, when she died following a stroke at her Malibu home, *The Canberra Times* ran an article noting her passing, and that the actress was 'Tasmanian-born' though 'educated in India'.[93] The obituary in *The Australian* called her a 'Taswegian', while that in *The Sydney Morning Herald* was titled 'Merle Oberon: "A star beauty in a golden age"'.[94]

Geographer Alison Blunt has shown, from her research on Anglo-Indian communities and migrations, that Anglo-Indians were unwelcome in 1930s Australia. Moreover, there was a general belief that they could be judged from visual appearance – a belief that must have fuelled the gossip and anxiety about Oberon's origins. After all, by the mid-1930s Oberon's face was one of the best known in the Anglophone world. The White Australia policy, entrenched by the Immigration Restriction Act of 1901, in practice prohibited the immigration of Indians or Anglo-Indians. The depth of resistance to Anglo-Indians, and the stress placed on appearance, became apparent in the 1940s when many Australians, British and Anglo-Indians sought to leave India during the turmoil surrounding independence. In August 1947, at the height of the upheaval, an Australian ship sent to evacuate Australians and British returned to Western Australia with more than 700 Anglo-Indians on board. While this group of Anglo-Indians was admitted, an investigation blamed the inability of immigration officers to screen properly those embarking in Bombay. In response, immigration restrictions were further tightened. In 1947, a new form was introduced for applicants from India, including questions about the applicant's parents' and grandparents' race, with applicants required to specify whether they were 'wholly European', or if partly Indian, whether that fraction was a quarter, a half, or three-quarters. Photographs were required with applications but not always considered sufficient proof; interviews were sometimes required as well. From 1949, applicants for migration to Australia had to prove that they were 'predominantly European in race or descent', as well as 'predominantly

92 'Merle Oberon "resting"', *The Courier-Mail* 18 November 1978, p. 3.
93 'Actress Merle Oberon Dies', *The Canberra Times* 25 November 1979, p. 5.
94 'She stopped a film and changed the law', *The Australian* 29 November 1979, p. 8; 'Merle Oberon: "A star beauty in a golden age"', *The Sydney Morning Herald* 26 November 1979, p. 8.

European in appearance'.[95] Before, during and after the 1930s, immigration policy reflected Australia's obsession with whiteness, and was regarded as one of, if not the, most restrictive in the British Commonwealth.

It was not until the late 1960s and the 1970s, when the White Australia policy had been relaxed, that Anglo-Indians were admitted into Australia in significant numbers. At that stage, Australia became a major destination for them because of its familiarity as part of the British Commonwealth, as well as its relative proximity; by 1970, 50,000 Anglo-Indians had left independent India, half of whom went to Britain in the late 1940s and 1950s, and many of the remainder coming to Australia, particularly forming a community in Perth. Yet even then, Anglo-Indians often faced racism from other Australians who regarded them as 'black'.[96] In the 1970s, the former immigration minister Arthur Calwell made racist remarks about the Anglo-Indian community of Highgate in Perth, derisively calling it the 'Durban of Australia'. Such attitudes existed despite the fact that, as shown in the 1981 Australian census, of the 41,657 Indian-born Australians counted, 75 percent were Anglo-Indian.[97]

It was not until after Oberon's death in 1979 that word of her Anglo-Indian origins began to circulate in the Australian press. In 1982 an article by a London journalist was printed in the Adelaide *Advertiser*, quoting a report from the London *Daily Mirror*, with the news that 'it seems she may not be a Tasmanian after all'. The report was based on the testimony of an Englishwoman living in California, who claimed to have been a 'lifelong companion' to Oberon. Phyllis Beaumont actually had her facts somewhat wrong, announcing that Oberon had not been born in Tasmania, but in Calcutta. She debunked the official publicity story of Oberon's birth and childhood, revealing that Oberon's real name was Queenie Thompson, asserting (wrongly) that Oberon had never been in Tasmania in her life, and was 'a "chi-chi" girl, as the children of mixed parentage were contemptuously called. She was the illegitimate daughter of an Indian mother and British Tommy. She never knew her father, only that his name was Thompson. Life was hard for Queenie. Until she managed somehow to get to England and into films'. Beaumont claimed that one of the sadnesses of Oberon's life was that she would have liked to become an American citizen, but could never do so because she would have had to produce a birth certificate.[98]

95 Blunt, *Domicile and Diaspora*, pp. 146, 150.
96 Blunt, *Domicile and Diaspora*, pp. 3, 164.
97 Ganguly, 'From Empire to *Empire?*', p. 34.
98 Chris Brice, 'More to Merle than meets the eye', *The Advertiser* 30 November 1982, p. 29.

Apparently some in Australia either did not read this debunking of the myth of Oberon's Tasmanian birth, or did not accept it. Two years later, *The Northern Territory News* printed a long biographical article on Oberon titled 'Australian-born movie star spent life seeking love'. *The Northern Territory News* at least was aware that Oberon had visited Australia, reporting that: 'In 1978 Merle Oberon visited Australia and spent four days in her birthplace. She was given a civic reception in Hobart and also took time out to visit two sheep properties in NSW in which she had interests'. But its long account of her origins was the publicity-story version of her birth in Hobart, to parents of British and other European origin, her father dying before her birth, her mother staying in Hobart until Merle was seven, at which point she took her to Bombay, and later to Calcutta. According to this writer, it was Merle's 'mixed – French, Dutch and Irish – ancestry [that] accounted for her unusual, almost inscrutable, oriental look'.[99] Thus in the 1980s, the myth of Oberon's Tasmanian birth retained currency, yoked as it still was to this Orientalist interpretation of her beauty that insisted on her exoticism at the same time as announcing her complete Europeanness. The retelling of this myth, only two years after *The Advertiser* had printed its debunking, shows how tenacious it was, and the fact that these two papers were printed in Adelaide and Darwin respectively reveals the nationwide basis of the interest in Oberon. The circulation of conflicting stories about her provenance has enabled the Tasmanian believers to defend their account of her birth to Lottie Chintock to this day.

The ways in which Australians accepted Oberon as an Australian in the 1930s, based on the film studio propaganda, tell us about the transnational imaginations of even those who never left Australia's shores. The Australian popular and women's press, at least, and presumably their readers, leapt at the idea of an Australian on the global silver screen, especially such a famous and glamorous star. As one reporter put it: 'Many Australians, male and female, have achieved success in Hollywood and the English studios. But Merle Oberon is the first to have won for herself a place in that small group of stars whose names are known to millions, and whose photographs are recognised by film fans in New York or London, Oshkosh, Pa., [sic] or Little Huddlecombe – to say nothing of the cities and towns of the six states of the Commonwealth'.[100] For Australians, it was a mixed blessing when the English paper *The Morning Post* referred to Oberon as 'probably

99 'Australian-born movie star spent life seeking love', *The Northern Territory News* 26 July 1984, p. 34.
100 Marshall, 'Australian Merle Oberon Wins Fame!' p. 24.

England's best known screen actress', because they wanted her to be not just famous but known as Australian.[101]

Jill Matthews has described the process in which movies, fans, and fan magazines became part of Australian modernity in the decades from the 1910s. As elsewhere in the world, Australians rapidly became movie-goers, embracing the fantasy world of the screen as an exciting new form of leisure and escape. They too became appreciative and discerning film audiences, and part of the global market for films and film-related commodities. Integral to the development of transnational film culture in the 1920s and 1930s was the cult of individual stars, a commodification of actors which fan magazines and movie studios both encouraged. Australian audiences participated in the construction of the glamorous film star as much as audiences elsewhere, through locally produced magazines as well as American imports.[102] Part of the appeal of film stars were their stories of emerging from anonymity and rising to celebrity, their embodiment of the magical possibilities of success. Curiosity about their background and origins, then, was inherent to the cult of individual stars, their stories and reputations. Fans were drawn to the stars through their visual appeal, the characters they played, the romance and opulence of their private lives, and through fascination with the question of what it took to become famous. The cult of celebrity has been an element of modernity, evidence of the possibility not only of self-transformation but also of individual success and wealth. That stories of stars were a staple of the women's press in the early twentieth century shows the popular appeal of women having successful careers and earning independent incomes – though feminist principles were compromised by the overwhelming emphasis on heterosexual romance in film plots.

Stage actors had long used make-up, but with film there were now two layers of illusory visual effects for audiences to conjure with: the make-up and the camera. As Liz Conor has shown of Australian culture within its broader transnational contexts, in the 1920s femininity became even more closely linked to visual spectacle and the female body than it had been. Fashion revealed the female body more than in any earlier period in cultural memory, at the same time that women newly transgressed cultural boundaries of space and public behaviour, feeling free to take advantage of urban amenities, as well as driving cars and smoking in public. Women office workers – themselves encroaching on urban and public spaces – consumed

101 *The British Australian & New Zealander* 1 July 1937, p. 15.
102 Jill Julius Matthews, *Dance Hall & Picture Palace: Sydney's Romance with Modernity* (Sydney: Currency Press, 2005), pp. 128–33.

fan magazine articles about movie stars, as they sought to dress, look, act and dance like them. The female screen star was the very model of feminine spectacularity, even as her 'illusory qualities were used as evidence that the spectacularised modern feminine was not to be trusted'.[103] If even Mary Pickford was regarded as visually deceptive because of her heavy make-up, then Oberon's ethnic identity was only another matter for speculation and curiosity – perhaps all the more so because her beauty was universally acclaimed. Yet Oberon's career hinged upon her passing as 'white', a fact her fans would fully have appreciated, just as she herself never wavered from the story of her Tasmanian origins. Thus, in largely accepting her as Australian, Australian fans played a crucial role in helping Oberon to secure her whiteness and consequently her career.

Australians negotiated racial ambiguities in order to claim Oberon as Australian through imagining her as quintessentially English or British. It did not undermine their conception of her as Australian when a 1936 reviewer of *These Three* commented of Oberon's voice: 'It is worth going to this show just to hear how charmingly English can be spoken';[104] rather, this would have been widely interpreted as evidence that an Australian could, in fact, be British.

Susan Courtney, in her recent book on Hollywood and miscegenation, suggests that the Production Code's refusal of cinematic representations of miscegenation in the 1930s and 40s marked a particular phase of racial thinking. She argues that racial thinking moved away from earlier discourses of 'blood' and ancestry, as cinema itself became partly responsible for increasing belief in visible bodily markers of racial difference. The 'dominant cultural assumption that racial difference is in fact visible', Courtney argues, '[was] an elaborate cinematic production'.[105] Racial ambiguity on screen was augmented by the widespread practice of overtly using actors to play racial identities other than their own; in the 1956 film *Bhowani Junction*, for example, 'white' actors in blackface were used to play Indian and Anglo-Indian characters.[106] The pervasive use of blackface in theatre and film from the nineteenth century onwards, and the layers of irony it enabled, meant

103 Liz Conor, *The Spectacular Modern Woman: Feminine Visibility in the 1920s* (Bloomington: Indiana University Press, 2004), p. 91.
104 Stewart Howard, 'Private Views', *The Australian Women's Weekly*, Movie World, 15 August 1936, p. 34.
105 Susan Courtney, *Hollywood Fantasies of Miscegenation: Spectacular Narratives of Gender and Race, 1903–1967* (Princeton: Princeton University Press, 2005), esp. pp. 142–3.
106 Glenn D'Cruz, 'Anglo-Indians in Hollywood, Bollywood and Arthouse Cinema', *Journal of Intercultural Studies* Vol. 28 No. 1 (February 2007), p. 58.

that cinema audiences were accustomed to racial ambiguity. Courtney's argument is a useful frame within which to consider Oberon's acceptance as white. It is clear from the coverage of her films in the Australian press that there was early anxiety and doubt surrounding her racial identity, but that these were largely overcome because – once she was playing proper, respectable British and American roles – she looked sufficiently Anglo to pass. Of course, the facts that she was beautiful, successful and cultivated an English accent all helped. In their eagerness to claim an Australian movie star, Australians set aside their doubts and bought into the studio propaganda. Yet in doing so, at some level, they showed that the category of white Australianness was negotiable. Through the transnational cultural imaginary, Australians grappled with and embraced racial ambiguities, in order to celebrate an extension of themselves on the global silver screen.

Conclusion

This book has told the stories of three women who were Australian by birth or pretence, and whose careers on the stage and the screen fused ideas of 'Australianness' with celebrity and changing ideas of femininity. In each case, there was also a particular 'other' racial or ethnic identity linked to Australianness through imagery, representation, gossip or cultural anxiety. Kellerman, Quong and Oberon's stories allow us to see how white Australianness was formed against multiple, particular forms of racial otherness. They show just how slippery racial identities were, and how complicated and active racial thinking was. These women's careers reveal too how curious Australian and wider audiences were about racial 'others', as well as how astutely they understood the dangers of being relegated to a racial identity below the status of white. If being properly Australian meant being 'white', that superior status could be best understood through its opposition to other specific forms.

Kellerman, Quong and Oberon's careers were each quite distinct as well as chronologically sequential, yet they shared some commonalities. Kellerman and Quong established their careers through live performance, in Kellerman's case moving from performance swimming and diving to vaudeville, and in Quong's moving from elocution competitions to repertory theatre and finally the West End. All three appeared in films, though in Quong's case this was a minor film at the end of her life, while Kellerman was one of the international silent film stars of the 1910s, and Oberon one of the most successful movie stars of the twentieth century. Both Quong and Oberon played roles opposite Laurence Olivier, in each case marking a high point of their careers. Kellerman and Quong both published books, using these publications to support their performance careers.

Kellerman represented feminine modernity through her extreme physical fitness and brazen bodily display, becoming such an icon that she was represented in American and Japanese literature as the ideal modern woman. Internationally, she exemplified the Australian woman's fitness and daring. Her stunning physical feats were perfectly in tune with the sensationalism and melodrama that shaped theatre and cinema in the century's first decades.[1] Quong used her body too, but as the basis for her

1 Ben Singer, *Melodrama and Modernity: Early Sensational Cinema and Its Contexts* (New York: Columbia University Press, 2001).

second career as a performer and interpreter of Chinese culture, invoking her body as the signifier of her Chinese authenticity despite her Australian birth, upbringing and nationality. Quong represented the modern through her career as a cultural interpreter between East and West, as well as challenging traditional assumptions that Chinese intellectuals were exclusively men. Oberon used her body and her face as her passport to film stardom, enabled by contemporary ideals of feminine beauty. She epitomised feminine modernity by attaining celebrity and being seen as glamorous. The necessity to prove her whiteness and obscure her origins was the imperative behind her pretence to be Tasmanian, yet her claims to whiteness were continually shadowed by gossip about her being Anglo-Indian.

Despite the various forms their careers took, it is no coincidence that the three women studied here were performers. Public performance, theatre and film were at the heart of urban modernity around the world. The multiple forms of live performance (vaudeville, cabaret, nightclubs as well as theatre) proliferated along with industrialization, commerce and modern urban life. Recent research has helped us to see the transnational reach and mobility of performers in various forms of theatre even before the rise of film, and has especially revealed the racial and ethnic mix of workers in theatre, music, dance and film. Women claimed respectable careers in various performance fields from the late nineteenth century onwards, even as many of them lived on marginal incomes in chorus lines and other low-status roles. As Jayna Brown argues, the fast-moving and racially-mixed nature of popular theatre meant that the messages presented by performers and received by audiences were open to all kinds of innuendo and multiple readings. Because race itself was often a matter of interpretation and performance, with blackface and other genres of racial mimicry both widespread and popular, theatre was one of the main arenas for racial jokes and satire.[2] Audiences understood that theatre and film could present racial slurs and hidden meanings. Because women performers were seen as especially modern, recognisable women actors on both stage and screen embodied both changing ideas of gender and the illusory possibilities of race.

Considering Kellerman, Quong and Oberon's careers together is a useful way to see the span of racial and ethnic 'others' with which Australianness was entangled in popular culture. Even before its inception as a nation in 1901, Australia's geopolitical location was based on being a developed

2 Jayna Brown, *Babylon Girls: Black Women Performers and the Shaping of the Modern* (Durham: Duke University Press, 2008), p. 6.

Western state and a dominion of the British Empire in the Asia-Pacific region. Through its status within the British Empire, by the early twentieth century Australia had become a regional imperial power, not only as the superior partner to New Zealand, but through its colonial relationships with New Guinea and multiple Pacific islands. Moreover, islanders had constituted a major labour force in the late nineteenth century sugar industry in Queensland, and descendants of islanders still lived there despite the suppression of the indentured labour system. 'South Sea Islanders' were one of the pervasive racial stereotypes of Australian culture, even more than in other parts of the Western world.

The early twentieth century also represented the strongest immigration barriers against the Chinese in Australia, and the lowest level of Chinese presence here from the mid-nineteenth century to the present. The need to exclude the 'yellow peril' was the oft-cited reason for the White Australia policy itself. Being Chinese and Australian at once was a difficult juggling act in this period; Quong's decision to leave Australia was based on her desire for a career in London, but it reflected the exodus of other Chinese-Australians. Indians too were kept at bay by the White Australia policy. In late-colonial India, Anglo-Indians were a subordinated community marginalised by both the British and Indians. While in the nineteenth century the term 'Anglo-Indian' had meant the British resident in India, by the 1910s it shifted to mean those of mixed British and Indian parentage. Eugenics was at its height as an influential pseudo-science in the first half of the twentieth century, stipulating that races should not mix and that cross-breeding led to genetic weaknesses. Miscegenation was supposedly prohibited in a range of European colonies, and mixed-race children were removed from their mothers in Australia as in other places. In such a climate, Anglo-Indians were unwelcome in Australia and discriminated against elsewhere. Yet, like South Sea Islanders and the Chinese, they could represent the allure of the exotic.

Kellerman's career provides us with particular insight into Australian culture from the turn of the twentieth century to the 1920s, and it is this period on which Chapter One focusses. But she did not disappear from Australian or global view; rather, her fame was such that she remained a public figure for much of her life. In the 1920s, besides performing in Europe and touring the US, Kellerman returned over several years to perform at the New York Hippodrome, with conductor John Phillip Sousa, 'the Hippodrome stage provid[ing] a vast aquatic setting for Annette Kellermann

"and her 200 mermaids".[3] In September 1925, the Hippodrome advertised Kellerman's 'farewell New York appearances', noting that her 'return has occasioned unusual interest'.[4] In September 1926, the London Coliseum presented her in a varied program not unlike her 1921–22 Australasian tour, and billed her as: 'The International Star of Stage and Screen from the New York Hippodrome. Foremost Exponent of Physical Culture, in a Spectacle of Novel and Sensational Acts'.[5] She again toured in Europe, performing in Berlin, Copenhagen, Sweden and Holland, and in the northern summer of 1928 she taught a physical culture course on the beaches of Deauville and Dinard in France.[6] After gradually retiring from vaudeville, Kellerman's life revolved around health and fitness. She developed her expertise on physical culture, even lecturing at the University of Southern California in September 1924 and writing health articles for the *The Los Angeles Times* in 1925.[7] From 1919, she increasingly spent time in southern California. In 1924 she came second in a tennis tournament in Los Angeles, and in the 1930s she was known to have taken up golf.[8] In 1924–25, she was involved in the establishment of a country club and estate in northern Los Angeles, advertised as a unique venture aimed at helping women and girls to health and fitness.[9] However, it went sour, and Kellerman ended up suing the company, Annette Kellermann Rancho Realty, for wrongful use of her name.[10]

Even in 1930 she was still represented as shocking, through wearing an early version of what would become known as the bikini.[11] For decades, she maintained a public profile in both America and Australia, taking organisational and lead roles at charitable and special events that had swimming themes; her charitable work began early in her career, when it

3 'Chas. B. Dillingham Dead at Age of 66', *The New York Times* 31 August 1934, p. 17.
4 Program for Keith-Albee's New York Hippodrome, Ephemera Collection, Petherick Reading Room, National Library of Australia.
5 Programme from the London Coliseum for week commencing 20 September 1926, Ephemera Collection, Petherick Reading Room, National Library of Australia.
6 Kellerman, 'My Story', Kellerman Papers, Box 1, Folder 3; 'Women in the World', *The Australian Woman's Mirror* 24 December 1928, p. 20.
7 'Kellerman to Talk', *The Los Angeles Times* 22 September 1924; 'Care of the Body, *The Los Angeles Times* 3 May 1925.
8 Photos, *The New York Times* 6 April 1924, p. RP3; Golf advertisement, *The New York Times* 7 June 1937, p. 38.
9 *The Los Angeles Times* 26 October 1924; 4 January 1925; 6 January 1925; 11 January 1925.
10 'Mermaid Queen Seeks Damages', *The Los Angeles Times* 15 May 1925; 'Kellerman Row is Aired', *The Los Angeles Times* 17 May 1925; 'Details of Kellerman Club Aired', *The Los Angeles Times* 29 May 1925; 'Miss Kellerman is Quizzed', *The Los Angeles Times* 17 June 1925; 'Annette Kellermann Sues Club', *The New York Times* 16 May 1925, p. 19.
11 'Styles for Beach will be Scanty', *The Los Angeles Times* 19 October 1930.

included support for disabled children, perhaps because of her own early disability. Kellerman continued her film work beyond her vaudeville career. In 1936 she took to the US several 'swimologue' films she and her husband Jimmy Sullivan had shot on Pandanus Island, on the Great Barrier Reef. Apparently they were not terribly successful, perhaps because, according to one reviewer, the plot of at least one was rather unclear, with Kellerman playing both a mermaid and a sea nymph who kidnaps the mermaid's 'waterbaby'.[12] Even then, she was still peddling her signature South Sea Islander and mermaid themes.

In 1939 Kellerman and Sullivan settled on Newry Island in Queensland, but when World War II erupted they moved to Sydney, where she organised large fundraising events for the Red Cross, as well as entertaining troops. Kellerman's patriotism extended to writing a song titled 'We're All In It!' for one of her fundraising shows, with lyrics including: 'The Aussies came from Gundagai, Murrumbidgee and from Mudgee; They also came from Bundaberg, Yarrawonga and from Widgee'.[13] Kellerman trained troupes of young women to swim and dance for these wartime reviews, as well as performing in them herself. After the war, she and Sullivan moved to California, where Kellerman had a house in Pacific Palisades. During this period she owned a health food store in Long Beach, which she saw as a product of her interest in and study of dietetics (including her vegetarianism). In 1959 they returned finally to live in Australia, briefly in Mosman, then settling in Southport, Queensland, where she died in November 1975 at the age of 89. Even in the last years of her life, Kellerman was reported to swim every day, still the energetic mermaid.

Fittingly, Kellerman is memorialised in Australia today through two swimming pools in Sydney: the Annette Kellerman Aquatic Centre in Enmore Park run by the Marrickville Council, and the eight Annette Kellerman murals painted by artist Wendy Sharpe at the Cook+Phillip Park pool in East Sydney. Kellerman was also the subject of an exhibition at the National Maritime Museum in Sydney from December 2005 to March 2006, and another at the National Portrait Gallery in Canberra in 2011.

The story of Rose Quong sheds light on Australia particularly in the 1910s and 1920s, while further illuminating the scale and dynamics of the Australian community in London in the 1920s and 1930s. From the late 1930s onwards, Quong largely disappeared from Australian view, despite

12 'Film Gossip of the Week', *The New York Times* 26 April 1936, p. X3.
13 I am grateful to Georgine Clarsen for the copy of the musical score of 'We're All In It!'

maintaining close connections with her siblings in Australia, and likely maintaining some correspondence with Australian friends. Despite the growing attraction of New York as an alternate metropole to London, the individual careers of Australians there were much less visible in a culture still oriented toward Britain by the legacies of colonial ties. The writings and activities of Australia's cultural elite who fled to London in the post-World War II decades were followed, even if with criticism and derision, while those in the United States were not until much later, despite successes such as the books Quong published with Pantheon. Her relative lack of visibility, of course, was also related to the fact that her level of success was much lower than that of either Kellerman or Oberon. While she continued to perform her solo shows of Chinese culture, and to give public lectures, she was not a celebrity of the same order. Perhaps too most Australians found her Chineseness an obstacle to their identifying with her, in a period when Chineseness and Australianness were viewed as antithetical.

Her remarkable longevity extended to being cast as herself, Rose Quong, venerable Chinese astrologer, in the offbeat Warner Brothers and Canadian film *Eliza's Horoscope* shot in Montreal between 1970 and 1974. By the time the film was completed, Quong had died in 1972 at age 93; not surprisingly, in the film she appears very elderly as well as pale. The film, which starred Tommy Lee Jones and is somewhat surrealistic, was reviewed in the *The Los Angeles Times* on 15 June 1977 when it screened in that city as part of a Quebec film series. The reviewer called it 'a boldly assertive and original work in which the creative imagination and the social conscience are joined in a way you seldom see'.[14] The film seems to have been distributed in 1976 and 1977, and to have received a fair amount of attention in Canada. But it seems not to have been reviewed by the Australian press, and, unlike Kellerman and Oberon, Quong received no obituaries in Australia.

Merle Oberon's story gives us considerable insight into anxieties about racial mixing in Australia in the 1930s, and the concerns which the widely-used term 'exotic' masked. Chapter Three focusses especially on the 1930s because the years in which Oberon was becoming known allow us to see how Australians reacted to this new celebrity, who pretended to be one of their own but in fact had never been here. Australians have continued to claim Oberon up unto the present, with diehard believers in Tasmania still maintaining the mythology of her birth to Chinese hotel worker Lottie

14 Charles Champlin, 'Movie Review: Eliza's Rocky Horoscope Show', *The Los Angeles Times* 15 June 1977, p. G22.

Chintock. Oberon's imagined Australianness has been maintained by a variety of other sources as well. *Who's Who in Australia* listed Oberon, citing her Tasmanian birth, from at least the 1950 edition until 1977.[15] When Oberon died in November 1979, her obituary in *The Times* (London) stated that she was born 'in Tasmania on February 19, 1911 and educated in India', and *Variety Obituaries* published the same claim as late as 1988.[16]

For her part, Merle Oberon maintained till her dying day the fiction that she had been born and spent her first years in Tasmania, and was thus 'Australian'. It must have been stressful and awkward for her to carry out this pretence, as she did on a variety of occasions. During World War II, for example, Oberon served as one of the hosts at a garden party in Encino, California, to raise money for the Australian War Relief Fund. The event included games supposedly popular in Australia, as well as 'a special Anzac barbecue'.[17] Had anyone attending asked Oberon for her reminiscences of Australia, or commentary on Australian culture, she would have had to be inventive in reply.

In 1965 Oberon came to Australia for the first time in her life, at the invitation of Qantas airlines to be on its inaugural flight from Mexico. Undoubtedly tired after the long flight, apparently Oberon was dismayed to find a pack of reporters waiting to greet her at 7.30 a.m., full of questions about her birth and childhood in Tasmania. Rather than sticking to the studio-publicity full script of her supposed origins, she uneasily presented a new version. The reporters were, apparently, taken aback. *The Sydney Morning Herald* commented: 'with as incisive and final a blow as that which ended her first big starring role – Anne Boleyn in "The Private Life of Henry VIII" – she stated bluntly that her birth there "was just a coincidence".'[18] The Adelaide *Advertiser* quoted her as saying: 'Both my parents were English and they just happened to be visiting Tasmania as tourists when I was born…. As soon as my mother was well enough to travel, my parents took me to India where I lived until I was 14. My parents and I then returned to England where I eventually broke into films'.[19] According to *The Age*, she diplomatically added: 'But I still have strong sentimental attachments,

15 'Oberon, Merle', *Who's Who in Australia* 14th edition (Melbourne: The Herald, 1950), p. 543.
16 'Obituary: Miss Merle Oberon; Notable beauty of the screen', *The Times* 26 November 1979, p. 14; 'Merle Oberon Dies At 68', *Variety Obituaries* Vol. 8, 1975–1979 (New York: Garland Publishing, 1988), entry for 28 November 1979.
17 'Garden Party Aids Australian Relief', *The Los Angeles Times* 11 August 1941, p. A6.
18 'Miss Oberon Ends Some Old Illusions', *The Sydney Morning Herald* 19 January 1965.
19 'Star To Visit Birthplace', *The Advertiser* 19 January 1965.

and in any case I believe Tasmania is such a pretty place'.[20] At a dinner in her honour, she told journalist David McNicoll conflicting stories about whether or not she had ever been to Hobart. Charles Higham interviewed her at the Menzies Hotel during her visit; she told him she was unwell, seemed distracted and frightened, and did not respond to questions about her childhood. Oberon briefly visited Canberra as part of the trip. She had a quick tour of the city, spoke to reporters (commenting that 'Australia is very like England.... Not the colours of course, but the warmth of the people and your accents. Oh, they sound so English to my ear'), but because she was 'not well', she apparently did not attend a luncheon arranged for her at University House, and returned to Sydney on the same plane.[21] She flew back to Mexico after only 72 hours in Australia.[22]

Her biographers Higham and Moseley report that in the mid-1970s Oberon came to Australia for a second time. It was a brief private visit with her fourth husband, Dutch actor Robert Wolders, who was about 25 years her junior, while they were on a cruise of the South Pacific. In 1978, Oberon made a third trip to Australia – at the invitation to appear at the Sammy awards, Australia's annual film awards ceremony, in Sydney.

Prior to Oberon's visit, *The Daily Telegraph* managed to catch an interview with her in New York. According to the reporter, Oberon was 'bubbling with an almost schoolgirlish enthusiasm over her visit to Australia', and full of questions about what she should expect in the way of the journey and the weather. She confided that: 'I was really tiny when I left Tasmania, about one I think, but the people there feel I'm Tasmanian and that I belong... It's very sweet and I like that'.[23] Again, she was accompanied on the trip by Wolders, who told her biographers in retrospect that he did not understand why she agreed to go. At the time, he believed she had been born in Australia; he only learned the truth after her death. He recalled that she was upset from the time they arrived in Sydney; that she had fits of weeping, and did a poor job of presenting the Sammy awards. The Lord Mayor of Hobart extended an invitation to Oberon to add a trip there to her itinerary, organising a reception for her at the town hall. Oberon attended the reception, and, according to Wolders actually began a speech referring to her childhood, before breaking down and apparently fainting. Higham

20 'Starts Sentimental Visit to Birthplace', *The Age* 19 January 1965.
21 'Film Star Visits Canberra', *The Canberra Times* 20 January 1965.
22 Charles Higham and Roy Moseley, *Princess Merle: The Romantic Life of Merle Oberon* (New York: Coward-McCann Inc., 1983), pp. 242–43.
23 Andrew McKay, 'Merle's out of the rat race', *The Daily Telegraph* 7 October 1978, p. 19.

and Moseley report that, prior to Oberon and Wolders's arrival in Hobart, the Registrar of Births, Deaths and Marriages had discovered that there was no record of her birth in Tasmania, and that everyone at the ceremony other than Wolders knew this.[24]

In Hobart, Oberon and Wolders stayed at the Wrest Point Hotel, where one night Oberon judged the 1979 Miss Tasmania Quest. Reportedly, the hotel received multiple phone messages from people claiming they remembered her from her childhood at St. Helens and in Hobart. During her brief visit, Oberon agreed to be interviewed on radio, by broadcaster Edyth Langham on a program of celebrity interviews. Langham later recalled how exciting it was to interview Oberon, in the Lady Mayoress's room at the Town Hall, and that Oberon 'was exquisite', 'dressed in powder blue and these wonderful cheekbones'. Langham was convinced of Oberon's Tasmanian birth in St. Helen's to Lottie Chintock, and her interview with Oberon, whom she found 'very fascinating', did nothing to contradict that belief.[25] Yet, according to one writer, Oberon told the driver who took her from her hotel to the town hall that she was not born in Tasmania, that she was born in India.[26] The Tasmanian visit was so stressful that, soon after her return to California, she collapsed, at the beginning of what would be her final bout of ill-health.

From the 1970s, Australia began to define itself as a 'multicultural' nation, to accept the presence of non-British cultures as part of what was newly seen as a national mix.[27] Even during the seven decades of White Australia, constructions of whiteness were anything but fixed or simple – despite the fact that, as Aileen Moreton-Robinson argues, they were 'central to the racial formation of Australian society'.[28] Australians negotiated their racial identities on local, national and global levels. What it meant to be 'white' was articulated in the arena of popular culture at least as much as in the law. Australians asserted their whiteness through social behaviour, language, attitudes, jokes, and visual imagery, both drawing on and contributing to national and transnational culture and practices. As a recent collection on Australian vernacular modernities argues, America and the

24 Higham and Moseley, *Princess Merle*, pp. 291–92.
25 Edyth Langham interviewed by Gwen Emden, 11 September 1996, Oral History No. 305115, National Film and Sound Archive.
26 Nicholas Shakespeare, *In Tasmania* (London: The Harrill Press, 2004), pp. 299–301.
27 The term 'multicultural' was officially adopted in 1973. James Jupp, *Understanding Australian Multiculturalism* (Canberra: Australian Government Publishing Service, 1996), p. 7.
28 Aileen Moreton-Robinson (ed.), *Whitening Race: Essays in Social and Cultural Criticism* (Canberra: Aboriginal Studies Press, 2005), p. ix.

British Empire were dominant sources of the books, magazines and films Australians consumed, but we need to see the particular and original contributions Australia made to globally-circulating cultural forms.[29] Whiteness was constructed through hierarchical thinking in which Anglo-Saxons and other northern Europeans were understood as superior to other races. Australians' sense of themselves as white, therefore, was expressed in relation to perceptions of other 'races', including South Sea Islanders, Chinese and Indians. The popular culture of the first half of the twentieth century incorporated racial representations that assumed hierarchies of race. Messages about racial characteristics and racial order suffused cultural forms from literature to advertising.

In the same period, technologies of culture changed rapidly, with film overtaking live theatre in popularity, radio becoming an important medium, and television emerging. Just as racial thinking permeated print media, radio, theatre and film, so did rapidly changing notions of respectable femininity. White Australian women were among the first in the world to be enfranchised, beginning with South Australia in 1894, then on a national basis from 1902. In political and other ways, Australian women asserted themselves as particularly modern, socially progressive, bold and physically fit. Gender became entwined with race in evolving definitions of what it meant to be 'Australian'. Live theatre and film, therefore, were not merely idle leisure pursuits, but media through which Australian and other audiences grappled with changing social meanings, identities and behaviours. Accessible to a range of social classes in both cities and country towns, theatre and film constituted an influential cultural canvas. The stars of theatrical and movie productions thus became household names, whose facial and bodily images were widely recognised. Women in particular read about celebrities in the women's and gossip magazines that were part of everyday life, and which featured stories about each of Kellerman, Quong and Oberon during the years of their greatest recognition.

Australia was White by both immigration policy and self-conception from 1901 to the 1960s. This racial order correlated with other parts of the world, ranging from the American South to South Africa, where the first half of the twentieth century saw either the full entrenchment of white supremacist systems begun in the nineteenth century (such as Jim Crow), or the genesis of systems that would not be demolished until the end of the

29 Robert Dixon and Veronica Kelly (eds.), *Impact of the Modern: Vernacular Modernities in Australia 1870s-1960s* (Sydney: Sydney University Press, 2008), pp. xvii-xix.

twentieth (such as Apartheid). Yet we are only beginning to grapple with the social and cultural meanings of Australians' attachment to whiteness from the late nineteenth century onwards. There is a growing body of scholarship uncovering the stories of Aboriginal Australians' exclusion and subordination legally, socially and culturally. To comprehend fully the racial thinking that saturated Australian culture we need to look not only at the plight of Indigenous people, though that is crucial, but also at the self-conception of those who saw themselves as constituting the nation. Kellerman, Quong and Oberon help us to see how Australian celebrities, especially modern women performers, embodied the cultural fascination with racial types.

Bibliography

Ang, Ien. 'Can One Say No to Chineseness? Pushing the Limits of the Diasporic Paradigm', *Boundary 2*, Vol. 25, No. 3 (Fall 1998), pp. 223–42.

Barkan, Elazar and Ronald Bush (eds). *Prehistories of the Future: The Primitivist Project and the Culture of Modernism*. Stanford, CA: Stanford University Press, 1995.

Bean, Jennifer M. 'Technologies of Early Stardom and the Extraordinary Body', *Camera Obscura* 48 Vol. 16, No. 3 (2001), pp. 8–57.

Berry, Professor. 'The Early Days of The Melbourne Repertory Theatre Society', in *R.T. Make This Your Theatre* (Melbourne: Melbourne Repertory Theatre Society and Ramsay Publishing, 1928), pp. 5–7.

Bhabha, Homi K. *The Location of Culture*. London: Routledge, 1994.

Blunt, Alison. *Domicile and Diaspora: Anglo-Indian Women and the Spatial Politics of Home*. Oxford: Blackwell Publishing, 2005.

Blunt, Alison. '"Land of our Mothers": Home, Identity, and Nationality for Anglo-Indians in British India, 1941–1947', *History Workshop Journal* Issue 54 (Autumn 2002), pp. 49–72.

Brisbane, Katherine (ed.). *Entertaining Australia: An Illustrated History*. Sydney: Currency Press, 1991.

Brown, Jayna. *Babylon Girls: Black Women Performers and the Shaping of the Modern*. Durham: Duke University Press, 2008.

Brown, Kendall H. 'The "Modern" Japanese Woman', *The Chronicle of Higher Education* 21 May 2004, B19.

Burren, Pauline B. *Mentone: The Place for a School: A History of Mentone Girls' Grammar School from 1899*. South Yarra: Hyland House Publishing, 1984.

Cannadine, David. *Ornamentalism: How the British Saw Their Empire*. Oxford: Oxford University Press, 2001.

Chan, Henry. 'The Identity of the Chinese in Australian History', in *Queensland Review* Vol. 6, No. 2 (Nov. 1999), pp. 1–9.

Chan, H.D. Min-his. 'Becoming Australasian but Remaining Chinese: The Future of the Down Under Chinese Past', in *The Overseas Chinese in Australasia: History, Settlement and Interactions*, eds Henry Chan, Ann Curthoys and Nora Chiang (Taipei: Interdisciplinary Group for Australian Studies, National Taiwan University, & Canberra: Centre for the Study of the Chinese Southern Diaspora, Australian National University, 2001), pp. 1–15.

Clarkson, Alan. *Lanes of Gold: 100 Years of the NSW Amateur Swimming Association*. Sydney: Lester-Townsend Publishing Pty. Ltd., 1990.

Conor, Liz. *The Spectacular Modern Woman: Feminine Visibility in the 1920s*. Bloomington: Indiana University Press, 2004.

Couchman, Sophie. 'From Mrs Lup Mun, Chinese Herbalist, to Yee Joon, Respectable Scholar: A Social History of Melbourne's Chinatown, 1900–1920', in *The Overseas Chinese in Australasia: History, Settlement and Interactions*, eds Henry Chan, Ann Curthoys and Nora Chiang (Taipei: Interdisciplinary Group for Australian Studies, National Taiwan University, & Canberra: Centre for the Study of the Chinese Southern Diaspora, Australian National University, 2001), pp. 125–39.

Courtney, Susan. *Hollywood Fantasies of Miscegenation: Spectacular Narratives of Gender and Race, 1903–1967*. Princeton: Princeton University Press, 2005.

Curthoys, Ann. "'Chineseness" and Australian Identity', in *The Overseas Chinese in Australasia: History, Settlement and Interactions*, eds Henry Chan, Ann Curthoys and Nora Chiang (Taipei: Interdisciplinary Group for Australian Studies, National Taiwan University, & Canberra: Centre for the Study of the Chinese Southern Diaspora, Australian National University, 2001), pp. 16–29.

Curthoys, Ann. "'Men of All Nations, except Chinamen": Europeans and Chinese on the Goldfields of New South Wales', in Iain McCalman, Alexander Cook and Andrew Reeves (eds), *Gold: Forgotten Histories and Lost Objects of Australia* (Cambridge: Cambridge University Press, 2001), pp. 103–23.

Daley, Caroline. *Leisure & Pleasure: Reshaping & Revealing the New Zealand Body 1900–1960*. Auckland: Auckland University Press, 2003.

D'Cruz, Glenn. 'Anglo-Indians in Hollywood, Bollywood and Arthouse Cinema', *Journal of Intercultural Studies* Vol. 28, No. 1 (February 2007), pp. 55–68.

Delofski, Maree. 'Storytelling and Archival Material in *The Trouble with Merle*', *The Moving Image* Vol. 6, No. 1 (Spring 2006), pp. 82–101.

Dixon, Robert and Veronica Kelly (eds). *Impact of the Modern: Vernacular Modernities in Australia 1870s-1960s*. Sydney: Sydney University Press, 2008.

Douglas, Dennis and Margery M. Morgan. 'Gregan McMahon and the Australian Theatre', *Komos* Vol. 2, No. 2 (1969), pp. 50–62.

Edmond, Rod. *Representing the South Pacific: Colonial Discourse from Cook to Gauguin*. Cambridge: Cambridge University Press, 1997.

Fields, Armond. *Women Vaudeville Stars: Eighty Biographical Profiles*. Jefferson, NC: McFarland & Co., 2006.

Fitzgerald, F. Scott. *This Side of Paradise*. New York: Charles Scribner's, 1920.

Fitzgerald, John. *Big White Lie: Chinese Australians in White Australia*. Sydney: University of New South Wales Press, 2007.

Furer, Andrew J. 'Jack London's New Woman: A Little Lady With a Big Stick', *Studies in American Fiction* Vol. 22, No. 2 (Autumn 1994), pp. 185–214.

Ganguly, Debjani. 'From Empire to *Empire*? Writing the Transnational Anglo-Indian Self in Australia', *Journal of Intercultural Studies* Vol. 28, No. 1 (February 2007), pp. 27–40.

Garelick, Rhonda K. *Electric Salome: Loie Fuller's Performance of Modernism*. Princeton: Princeton University Press, 2007.

Gibson, Emily with Barbara Firth. *The Original Million Dollar Mermaid: The Annette Kellerman Story*. Crows Nest, NSW: Allen & Unwin, 2005.

Glenn, Susan A. *Female Spectacle: The Theatrical Roots of Modern Feminism*. Cambridge, MA: Harvard University Press, 2000.

Hage, Ghassan. *Against Paranoid Nationalism: Searching for Hope in a Shrinking Society*. Annandale, NSW: Pluto Press, 2003.

Hage, Ghassan. *White Nation: Fantasies of White Supremacy in a Multicultural Society*. Annandale, NSW: Pluto Press, 1998.

Herlihy, Mark A. 'Leisure, Space, and Collective Memory in the "Athens of America": A History of Boston's Revere Beach'. PhD Thesis, Dept of American Civilization, Brown University, 2000; UMI Films.

Hetherington, John. *Melba*. London: Faber & Faber, 1967.

Higham, Charles and Roy Moseley. *Princess Merle: The Romantic Life of Merle Oberon*. New York: Coward-McCann Inc., 1983.

Holland, Wendy. 'Reimagining Aboriginality in the Circus Space', *Journal of Popular Culture* Vol. 33, No. 1 (Summer 1999), pp. 91–104.

Hunter, Kate. "'Fifi from Tahiti" and other Koori girls: Untangling race and gender

in travelling shows to the 1950s', paper presented at the Australian Historical Association Conference, University of New England, Armidale, September 2007.

Imada, Adria L. 'Hawaiians on Tour: Hula Circuits through the American Empire', *American Quarterly* Vol. 56, No. 1 (March 2004), pp. 111–49.

Johnson, Bruce. *The Inaudible Music: Jazz, Gender and Australian Modernity.* Sydney: Currency Press, 2000.

Jordan, Deborah. *Nettie Palmer: Search for an Aesthetic.* Melbourne: History Department, University of Melbourne, 1999.

Jules-Rosette, Bennetta. *Josephine Baker in Art and Life: The Icon and the Image.* Urbana: University of Illinois Press, 2007.

Jupp, James. *Understanding Australian Multiculturalism.* Canberra: Australian Government Publishing Service, 1996.

Kellerman, Annette. *Fairy Tales of the South Seas and Other Stories.* London: Sampson Low, Marston & Co., n.d. [1926].

Kellermann, Annette. *How to Swim.* London: William Heinemann, 1919.

Kellerman, Annette. *Physical Beauty: How to Keep It.* New York: George H. Doran Co., 1918.

Kelly, Veronica. 'A Complementary Economy? National Markets and International Product in Early Australian Theatre Managements', *New Theatre Quarterly* Vol. 21, Pt. 1 (Feb. 2005), pp. 77–95.

Kelly, Veronica. 'An Australian Idol of Modernist Consumerism: Minnie Tittell Brune and the Gallery Girls', *Theatre Research International* Vol. 31, No. 1 (March 2006), pp. 17–36.

Kilner, Kerry. 'Performing Women's History: Re-assessing the Role of Women in Melbourne's Little Theatre Movement 1901–1930', MA Thesis, Centre for Women's Studies, Monash University, 1996.

Kohn, Marek. *Dope Girls: The Birth of The British Drug Underground.* London: Lawrence & Wishart, 1992.

Korda, Michael. *Charmed Lives: A Family Romance.* London: Allen Lane, 1980.

Korda, Michael. *Queenie.* New York: Warner Books, 1985.

Lake, Marilyn and Henry Reynolds, *Drawing the Global Colour Line: White Men's Countries and the Question of Racial Equality.* Carlton, Vic.: Melbourne University Press, 2008.

Leong, Karen J. *The China Mystique: Pearl S. Buck, Anna May Wong, Mayling Soong, and the Transformation of American Orientalism.* Berkeley: University of California Press, 2005.

Lim, Shirley J. *A Feeling of Belonging: Asian American Women's Public Culture, 1930–1960.* New York: NYU Press, 2006.

London, Jack. *The Valley of the Moon.* New York: Macmillan, [1913] 1928.

Lowe, Lisa. *Critical Terrains: French and British Orientalisms.* Ithaca: Cornell University Press, 1991.

Mackie, Vera. 'The Moga as Racialised Category in 1920s and 1930s Japan', in L. Boucher, J. Carey and K. Ellinghaus (eds), *Historicising Whiteness: Transnational Perspectives on the Construction of an Identity.* Melbourne: RMIT Publishing, 2007.

Markus, Andrew. 'Government Control of Chinese Immigration to Australia, 1855–1975', in *The Overseas Chinese in Australasia: History, Settlement and Interactions*, eds Henry Chan, Ann Curthoys and Nora Chiang (Taipei: Interdisciplinary Group for Australian Studies, National Taiwan University, & Canberra: Centre for the Study of the Chinese Southern Diaspora, Australian National University, 2001), pp. 69–81.

Martin, Wendy. "'Remembering the Jungle": Josephine Baker and Modernist Parody',
in Elazar Barkan and Ronald Bush (eds), *Prehistories of the Future: The Primitivist
Project and the Culture of Modernism* (Stanford, CA: Stanford University Press,
1995), pp. 310–325.

Matthews, Jill Julius. *Dance Hall & Picture Palace: Sydney's Romance with Modernity.*
Sydney: Currency Press, 2005.

Matthews, Julie. 'Eurasian Persuasions: Mixed Race, Performativity and
Cosmpolitanism', *Journal of Intercultural Studies* Vol. 28, No. 1 (February 2007),
pp. 41–54.

Modern Girl Around the World Research Group, The. Tani E. Barlow, Madeleine
Y. Dong, Uta G. Poiger, Priti Ramamurthy, Lynn M. Thomas, and Alys Eve
Weinbaum, 'The Modern Girl around the World', *Gender and History* Vol. 17, No. 2
(2005), pp. 245–94.

Modern Girl Around the World Research Group, The: Alys Eve Weinbaum, Lynn
M. Thomas, Priti Ramamurthy, Uta G. Poiger, Madeleine Yue Dong, and Tani
E. Barlow (eds). *The Modern Girl Around the World: Consumption, Modernity, and
Globalization.* Durham: Duke University Press, 2008.

Moreton-Robinson, Aileen (ed.). *Whitening Race: Essays in Social and Cultural Criticism.*
Canberra: Aboriginal Studies Press, 2005.

Nenno, Nancy. 'Femininity, the Primitive, and Modern Urban Space: Josephine Baker
in Berlin', in Katharina von Ankum (ed.), *Women in the Metropolis: Gender and
Modernity in Weimar Culture* (Berkeley: University of California Press, 1997),
pp. 145–61.

O'Brien, Patty. *The Pacific Muse: Exotic Femininity and the Colonial Pacific.* Seattle:
University of Washington Press, 2006.

Osmond, Gary and Murray G. Phillips. "'Look at That Kid Crawling": Race, Myth
and the 'Crawl' Stroke', *Australian Historical Studies* No. 127 (April 2006),
pp. 43–62.

Palmer, Nettie. *Fourteen Years: Extracts from a Private Journal 1925–1939.* Melbourne:
Meanjin Press, 1948.

Parsons, Philip (ed.), *Companion to Theatre in Australia.* Sydney: Currency Press, 1995.

Patrick, John. *The Teahouse of the August Moon.* New York: G.P. Putnam's Sons, 1952.

Peiss, Kathy. *Hope in a Jar: The Making of America's Beauty Culture.* New York: Henry
Holt and Co., 1998.

Peltonen, Matti. 'Clues, Margins, and Monads: The Micro-Macro Link in Historical
Research', *History and Theory* Vol. 40 (October 2001), pp. 347–59.

Poignant, Roslyn. *Professional Savages: Captive Lives and Western Spectacle.* Sydney:
University of New South Wales Press, 2004.

Pybus, Cassandra. 'Lottie's Little Girl', in *Till Apples Grow on an Orange Tree* (St. Lucia,
Qld.: University of Queensland Press, 1998), pp. 91–111.

Quong, Rose. 'Spiritual Forces and Race Equality', in Harry W. Laidler (ed.), *The Role of
the Races in Our Future Civilization* (New York: League for Industrial Democracy,
1942), pp. 33–36.

Raszeja, Veronica. *A Decent and Proper Exertion: The Rise of Women's Competitive
Swimming in Sydney to 1912.* Campbelltown, NSW: Australian Studies in Sports
History, No. 9, 1992.

Rees, Leslie. *The Making of Australian Drama.* Sydney: Angus & Robertson, 1973.

Roe, Jill. *Stella Miles Franklin: A Biography.* London: Fourth Estate, 2008.

Rolls, Eric. *Sojourners: The Epic Story of China's Centuries-Old Relationship with Australia.*
St. Lucia, Qld.: University of Queensland Press, 1992.

Ryan, Mary P. 'The Projection of a New Womanhood: The Movie Moderns of the 1920's', in Jean E. Friedman and William G. Shade (eds), *Our American Sisters: Women in American Life and Thought* (Boston: Allyn and Bacon, 1976), pp. 366–85.

Said, Edward W. *Orientalism*. New York: Vintage Books, 1979.

Sentilles, Renee M. *Performing Menken: Adah Isaacs Menken and the Birth of American Celebrity*. Cambridge: Cambridge University Press, 2003.

Shakespeare, Nicholas. *In Tasmania*. London: The Harrill Press, 2004.

Shimakawa, Karen. *National Abjection: The Asian American Body Onstage*. Durham: Duke University Press, 2002.

Singer, Ben. *Melodrama and Modernity: Early Sensational Cinema and Its Contexts*. New York: Columbia University Press, 2001.

Smith, Vivian (ed.). *Letters of Vance and Nettie Palmer 1915–1963*. Canberra: National Library of Australia, 1977.

Smith, Vivian (ed.). *Nettie Palmer: Her Private Journal 'Fourteen Years', Poems, Reviews and Literary Essays*. St. Lucia, Qld.: University of Queensland Press, 1988.

Sneider, Vern. *The Teahouse of the August Moon*. New York: G.P. Putnam's Sons, 1951.

St. Leon, Mark. *Wizard of the Wire: The Story of Con Colleano*. Canberra: Aboriginal Studies Press, 1993.

Sturma, Michael. *South Sea Maidens: Western Fantasy and Sexual Politics in the South Pacific*. Westport, Conn.: Greenwood Press, 2002.

Tanizaki, Junichiro. *Naomi*. New York: Vintage Books, [1924] 2001.

Travers, Robert. *Australian Mandarin: The Life and Times of Quong Tart*. Kenthurst, NSW: Rosenberg Publishing, 2004.

Walker, David. *Anxious Nation: Australia and the Rise of Asia 1850–1939*. St Lucia, Qld: University of Queensland Press, 1999.

Waterhouse, Richard. *Private Pleasures, Public Leisure: A History of Australian Popular Culture Since 1788*. South Melbourne: Longman Australia, 1995.

Williams, Margaret. *Australia on the Popular Stage, 1829–1929*. Oxford: Oxford University Press, 1983.

Woollacott, Angela. 'The Fragmentary Subject: Feminist History, Official Records, and Self-Representation', *Women's Studies International Forum* Vol. 21, No. 4 (1998), pp. 329–339.

Woollacott, Angela. 'Rose Quong Becomes Chinese: An Australian in London and New York', *Australian Historical Studies* No. 129 (April 2007), pp. 16–31.

Woollacott, Angela. *To Try Her Fortune in London: Australian Women, Colonialism, and Modernity*. New York: Oxford University Press, 2001.

Yarwood, A. T. *Asian Migration to Australia: The Background to Exclusion 1896–1923*. Parkville, Vic.: Melbourne University Press, 1964.

Yoshihara, Mari. *Embracing the East: White Women and American Orientalism*. New York: Oxford University Press, 2003.

Young, Edith. *Inside Out*. London: Routledge & Kegan Paul, 1971.

Yuanfang, Shen. *Dragon Seed in the Antipodes: Chinese-Australian Autobiographies*. Carlton South, Vic.: Melbourne University Press, 2001.

Index

Aboriginals xvi, xviii, xx, 48, 65, 143
 swimmers 4
 removal of children 9
Adams, Mildred 14
American League of Decency 115
Ang, Ien 92
Anglo-Indians 94, 97, 103–106, 135
 in Australia 109, 127–128
 women 105
Annette Kellerman Aquatic Centre 137
Annette Kellerman murals at Cook+Phillip
 Park pool 137
Anzac mythology 117
Apperly, Elizabeth 63, 64
Archer, W.G. 71
Australian crawl 4, 6, 41
Australian female celebrities, racial
 interpretations of 96
BBC 49, 74, 78
Bailey, Judy 123
Baker, Josephine xxi–xxii
Ballard, Lucien 106
Barkan, Elazar xxii
bathing suits 9, 10, 13, 14
Bean, Jennifer M. 40
Beaumont, Phyllis 128
Berkeley, Busby 47
Berkeley, Wilma 68
Bernhardt, Sarah xxiv
Berry, Prof. 62
Bhabba, Homi 93
Blunt, Alison 105, 127
Boyer, Charles 112
Brecht, Bertolt 76
Brenon, Herbert 41
Brewster, Edwin Tenney 22
Brown, Jayna 134
Brown, Kendall H. 38
Buck, Pearl S. 87
Bush, Ronald xxiii
Calcutta Amateur Theatrical Society 96, 97
Calwell, Arthur 128
Cannadine, David 51
Cavill, Arthur 41
Cavill, Frederick 4, 6
Cavill, Percy 3, 6
Cavill's Baths 3–4
Chabonnet, Amable 6

Chevalier, Maurice 116
Chinese in Australia 51–52, 56–57
Chintock, Lottie 95, 122, 129, 141
Chisley, Mr. 58
Churchill, Winston 101
Clark, Marjorie 62
colonialism 93
Commonwealth Immigration Restriction Act
 (1901) xvi, 51, 127
Conor, Liz xxv, 130
coo-ee 44
Coogee baths 7
Cornish, Henry 109
Couchman, Sophie 57
Courtney, Susan 131–132
Craig, Edith 70, 73, 74
Croker, Richard 23
Crossley, Ada 69
Curthoys, Ann 51, 52
Davies, John B. 123
Dean, Basil 76
Dietrich, Marlene 124
Delofski, Maree 94, 95
Donaldson, Mary 95
Douglas, Dennis 63
Durack, Fanny 9
Ederle, Gertrude 10
Edmond, Rod 44
Elstree Studios 97, 100
English girl xx, 111
Esson, Hilda 59
Esson, Louis 59, 61
Eurasian women 93
Evans, Edith 75–76
Fairbanks, Douglas Sr. 100
feminine modernity 3, 133, 134
feminist analysis xix
Filippi, Rosina 70, 71
Finney, Gladys 17
Finney, Maud 17
Fitzgerald, F. Scott 35
Fitzgerald, John 53, 54
flapper xxiv, 14
Flynn, Errol 115
Franklin, Miles 69
Fuller, Loie xxiv
Furer, Andrew 36
Ganguly, Debjani 109

Gauguin, Paul 42
gender transgression 40
Gibson Girl 13
Glenn, Susan xxiv
Goodsall, Arthur 61–62
Grimshaw, Beatrice 42
Hage, Ghassan xvi, xvii, xix–xx
Hall, William 126
Harrison, Rex 99, 124
Haslam, Mark 105
Hayphee, Mary 56
Hellman, Lillian 122
Helmore, Kristin 103
Herlihy, Mark 12
high modernity xxii
Higham, Charles 94, 95, 100, 103, 106, 140
Hoffmann, Gertrude 17
Hopkins, Miriam 123
Hopper Hedda 124
Houdini, Harry 41
Howard, Leslie 100
hula dancing 47
Hunter, Kate 48
Imada, Adria L. 48
imperialism xxii, 1, 135
jazz xxii
Johnson, Gertrude 68, 74
Johnson, Martin 43
Kakutani, Michiko 103
Kellerman, Alice Charbonnet 3, 7
Kellerman, Annette
 accidents 40
 as South Sea Islander xv, 6
 arrested for bathing costume 12–13
 attempts to swim English Channel 10
 books 22, 42
 cars 16
 correspondence course 22
 cross-dressed 41
 European career 9–10
 films 24–33, 39
 illness as a child 3
 in Melbourne 7–8
 lectures on fitness, health and beauty 22
 modern woman 93
 moves to United States 11
 nudity 26–27, 44–45
 Perfect Woman 18–19
 performative career xv
 private lessons on fitness 22
 Southern California 136, 137
 tours Australia and New Zealand 33
 Queen of the Automobile Carnival 15
 'Undine', stars in 23–24
 vaudeville career 10–24
Kellerman, Frederick 3, 7
Kellerman, Marcelle 7

Kelly, Judy 111
Kelly, Veronica xviii
Kilner, Kerry 63
Kohn, Marek 90
Korda, Alexander 98, 99, 100, 101, 102, 124
Korda, Michael 100, 101, 103
Korda, Vincent 100, 101, 102
Korda, Zolton 100, 102
Lake, Marilyn 92
Langham, Edyth 141
Laughton, Charles 120, 124
League for Industrial Democracy 87
Leong, Karen 91
Light, Col. William 109
Lockyer, Winifred 67, 68, 69
London Great Exhibition (1851) xxiii
London, Charmian 43
London, Jack 35, 43
Lowe, Yarlock 19, 22
Lyceum Club 64, 68
Mackie, Vera 38
Maclaren, Ada 68
Magee, G.E. 19, 22
March, Fredric 116
Markus, Andrew 66
Marshall, Cassie 118
Marshall, Herbert 116
Martin, Wendy xxii
Matters, Louise 66, 67, 68
Matthews, Jill xxv, 130
Matthews, Julie 93
McCrea, Joel 99, 123
McMahon, Gregan 61, 63
McNicoll, David 140
Melba, Nellie 46, 66, 69
Melbourne, University of 58, 63
Melbourne University Dramatic Club 61
Melbourne Repertory Society 77
Melbourne Repertory Theatre 61, 63
Menken, Adah Isaacs xxiii–xxiv
Mentone High School 7
Mermaid Play Society 61, 63, 64, 69
Mermaid Society Orchestra 63
mermaids xxii, 2, 6, 14, 17, 25, 31, 32, 38,
 45–46, 136, 137
modern celebrity culture xxiii, 130
modern girl xxv, xxvi, 38
Moore, William 61
Moreton-Robinson, Aileen 141
Morgan, Margery M. 63
Moseley, Roy 94, 95, 100, 103, 106, 140, 141
Murray, Gilbert 71
Musgrove, Harry 34
Musgrove, Gertrude 100
Nenno, Nancy xxi
New South Wales Ladies' State Swimming
 Association 29

Niven, David 99, 100
Oberon, Merle
 bleaching cosmetic 106, 108
 complexion 106
 death 127, 139
 English girl 111, 116, 118, 119
 in India 97
 in London 96
 mixed-race origin 97, 102, 103, 120, 121
 named Estelle Merle O'Brien Thompson
 97
 Queenie 100, 102, 104
 'Tasmanian' birth xv, 94–96
 exposed 128
 transnational life 94
 visits Australia 129, 139, 140
O'Brien, Patty 47
Olivier, Laurence 49, 76, 77, 99, 124, 133
oriental xx, 26, 49, 72, 73, 90, 113, 120
orientalism xv, xxvi, 38, 50, 51, 55, 91
Osmond, Gary 6
Pagliai, Bruno 107–108, 126
Palmer, Nettie 59, 64
Palmer, Vance 59, 64
Patrick, John 86
Pattee, Herbert 11–12
Pavlova, Anna 31
Peiss, Kathy 108
Phillips, Murray G. 6
Pickford, Mary 131
Pioneer Players 59, 60, 61
popular culture xvii, xxiv
 ethnic stereotyping 38
 racism, racial hierarchies 38
postcolonial studies xix
Pybus, Cassandra 94, 95
Quong, Annie May 56
Quong, Chun 56
Quong, Eric 57
Quong, Florence 55, 57, 90
Quong, John 56
Quong, Norman 57, 83
Quong, Rose 49
 and feminism 64
 books 83–84
 China, travels to 81
 Chinese identity xv, 72–75, 92
 Circle 77, 78, 83
 Circle of Chalk, The 76–77, 87
 Cold War 86, 87, 92
 Eliza's Horoscope 89, 138
 first trip to United States 79–80
 in London 52, 55, 66–80
 interest in the metaphysical 88–89
 London Australian community 68–70,
 137
 juggled mixed identities 50

Melbourne years 56–66
 network of women's clubs 79–80, 83
 play typescripts 86
 second tour of Unites States 80–81
 television 80
 theatrical career in Melbourne 58–66
racialised and erotisised images xxi
Revere Beach, Boston 12–13
Reynolds, Henry 92
Ryan, Mary xxiv
Said, Edward 50–51
Sandow, Eugen 14, 41
Sassoon, Sir Victor 103
Schenck, Joseph 99
Selznick, Irene Mayer 106
Sergeant, Dr. Dudley Allen 19
Sentilles, Renee xxiii
Scott, Rose 9
Selby, Constance 95, 97
Selby, Harry 95
Shakespeare, William 49, 50, 55
Sharp, Wendy 137
Shirley, Arthur 42
Sing, Justine Kong 55
Sneider, Vern 86
social Darwinism 51
Sousa, John Phillip 135
South Sea Islanders xv, xvi, 1, 38–39, 41, 48,
 123, 135, 137
South Sea Islands xx, 41–44
 films about 43–44, 47
Stephensen, Percy 69
Sullivan, James 15, 39, 137
swimming strokes 4, 6
St. George Baths 7
Tanizaki, Junichiro 36, 37
Tart, Quong 53
Tate, Henry 61
Teahouse of the August Moon 86–87
Terry, Ellen 66, 70
Thomas, Norman 87
Thompson, Arthur O'Brien 97
Thompson, Charlotte Selby 97
Time and Tide 64
Toscanini, Arturo 33
transnational xvii, xviii, xix
 construction of Australianness xvii–xviii
 racial understandings xx
 theatre and film circuits xviii, 1, 134
von Sternberg, Josef 124
Walker, David 109
Wallis, George 4
Waley, Arthur 74
Weismuller, Johnny 41
White Australia xvi, xvii, xx, xxi, xxvi, 52,
 55, 65, 90, 109, 127, 128, 135, 141
whiteness xvii, xx

Wickham, Alick 4, 6, 42
Wickham, Harry 4
Williams, Annie 68
Williams, Esther 44, 47
Williamson, J.C. 34
Wolders, Robert 126, 140, 141
women's bodies xviii, xix, xxii, xxiii
Wong, Anna May 49, 53, 76, 77, 79, 91, 92
Wooster, Marcelle 34
Wray, Fay 116
Wyler, William 99, 122
Wylie, Minna 9
Yoshihara, Mari 91
Young, Edith 64, 68
Young, Gibson 65